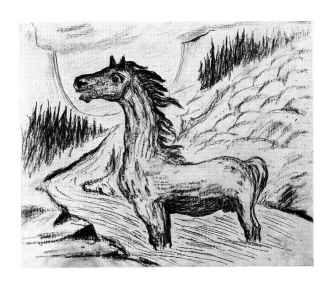

Carl Fredrik Hill *Untitled*, (undated) (cat. 20)

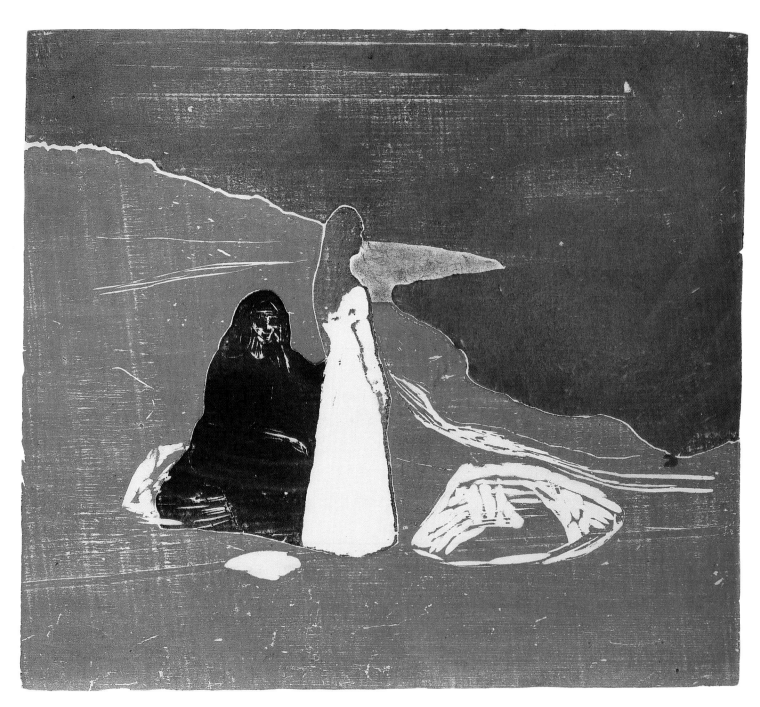

EDVARD MUNCH *Two Women on the Shore*, 1898 (cat.63)

BORDER CROSSINGS
FOURTEEN SCANDINAVIAN ARTISTS

Jane Alison and Carol Brown

With essays by
Dorthe Aagesen, Halldór Björn Runólfsson, Gertrud Sandqvist
and Thor Vilhjálmsson

Selected writings by
August Strindberg, Edvard Munch, Asger Jorn,
Per Kirkeby and Sigurdur Gudmundsson

BARBICAN ART GALLERY

AUGUST STRINDBERG *Photogram of crystallisation*, 1892-96
Courtesy of the Royal Library, Stockholm

CONTENTS

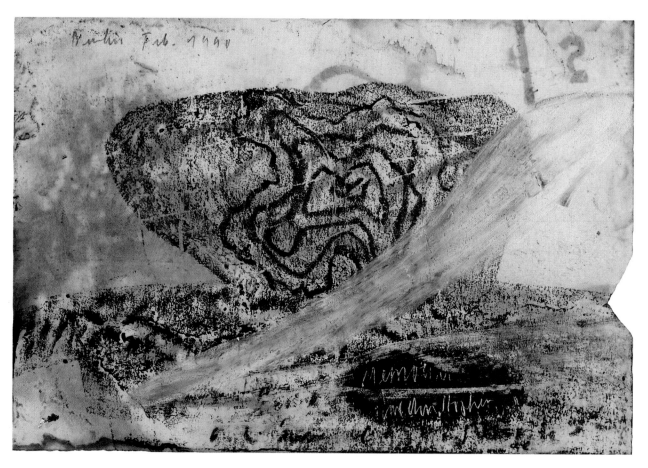

Olav Christopher Jenssen *Berlin*, February 1990 (cat.41)

FOREWORD

*B*order Crossings forms a part of the Barbican Centre's Scandinavian Festival *Tender is the North* and is one of a series of exhibitions mounted by Barbican Art Gallery exploring the art of other countries with which there are many links but yet of whose culture we know much less than we might.

In making *Border Crossings* we have brought major international figures together with artists who, whilst highly regarded in their respective countries, and indeed in Scandinavia as a whole, are as yet hardly known here. We hope, therefore, that the exhibition will hold revelations for our British audience and broaden our understanding of art from the Nordic countries.

Barbican Art Gallery has been helped in the development of the exhibition by many individuals and institutions in each of the countries we have been working with and have been met with great kindness and encouragement throughout. This applies to our colleagues in Denmark, Finland, Iceland, Norway, and Sweden as well as to those in Germany, France, The Netherlands, Switzerland and the United States, and also here in Britain. A list of those people who have been of invaluable assistance, and are too numerous to mention here, is given on p.165. We are indebted to them all.

We wish to give particular thanks to the Nordic Council of Ministers for their considerable financial support, without which the exhibition would not have come to fruition. We are also extremely grateful to Visiting Arts for their financial assistance. We are indebted to the Cultural Attachés of Denmark, Finland, Iceland, Norway, and Sweden for their kind co-operation and assistance from the outset. Our special thanks go to Björn Fredlund and Birgitta Schreiber of the Nordic Council of Ministers who have supported us throughout the development and progress of the exhibition, even through its more uncertain moments. Also to Dorthe Aagesen who worked with us in London for several months at a crucial period of development. Above all, we wish to extend our grateful thanks to all those who have most generously lent their works to the exhibition, including the artists and their agents who have given a great deal of time and assistance throughout the selection process.

Finally, we would like to offer our warmest thanks to those who have helped in the preparation of this catalogue: the authors, Leena Ahtola-Moorhouse, Halldór Björn Runólfsson, Gertrud Sandqvist, Thor Vilhjálmsson, and others that have advised us, particularly Douglas Feuk, Michael Robinson and Peter Shield.

Jane Alison *Exhibition Organiser*
Carol Brown *Senior Exhibition Organiser*
John Hoole *Curator*

CARL FREDRIK HILL *Untitled*, (undated) (cat.26)

SIGURDUR GUDMUNDSSON

SVAVAR GUDNASON

HULDA HÁKON

CARL FREDRIK HILL

OLAV CHRISTOPHER JENSSEN

ASGER JORN

PER KIRKEBY

JÓHANNES KJARVAL

EVERT LUNDQUIST

MARIKA MÄKELÄ

EDVARD MUNCH

TYKO SALLINEN

AUGUST STRINDBERG

EDVARD WEIE

SIGURDUR GUDMUNDSSON *Event*, 1975 (cat.2)

BORDER CROSSINGS

JANE ALISON AND CAROL BROWN

It was one of Per Kirkeby's pieces of writing, 'Geological Faults' (see.p.110), which first suggested the idea of 'Border Crossings' to us, something around which we could hinge the multitude of impressions and ideas that had been forming since we first began our research. Kirkeby's idea is specific; it concerns the movement of thought that results from many Scandinavian artists' urge to travel. And so in Kirkeby's example, Strindberg and Munch together in Berlin didn't 'travel to anything, they created something by moving.' But for Kirkeby the homecoming is equally important, as the way in which artists can most meaningfully come to understand their own experience, culture and heritage. According to Kirkeby, Munch asked 'Do you notice the stench' on his return to Ekely, signalling that those who come back 'cut all ties, overstep the borders in earnest.'

All fourteen artists in *Border Crossings* have travelled in the way Kirkeby suggests, 'creating something by moving.' They have done this as a means of broadening their horizons, finding their place within a European and more recently, international arena. It is the act of standing outside, shaking off the dust, taking on board new worlds and returning 'to measure the slide' as Kirkeby put it.

Stimulating as Kirkeby's article is, it was also the wider ideas and resonances that 'Border Crossings' evoked which excited us. Quite apart from the significance Kirkeby gives to *a return* our title simply implies the cross-currents between the artists we have selected, without pre-judging whether these constituted a particular Nordic aesthetic.

Our reticence about the idea of 'the Nordic' stemmed from a painful awareness of the dangers of labelling artists. After all, the perception in Britain of Scandinavian art as melancholic and, on a related front, being about a particular 'light', contains a great deal of truth, but is an understanding that has been at the expense of an approach attentive to variance as well as commonality. In short, a loss of the sense of complexity of individual experience, not least the buoyancy, lyricism, humour, and to some degree, the rationality that runs counter to this dark night of the northern soul. Whilst fascinated by 'the Nordic' Kirkeby has always had something of an apprehensive attitude to it. Writing in the catalogue for the 1991 Aarhus exhibition, *Melancholy*, he felt ambivalent enough about the whole thing to conclude: 'It is altogether a rather unsavoury and muggy business which is certainly highly dangerous for an artist to invoke.'[1] If it was dangerous for artists, it was certainly a no-go area for us!

We hope that the exhibition though not abandoning the possibility of a shared aesthetic, will rather suggest subtler and more various nuances, and that out of *Border Crossings* a truer picture of the interchange between Scandinavian artists will emerge. Significantly, among the connecting threads of the fourteen artists selected, a poetry, a humanity, an insistence on meaning, an existentialism was apparent; shared dreams conjured up and battles fought on the canvas. Ties

between individuals that seem to indeed have a bearing on the particulars of a northern, if not Nordic experience.

In asking two of our essay contributors, Halldór Björn Runólfsson and Gertrud Sandqvist for insider accounts, we could not have hoped for a finer response. Both offer perceptive viewpoints which reflect upon the conditions and responses to be found in the Nordic arena. It seems that in our selection they too found new food for thought. Further texts by Asger Jorn and Per Kirkeby point to their desire to track down an essential northern sensibility; some kind of continuum.

It was clear from the start that Expressionism and Romanticism would loom large in our considerations. In the early stages of thinking about the exhibition, the possibility was mooted that one of these might even govern the selection. But, as Runólfsson makes clear in his essay, both of these notions are too limiting, and ultimately too innacurate to describe the artists we are showing. It appeared that much of the work we were looking at was at the interface between these two currents, or slightly off-set from one or other.

Putting to one side then these art historical categories, we began to find a tracery of connections between artists, and out of the selection process we found a thread, albeit precarious, through the century.

Focusing on 'the self' and 'the land' provided an open, although still relevant framework upon which to build. Jorn believed that Nordic art is different and dangerous because artists concentrate all its power in themselves. Whereas, on the other hand, nature the great vastness, with all its complexity and magic is everywhere apparent in the Nordic countries. And once again the title 'Border Crossings' comes into its own, alluding to the crossing between these two worlds; the interior and the exterior, the heart and the land. Boundaries, perimeter zones, extreme states of being, journeying, birth and death – each of these are wonderfully resonant, and reappear again and again – in works which have no formal link even, but are nevertheless bound together in a way that was continually inspiring in the making of this exhibition.

'Border Crossings' also stands for connections across space and time, lines of contact that are variously fragile, heavenly, concrete and fleeting. Perhaps the most extreme of the juxtapositions in the exhibition, that had for us a special magic, is the one between Munch and Gudmundsson; separated by generations and oceans, and means of expression. These two artists mark the beginning and end of the exhibition. Take two works, one by each, Munch's *Encounter in Space* (ill.p.51) and Gudmundsson's *Molecule* (ill.p.121); both evoke a transitional world; each artist projecting themself onto the infinite, staging the self in the great cosmos. 'Human Destinies are like planets' writes Munch 'which move in space and cross each others' orbits'. Another two works: Munch's *Two Women on the Beach* (ill.p.2) and Gudmundsson's *Mathematics* (ill.p.112) as Munch writes, 'Down here on the beach I seem to find an image of myself – of my life.' The same cool shoreline – a periphery, a symbolic divide between life and the unknown, between matter and spirit. How consonant with Munch's approach is Gudmundsson's assertion that his art is drawn from the 'ebb and flow, sun and rain, day and night, love and grief.'

In paintings such as *High Sea*, 1894 (ill.p.41) Strindberg developed an aesthetics of alchemy, of transformation, eventually finding a reflection of himself in God 'the great artist'. He didn't

quite make the celestial grade, but the idea of the artist mediating between the material and spiritual worlds has many echoes throughout the exhibition. As Runólfsson writes, Scandinavian artists have a 'pagan attitude' in which they take nature's sublimity as a sign of their own 'unlimited imagination'. Less dramatic than Strindberg with his crucible and 'chemical sonnets', the contemporary artists Olav Christopher Jenssen and Marika Mäkelä preside over silent stirrings, the emergence of subtly intuited forms. Kirkeby's concentration upon nature's underlying flux is a reflection of Strindberg's desire 'to imitate nature's inner workings'. Kjarval and Hákon invoke the spirits of the land, and Gudnason the great sweep of the seasons, the wild currents. Gudmundsson decked out in his best, on the touch-line to heaven looks for 'wordless answers in nature'.[2] All this affirms Jorn's observation that: 'If one could call England Europe's centre of refinement' then Scandinavia is the 'the dream centre of Europe'.

Apart from the renegade Gudmundsson with his photographic 'Situations', our title refers to the test of making paintings, the realisation of an image, the transformation of mute substance into meaning. In Munch, Weie, Jorn, Lundquist and Kirkeby this experience with pigment on canvas becomes one of great significance, in which to varying degrees, the forces of light and dark are brought into play. Painting becomes the way of making the 'border crossing', the transposition of internal or existential struggles. And in these artists too, nature provides an anchor. In Lundquist's *Man on the Hill* (ill.p.101) the ground becomes a heaving rutted subsoil forced to the surface reminding onc of Kirkeby's belief in 'the material, the living, moving, mass, the magical lump' which lives 'a life of its own'.[3]

The disruption of the motif – the naturalistic image, in the pursuit of meaning, which is also the great Scandinavian *dream,* leads Edvard Weie to paint one of the most extraordinary and profoundly moving paintings in the exhibition, *Dante and Virgil in the Underworld, after Delacroix,* 1930-35 (ill.p.73). Here, the motif has to all intents and purposes disappeared to be replaced by an ecstatic vortex of colour which speaks of the great hopes and dreams of human existence.

Only Carl Fredrik Hill made the leap into the unknown, a border crossing to the interior, fashioning a psychic topography of mythical beings in a primeval land beyond the temporal world. The intensity of Hill's vision, the power and clarity with which it is expressed, is there in the work of Munch – and Jorn, the new primitive, who felt for Hill, understood the significance of his work. As Kirkeby once said you can 'paint yourself over the edge.'[4]

1. From 'The Nordic' in Exh. Cat. *Melancholy,* Aarhus Kunstmuseum, 1991

2. From 'Dear Marlene, Dear Siggi' in Exh. Cat. *Sigurdur Gudmundsson,* Mál og menning / Uitgeverij Van Spijk, 1991

3. From 'Synopsis' in *Selected essays from Bravura,* Van Abbemuseum, 1982

4. From 'Painterly Poetry' in *Selected essays from Bravura,* ibid

Chaos and God are Neighbours

Gertrud Sandqvist

'A boggy, soggy, squitchy picture truly, enough to drive a nervous man distracted. Yet was there a sort of indefinite half-attained, unimaginable sublimity about it that fairly froze you to it...'[1]

The quotation is from Herman Melville's *Moby Dick*. The Swedish art historian Douglas Feuk uses it to characterise August Strindberg's painting. But it could just as well be applied to the special tone of a considerable amount of Nordic art, which is perhaps a matter of equal respect for both human worlds, the inner and the outer. Perhaps it also has to do with a certain distrust of any art that is simply too amenable to being incorporated into a particular system, a particular tradition. Perhaps it is a question of an insight into the points of contact between humanity's extreme states, of how, in the words of Stagnelius, 'Chaos and God are neighbours.'[2] Nordic artists tend to take enormous risks.

The greatest of these is perhaps that of the myth overshadowing the work.

Nordic art, like, for instance, American art, is young in the sense that there is no long artistic tradition to fall back on, or to fight against. Edvard Munch, Carl Fredrik Hill and August Strindberg were all pioneers.

'Such unaccountable masses of shades and shadows, that at first you almost thought some ambitious young artist, in the time of the New England hags, had endeavoured to delineate chaos bewitched.' (*Moby Dick*)

Where does the greatness of Munch, Hill and Strindberg lie? Perhaps in the fact that they were all capable, at least for a time, of using personal experience of psychological borderline states in their art. They were creative precisely because they did not 'know' in advance what their painting was supposed to look like. In such a state of uncertainty the relationship between the artist and the material becomes the only thing about which it is possible to form an opinion.

Their art is an art of solitude. Their pictures are private, yet for that very reason universally applicable. Their painting thus exists outside of language; since the very concept of 'language' assumes a form of encoding or symbolisation, a degree of abstraction which means that an experience can be taught and shared virtually in its entirety. On this, Munch, Hill and Strindberg maintain silence. Their works are not amenable to imitation – although many have made the mistake of trying.

Having solitaries as one's mainstay is demanding, and in the worst case, stifling. Anyone with an instinct for self-preservation would seek to keep out of their shadow.

At the same time we repeatedly find painters in the Nordic countries who touch on human existence; painting that springs from mankind's failures and joys; painting that is authentically present.

Solitude is not the same as alienation. It is fascinating to observe how little meaning there seems to be in strategies aimed at establishing an objective distance. It is as though central perspective, which for Panofsky was 'The symbolic form of the Modern Man', was never really serviceable. The evaluating, controlling, all encompassing eye, the sceptic who demands an illusion that is faithful to reality in order to be able to believe in miracles, has not established any great Nordic pictorial culture.

Instead we find works that require trust, works that are based on familiarity, works that are founded on intimacy – intimacy between the artist and the work, between the work and the viewer.

In an essay about Edvard Weie, Per Kirkeby writes of the importance of faith. The painter has to believe, or rather entertain a belief, that the application of paint to canvas can be a great unifier, and may even be the greatest, the most important of all. If the painter loses this absurd faith the work becomes a matter of technique, of strategy, of style.

An American friend once asked me, 'Who do you imitate

when you write?' I replied with a certain amount of indignation that I hoped that what I wrote came from myself, although I was aware that one of the premises for language is that it can be shared. He did not understand what I meant. Two conceptions collided: distance versus trust as a working method.

Nordic culture has never been, and is not now, particularly urban. It has never been necessary to establish a clearly defined social structure that permits a comprehensive view. It is of no great moment whether people define their own individuality in relation to all others, or alternatively make a conscious decision to imitate this or that, through belonging to one school or another. The growing conditions for academies are poor, as poor as those for the Icelandic potato. Sigurdur Gudmundsson likens the Nordic artist to this potato, which everyone hopes for and expects. But the Icelandic summer is too short to allow time to mature. It needs at least two summers... and a Nordic artist can reach middle age before being described as 'promising.' Without trust, maturity never comes.

'...Enough to drive a nervous man distracted...a
sort of indefinite half-attained, unimaginable
sublimity...' (*Moby Dick*)

It is thus actually misleading to talk, for example, of Nordic Expressionism. It is so easy to confuse it with a German movement of the same name. There is no question here of allowing personality to reshape reality, but just the opposite: personality is reduced to zero; ego, hand and material are allowed to become the medium. Thus, it is not easy to speak, for instance, of the importance of the landscape or of nature, as is so frequently done. To the extent that the landscape is present it is taken up and transformed into an inner landscape; to the extent that nature is present here, it is in the desire to work like nature – and this in itself is already a dream.

'Credo quia absurdum'. A few Nordic artists have managed, relatively undisturbed, to find quiet in the midst of chaos; they have managed to wait out the emptiness; to use solitude to allow the work to become the object of faith. Thus, we almost never find what we expect in Nordic art.

Simone Weil proposes a definition of authenticity that relies on our making a distinction between person and personality. The person is ultimately the child who has no knowledge of self, the child who says, 'It hurts.' While, on the contrary, personality is a social construction, which, like clothes, conceals nakedness. It is possible to be close to the person. The personality has none of the prerequisites required to allow it to assimilate the pictures shown in *Border Crossings*.

Authenticity is a big word, and a highly inflamed notion, since it has been so frequently misused, since it has been used as a label for merchandise, since it has been confused with originality. But, without this authenticity, this absurd trust – which some Nordic artists suggest is now exhausted – would be meaningless. Besides, authenticity cannot become a project. To the extent that we seek it out, it vanishes.

Again, trust. Trust in the picture and in the viewer. Trust in the possible impossibility formulated by Olav Christopher Jenssen: 'To do what I am.'

Translated by Michael Garner

1. Herman Melville *Moby Dick*, 1851
2. Erik Johan Stagnelius (Swedish romantic poet, 1793-1823) *Samlade Skrifter* [Collected Writings], 1824-26

CARL FREDRIK HILL

(1849-1911)

THE HEART OF TRUTH

Carl Fredrik Hill writes his name across the sky for all to see, like an incantation, animating the expanse with a rhythmic pattern. Hill makes his mark, placing himself at the centre of his own world.

Delving into the many thousands of drawings which Hill made during his lifetime is an extraordinary experience, not least for the sense of sheer energy with which he worked, but more for the lasting potency of the images he created. Here we are confronted by a world in which the forces of nature are so strong, human life itself is vulnerable. We are given fascinating insight into the mysterious and intricate workings of Hill's mind, where feelings can be as sensual as they can be fraught. And whilst at times their meaning may seem impenetrable, their thinking irrational, these drawings nevertheless speak with tremendous power of the depths of human experience.

From the age of 28, Hill's work was made under the mantle of schizophrenia in an endless flow of chalk drawings and watercolours with gold that show the mark of a heightened sensitivity. Here Hill's thoughts, schemes and dreams are played out and embellished. The unconscious regions of the mind that other artists had hoped to gain access to, Munch and Strindberg included, are here released as Hill responds with great energy to the inner rhythms of life.

Stepping back to his early years, Hill seems always to have possessed the impetus shown in these later works. His father, an eccentric Professor of Mathematics, had attempted to direct him away from his early conviction that he would become an artist, but Hill was finally able to do as his wished and, after two years at the Academy in Stockholm, left for Paris, feeling that he had much ground to make up. With urgency and great prescience he said: 'ambition hounds me on to overstrain myself, and gives me no peace, because I am afraid to die before I am ready with my work.'[1]

CARL FREDRIK HILL *Untitled*, (undated) (cat.33)

As other artists, Hill made the journey southward to study the old masters and to place himself at the centre of the artistic current of his time. His encounters with French art gave him much food for thought, stirring him on to new developments in his own landscape paintings, which initially have a light, a luminescence akin to Corot.[2] But the death of one of his sisters, Anna, closely followed by that of his father in 1875, brought depression and the first signs of illness. And yet he

immersed himself ever deeper in his work, struggling to achieve an individual means of expression. He always hoped that this originality would be matched by public recognition, but it was a dream that was to be thwarted in his lifetime.

Spurred on by his discovery of the Impressionists, in 1876 at Luc-sur-Mer, Hill took his own painting further than he had ever done before. The art historian, Nils Lindhagen, who wrote extensively on Hill, describes how here, in confrontation with the sheer beauty of nature, Hill 'felt happy and liberated' and spoke of 'a burning desire to paint'; a state of mind in which he was able to call up all his artistic powers.[3] Rather than evoking the translucence of water, Hill wanted to paint 'the sea as a swamp',[4] and he re-creates the wastes of the shoreline with an earthiness and tense energy. *The Beach, Luc-sur-Mer*, 1876 (ill.p.18), with its impassioned handling shows the hallmarks of his frantic working method in which thick layers of impasto are laid on with a palette-knife and even glass. As Strindberg was later to do, Hill forged his work with

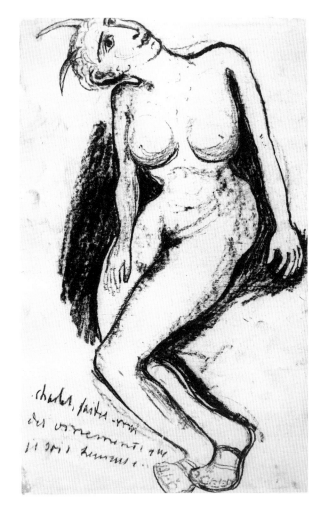

CARL FREDRIK HILL *Untitled*, (undated) (cat.32)

physical intensity. 'Impelled by his own burning spirit' (Blomberg)[5] and possessed by what he himself described as the 'demon of art', it is as if Hill worked in moments of ecstatic creation, writing: 'One hour of painting in a delirium is so marvellous that one gladly gives a whole life for it.'[6]

In the midst of his strenuous yet rewarding exploration of the painting medium Hill wrote home to his family in Lund saying: 'I have now reached the conviction that, in art, nothing else is to be sought but that which is true, "le vrai". But not the commonplace, the naturalistic, but the heart of truth.'[7]

This quest took Hill far beyond any realism that he had known hitherto. The painter Per Kirkeby has remarked that Hill, as other Scandinavian artists, 'combined the sense perceptions of "impressionism" with an existential consequence. The sensory perceptions of the individual – with the running backwards of the innermost sides of the personality.'[8] In just this way, it is as if Hill, in wanting to penetrate the unfathomable mysteries of nature, almost exploded his own being.

The paintings that followed in the next two years introduce a brooding melancholy to his work, presaging the illness soon to be manifest. *The Lone Tree*, 1878 (ill.p.19), with its darkened

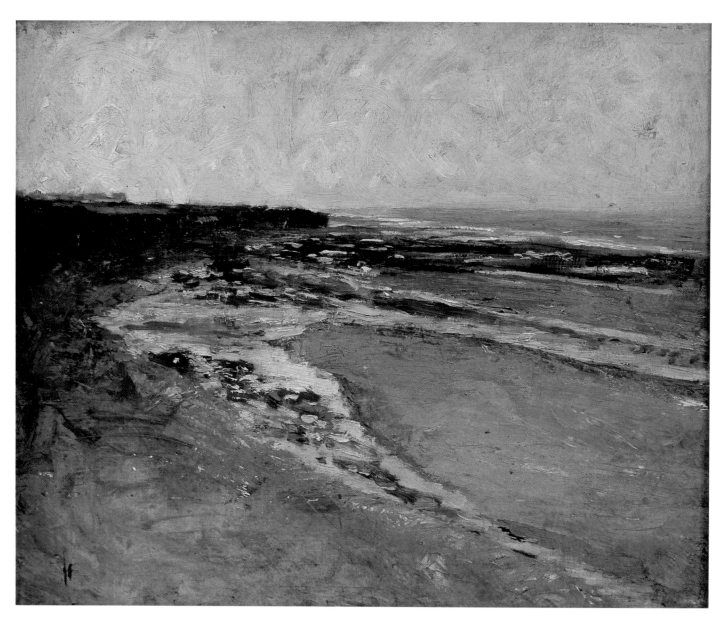

CARL FREDRIK HILL *The Beach, Luc-sur-Mer*, 1876 (cat.12)

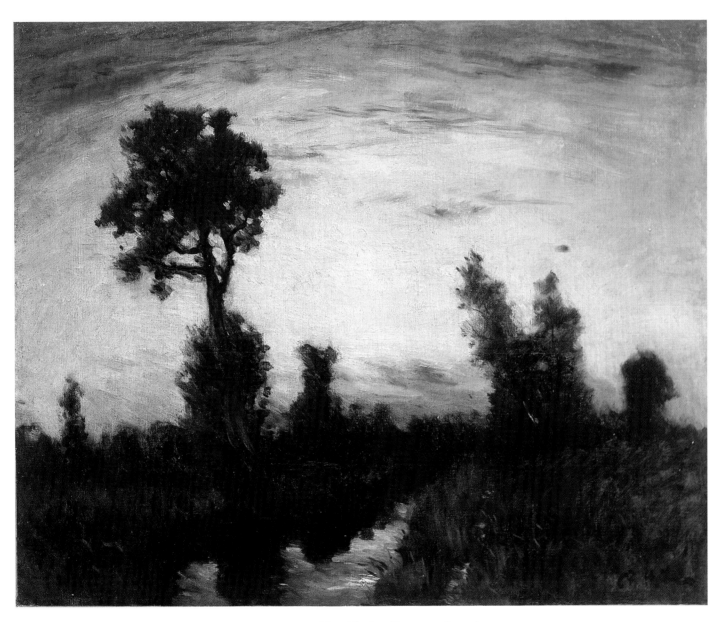

CARL FREDRIK HILL *The Lone Tree*, 1878 (cat. 13)

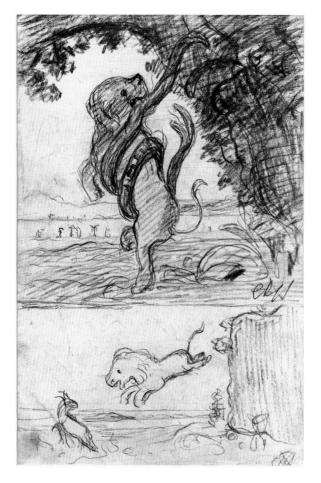

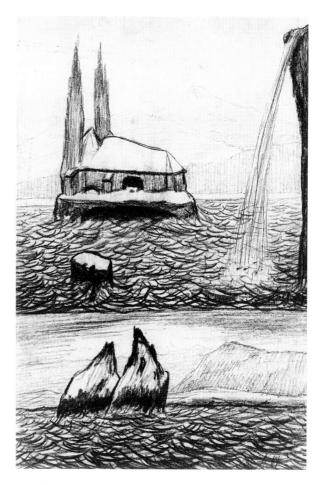

CARL FREDRIK HILL *Untitled,* from the *Flood Suite,*
(undated) (cat. 16)

CARL FREDRIK HILL *Untitled,* from the *Flood Suite,*
(undated) (cat. 15)

silhouettes against an almost acid evening light and animated, febrile strokes, suggest the inner torment that was soon to surface. In his attempt to reach an understanding of the world, Hill projects his emotional state onto the image, creating an atmosphere far removed from the optimism of Impressionism.

Hill's profound feeling for nature, indeed empathy, continues in the works made after the onset of illness. His softer pastel drawings of wooded landscapes with their dark coloration and sense of disquiet, show resonances of *The Lone Tree*. But the perspective has changed; we now look deeper into cavernous spaces and shadowy root structures that coalesce below the surface of the earth, as if Hill senses the very growth of nature and the underlying forces that animate it.

Constraints removed, Hill's anguish and suffering comes to the fore. Echoing the Romantics before him, often focusing on a single motif, Hill's wind-thrown pines takes on a human aspect, trembling, pitted against nature's drama. A horse is stranded, terrified, and the stag raises his head to release a cry of horror (ill. p.1 and p.23); Hill, as Munch, gives expression to the scream of nature and human kind.

Hill's knowledge and understanding of nature underscore a series of apocalyptic images on the biblical theme of *The Flood* (ill. above and opp.) where the mysterious, elemental forces of nature overwhelm. The sea invades whilst rivers plunge through a terrain now broken by gullies

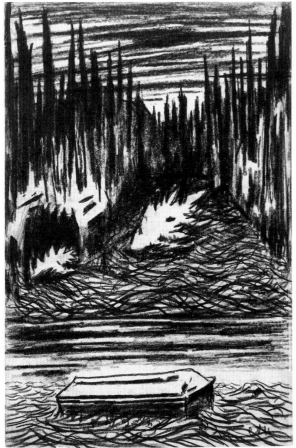
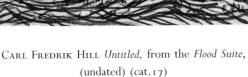

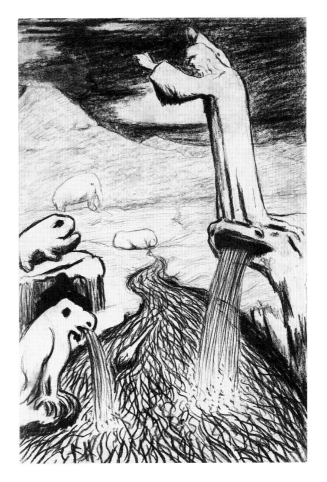

CARL FREDRIK HILL *Untitled,* from the *Flood Suite,*
(undated) (cat.17)

CARL FREDRIK HILL *Untitled,* from the *Flood Suite,*
(undated) (cat.14)

and deep chasms. A prophet-like figure, perhaps Hill himself, stands beside a river, gargoyles at his feet spewing out waters from the depths. His arms are raised as if directing the flood, or in appeal to some distant god, attempting to stem the flow. Death is ever-present. Hill draws a coffin below a scorched or burning forest of pines with the same bleak and desolate vision that leads Strindberg to his *Burn-Beaten Land,* 1892 (ill.p.31).

Hill's break with the rational world finally released him from any necessity he may have felt for realistic description. Rather than holding a mirror to the visible world he found more expressive means to convey inner feeling (Munch's 'mirror of the soul') enabling him to construct his pictures in a simplified and dramatic manner. As in Munch's *The Murderer,* 1910 (ill.p.57), images plunge toward you and perspective races away in the central distance. Banks of trees or waterfalls cascade inward from the sides of the picture, and with the barest of abstract touches, Hill is able to give form to flowing waters that are magically transformed into a beast, or a lion.

Human beings, too, are brought by Hill into these primal scenes, and there can be little more vulnerable in Hill's drawings than figures holding to the safety of a rock, surrounded by flood waters, exposed to the elements. Adam stands, his body turned towards us with his arm outstretched, holding before him an enlarged apple, symbol of temptation, which he quietly

CARL FREDRIK HILL *Untitled*, (undated) (cat. 34)

CARL FREDRIK HILL *Untitled*, (undated) (cat. 29)

considers. The outline of his figure is softly emphasised, an aura such as Munch used, generated by an inner feeling.

All Hill's innermost desires and sexual anxieties find form here, embodied in a bestial array. Woman, the subject of Munch's jealous fantasies, is depicted by Hill with horns – the evil temptress of his imagination and the object of erotic desire.

Yet to suggest that Hill's work is fabricated purely from the well-spring of his own imagination would be far from the truth. Isolated, no longer able to work direct from nature, and spending his days in the family home at Lund with blinds half closed, he drew images from books, magazines and encyclopedias in his father's library. Lindhagen has shown that Hill quite literally copied motifs from sources such as Dore's Bible illustrations and Wallis' *History of the World* taking them into his own work.[9] The point for Lindhagen was not to give justification to

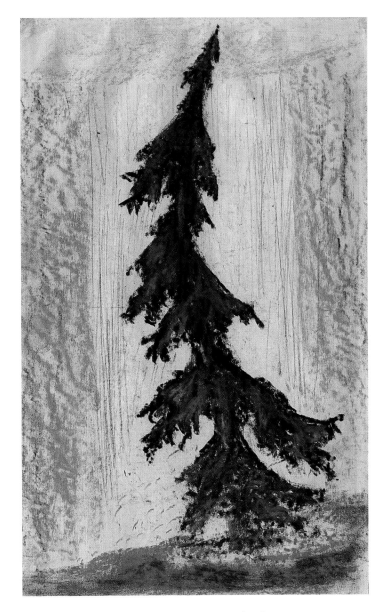

CARL FREDRIK HILL *Untitled*, (undated) (cat.36) CARL FREDRIK HILL *Untitled*, (undated) (cat.35)

Hill's art, but rather to show that, he, just as any other artist, transformed his source imagery in a process of creative renewal, and that with this understanding we gain insight into his work and thinking.

Classical motifs, colonnaded buildings, and more decorative images appear in Hill's drawings, no doubt drawn from these sources. An example from such a series of oriental works is the study of a reclining Arab figure in white robes with a strange clothed monkey beside (ill.p.26). Here Hill reduces the image to the simplest of lines, yet retains a mysterious and exotic air. The same arabesque gives movement to three swaying nude female figures, three graces (ill.p.27), and with equal ease, Hill draws a nude female figure, as bare and essential as Adam, virtually floating in space cast around an apple, or the globe of the world (ill.p.8).

The vast output of drawings in these years can been seen as Hill's means of apprehending the

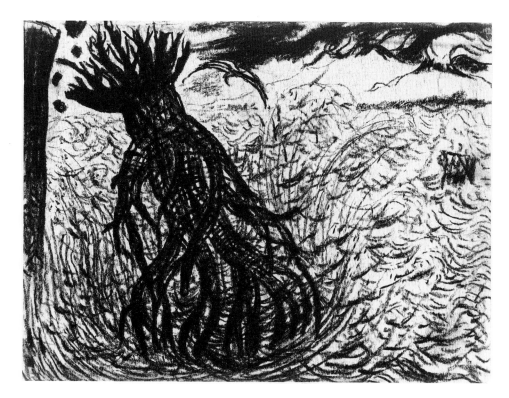

CARL FREDRIK HILL *Untitled*, (undated) (cat. 19)

CARL FREDRIK HILL *Untitled*, (undated) (cat. 18)

world, of making sense of existence, just as both Munch and Strindberg strove to do. Yet if these artists hoped to use the unconscious, Hill worked from within it, with all the attendant strains and passions of his illness. Kirkeby has understood Hill's evident suffering as the painful, but necessary price to pay for overturning the constraints of reason, 'the normal tradition and knack of this purposeless world...Plato's world.'[10] In struggling towards a greater insight, Hill put himself at risk – and as Kirkeby has said: 'One does not unpunished defeat a tradition that was (is) a whole culture's idea of purpose and meaning.'[11]

Hill crossed the threshold to the irrational, where he succeeded in giving powerful voice to the fears and hopes of human existence.

CARL FREDRIK HILL *Portrait of August Strindberg*
Malmö Konstmuseum

'Madness – how sublime when you wholly intoxicate...proud madness, loose your wild foals...O madness, step down from your zenith!'[12]

(CB)

1. Eric Blomberg, *Carl Fredrik Hill*, The Swedish Institute, Stockholm, p.8. The text is a revised version of an earlier translation of the introduction to *Drawings by C.F. Hill*, Albert Skira, Paris, 1950

2. Camille Corot (1796-1875), French

3. Nils Lindhagen, 'Hill Redivivus', Exh. Cat. *Carl Fredrik Hill*, Malmö Konsthall, 1976, p.146

4. Ibid., p.173

5. See Blomberg, op cit, p.17

6. Carl Fredrik Hill in a letter to his family, 1877. Quoted by Lindhagen, op cit, p.174

7. Carl Fredrik Hill in a letter written from Paris to his family in Lund, 1876. Quoted by Blomberg, op cit, p.3

8. Per Kirkeby, *Selected essays from Bravura*, Van Abbemuseum Eindhoven, 1982, p.60

9. See Lindhagen, op cit, p.151

10. See Kirkeby, op cit, p.114

11. Ibid, p.115

12. Carl Fredrik Hill, written in Lund. Quoted by Blomberg, op cit, p.40

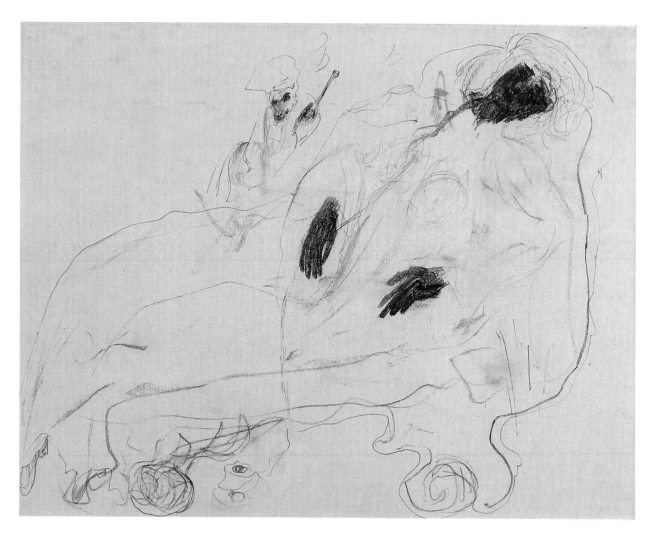

CARL FREDRIK HILL *Untitled*, (undated) (cat. 30)

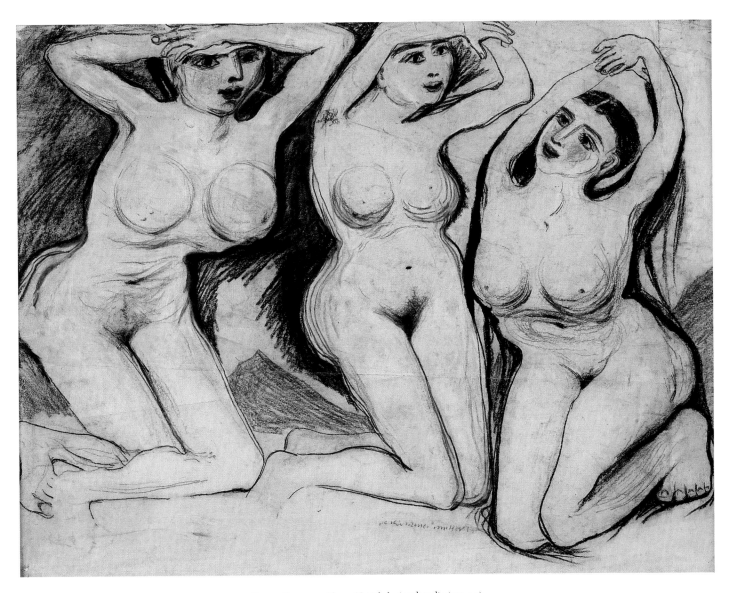

CARL FREDRIK HILL *Untitled*, (undated) (cat. 31)

August Strindberg
(1849-1912)

Rational Mystic

About fifty years ago, Strindberg sat in Paris and found his inferno in the attempt to prove the unity of matter, convinced that the elements were not, as science was maintaining at that time, incompatible and indivisible terminal points but that matter is a coherent fluid whole, a subject, and that everything that exists, at its most profound, understands and knows everything else, is everything else, is really only the same thing in different states. Now every scientist in the world has to admit he was right but he'll get no pleasure from that.'

Asger Jorn, from *Risk and Chance*, 1952[1]

Strindberg's talents ranged variously across theatre, novels, autobiographical fictions, studies in the natural sciences, polemics, satire, art criticism, experimental and naturalistic photography and painting. As Strindberg himself had once jibed: 'I'm a devil of a fellow who knows many tricks.'[2] He may have made light of his protean skills, but each one fed the other in a dynamic and often radical way. The multi-faceted and shifting nature of his interests, however, has tended to result in a general lack of appreciation of his work – certainly in Britain in the late twentieth century. At the 1990 international conference on Strindberg, Jan Myrdal pointed to a general misconception of the playwright as 'inherently pessimistic and neurotic.' Not surprisingly Myrdal refutes this simplistic analysis of Strindberg, whom she went on to describe as 'a pliable, shimmering writer who cannot be easily labelled.'[3]

This is far removed from Strindberg's meteoric rise to fame in Germany during the First World War when his new brand of expressionist drama filled theatres throughout the country.[4] In Sweden there is a deeply rooted love of his writings, a legacy that was further elaborated and enhanced when in the 1960s his paintings were hailed there as radical precursors of Abstract Expressionism, with Strindberg emerging as a kind of Jackson Pollock of the north. He began painting in the late 1870s, but it is those works painted between 1892-94 that represent the high-point of Strindberg's achievement and signal the most significant development in his writing. Michael Robinson, Britain's leading authority on Strindberg, has written of his experiments in painting as well as photography as being critical in the formation of his decisive and all important shift from the naturalist plays of the 1880s, such as *Miss Julie*, 1888, to a fully-fledged modernism along expressionistic lines. Robinson believes that painting allowed Strindberg to take chances, make mistakes, paving the way for a more experimental theatre, as witnessed in *To Damascus*, 1898, *A Dream Play*, 1901, and *The Ghost Sonata*, 1907, among others.[5]

At a first glance, any one of Strindberg's paintings in this exhibition illustrates the spontaneous method that he described as an 'art fortuite'.[6] In *The Role of Chance in Artistic Creation* published in 1894,[7] Strindberg explained his idea that 'possessed of a vague desire' he then gives it form

through 'free hand drawing'[8] 'moving the palette knife at random', whereupon 'the whole reveals itself as a wonderful mix of conscious and unconscious.'

But perhaps too much has been made of Strindberg as a pioneer of the medium itself. The art critic Douglas Feuk suggests that however much ahead of its time Strindberg's brand of automatism was, too great an emphasis upon it has resulted in a concentration on the surface appearance of his works at the expense of what they convey as a 'world of ideas.'[9] Strindberg's paintings from the 1890s are his most satisfactory as independent works of art, and are all the more memorable and relevant if considered as one important aspect of his enquiry into the nature of being and existence, a counterpoint to his literary enterprise. Essentially, Strindberg's interest was the elemental stuff of nature, its mechanisms and intercon- nections, and a reading of his art in this light brings into question the other widely accepted interpretation of Strindberg as a Romantic transported by nature's sublime

Picturing a life: August Strindberg, Gersau, 1886. Courtesy of Strindbergsmuseet, Stockholm

qualities. Certainly, he was a devotee of Turner but, by contrast, as Harry G. Carlsen writes, Strindberg's romanticism was based on a desire 'to *find* not *lose* himself... to explore his own feel- ings, to scrutinise the truth of inner essences.'[10] For at root, the most interesting aspect of Strindberg as a painter, certainly with regard to the works shown in *Border Crossings*, is the unique chemistry he brings to painting, a fusion of poetry and rationalism.

This investigation of Strindberg's into the nature of matter, a scientific interest rather than an artistic one, partly explains some of the undoubtedly inept handling of paint in his work, which is often mistaken, indeed scorned as being amateurish, for Strindberg required only that painting suited his own purposes. Nevertheless he did mix with other artists, Munch first and foremost amongst them, Gauguin also, and in the 1890s he very much wanted his works to be shown and assessed within the context of a contemporary debate. Hence, we find Strindberg showing along- side Munch at the Salon des refusés, the alternative Freie Vereinigung Berliner Künstler exhibition in Berlin in 1893. Very often penniless and with a family to support, he hoped to also sell his works through exhibitions but, not surprisingly, given the radical nature of his painting, popular and critical success eluded him.

Strindberg's exploits as an artist were conducted in bursts of activity when he was having personal problems, and the writing just wouldn't flow. It seems that from the beginning painting opened new doors for him whilst also fulfilling a reparative need, as shown when he writes that 'his small, crabbed handwriting lay dead on the paper and was incapable of revealing as openly [as writing] what he felt' whereas painting 'showed himself to himself' and being at the easel 'was like sitting down to sing.'[11]

The last decade of the nineteenth century opens with Strindberg in the throes of an extremely

AUGUST STRINDBERG *White Mare II*, 1892 (cat.79)

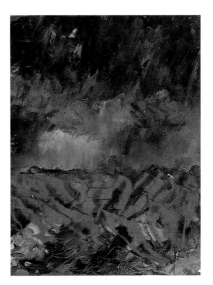

reverse (cat.78)

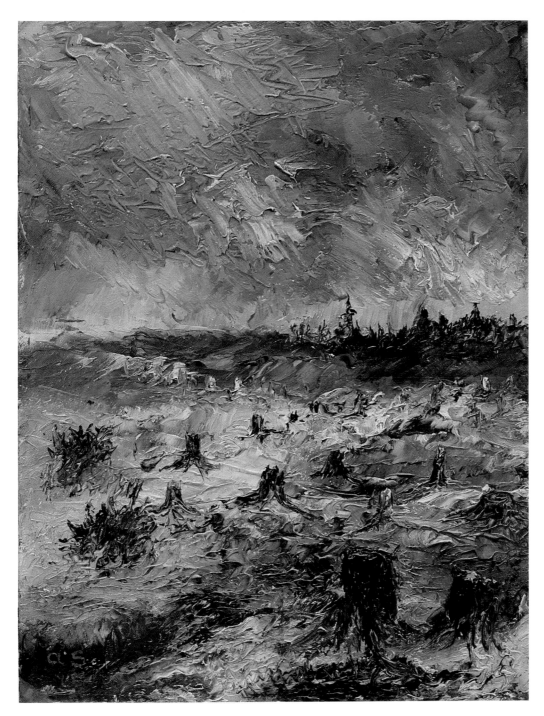

AUGUST STRINDBERG *Burn-Beaten Land*, 1892 (cat.78)

messy separation from his first wife, the actress Siri von Essen. In 1891 on Dalarö, in the Stockholm Archipelago, Strindberg entertained ideas of suicide (a frequent scenario) and expressed regret at his separation from the children. But his anxiety is in marked contrast to further reports of crayfish feasts where Strindberg played the mandolin and of general good times being had in the company of artists, Anders Zorn and Ernst Josephson among them.[12] Here in a landscape that Strindberg loved above all others – 'to the point of ecstasy'[13] – he returns to paint *Burn-Beaten Land* (ill.p.31) and *The White Mare II* in 1892 (ill.p.30).

In his short fiction *Life in the Skerries*, written in 1888 and based on his experience of the Archipelago, Strindberg writes of the main character: 'But nature, with which he had always sought to communicate now appeared dead to him.'[14] What could illustrate Strindberg's shift away from the naturalism of the 1880s more clearly than *Burn-Beaten Land* with its unreal parched terrain yielding only lifeless stumps. It is undoubtedly the bleakest of Strindberg's paintings, and suggests that his own disquiet although otherwise repressed could find expression through painting. In some of Strindberg's work it is clear that landscape did offer the possibility of psychological renewal, of succour, but *Burn-Beaten Land* shows that it could also be, as for Munch, 'a mirror of the soul'[15] at its darkest and most helpless.

In 1885 Strindberg had declared himself an atheist and thereafter sought to make sense of his life through an exploration of the unconscious, 'this wonderful turning inside out of the soul... which is the precondition of art.'[16] An idealisation of Nietzsche from the late 1880s[17] brought with it an understanding of the uncontrollable and dark forces of the will which Strindberg blended with a bleak existential vision of humanity, modelled on Kierkegaard, another of his early heroes.[18] Michael Robinson, ever conscious of the nuances of Strindberg's adventure of self-discovery, explores how, for Strindberg, writing could be cathartic, an 'acting out' in Freudian terms,[19] whilst painting served another function, freeing him from the constraints of language and offering direct access to the unconscious. But Strindberg also held out for a passage to a deeper layer of meaning 'where the functions of his soul worked independently of his will.'[20]

On the Archipelago, sea and sky dominate the horizon and thereafter become the focus of nearly all Strindberg's pictures. His love of the Archipelago mirrors Munch's passion for Åsgårdstrand with its long undulating shoreline and the play of light on sea and stones. For both, the sea becomes a Baudelairian symbol of birth and annihilation, a mirror of Strindberg's own struggles with the paint as he releases inner tensions, but ultimately wants some kind of order to emerge from the intoxicated layering of impasto.

The two Dalarö paintings from 1892 introduce a new earthiness, a materiality not seen in early works. The craggy, storm lashed nether region where sea meets sky, depicted in many of Strindberg's paintings have something of the same feel as Carl Fredrik Hill's *The Beach, Luc-sur-Mer*, 1876 (ill.p.18), with its barely constrained anguish, and Hill's increasingly clay-like deposits of shingle; suggestions of a sculpted landscape. Of those paintings shown in *Border Crossings*, Strindberg's own shore scene, painted in Paris-Passy in 1894 (ill.p.39) bears the most obvious relation to Hill's naturalistic works. A painting like this could have failed abysmally. But here, in this little painting, it is as if Strindberg could just give and pull back enough to achieve the balance of elements he sought.

In late 1892 the scene shifts to a Café in Berlin named by Strindberg, 'Zum schwarzen Ferkel' [The Black Pig][21] where the spirit of Nietzsche is king and Strindberg lords over riotous scenes of bohemianism, drunkenness and debauchery. A key player in this new Berlin based avant-garde was the young, and now, after the furore surrounding his show at the Berlin Artists Association, the highly controversial Edvard Munch. In her account of the Berlin avant-garde in the 1890s, Carla Lathe describes how, essentially, the group based around the 'Ferkel' worshipped intuition and psychology over rationality and aestheticism and celebrated the idea of a brooding, anxious Nordic sensibility.[22] In this anarchic climate Strindberg's visual imagination, and scientific and human interests are nourished. But at the same time jealousies and hatreds festered like open wounds and were encouraged as soul food for art. Strindberg's painting *Night of Jealousy* (ill.p.34) with its many parallels in Munch is testimony to that.

Worshipping the demonic: *Self-portrait*, *Berlin*, 1893. Courtesy of the Royal Library, Stockholm

Aside from their influence on each other, it seems that for both Munch and Strindberg, the medical student turned musician, writer and occultist, the Pole, Stanislaw Przybyszewski was the most influential amongst the circle. His celebration of the demonic and his misogyny are well known, especially in relation to his influence on Munch. In 1892 he wrote a book of essays entitled *Concerning the Psychology of the Individual* which included a study of Nietzsche and Chopin, and later he wrote on Munch himself. What is particularly interesting about him in relation to Strindberg is the way in which he took up Nietzsche's idea 'Rausch' [Frenzy] as the basis of artistic expression. Stories abound of Przybyszewski's improvised versions of Chopin's piano sonatas in which he reportedly whispered, prayed, and murmured poetry to himself[23] – an 1890s 'happening'. Such an event must have appealed to Strindberg's sense of theatricality, and humour perhaps, but more importantly would have encouraged his own ideas on 'chance' effect and it's importance in creativity.

'Now and then I believe myself to be a sort of medium... because everything works so easily, only half-consciously, with moderately little calculation' Strindberg had written in 1909.[24] And elsewhere, he explained: 'I often put myself into a state of unconsciousness, not with drink or the like, for that awakens a host of memories and new ideas, but by distractions, games, play, sleep, novels, and then I let my brain work freely, without bothering about the outcome or consequences, and something then emerges which I believe in, just because it has grown inevitably.'[25] So here we have the real Strindberg of the 1890s taking shape, not the writer but the self-described 'poet-chemist',[26] fusing a fascination for spiritualism, alchemy, art and all matters of the occult with a real intellectual and spiritual desire to form a unified vision of the world. A mad-scientist of the popular imagination springs to mind – only Strindberg was deadly serious.

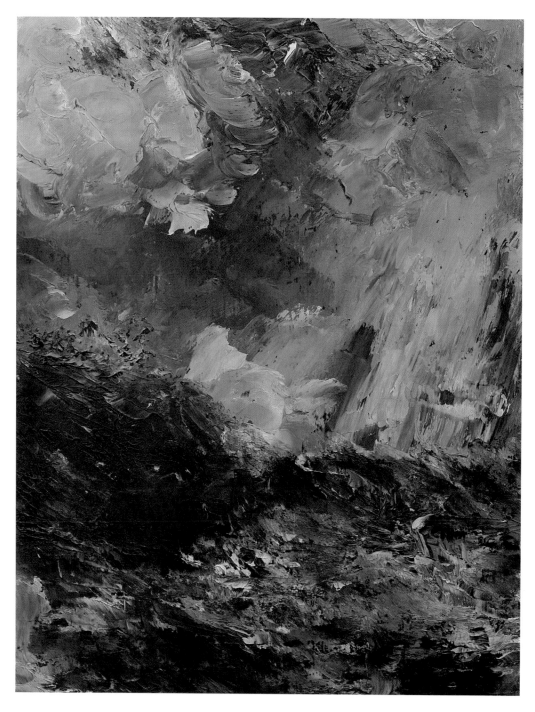

AUGUST STRINDBERG *Night of Jealousy*, 1893 (cat.80)

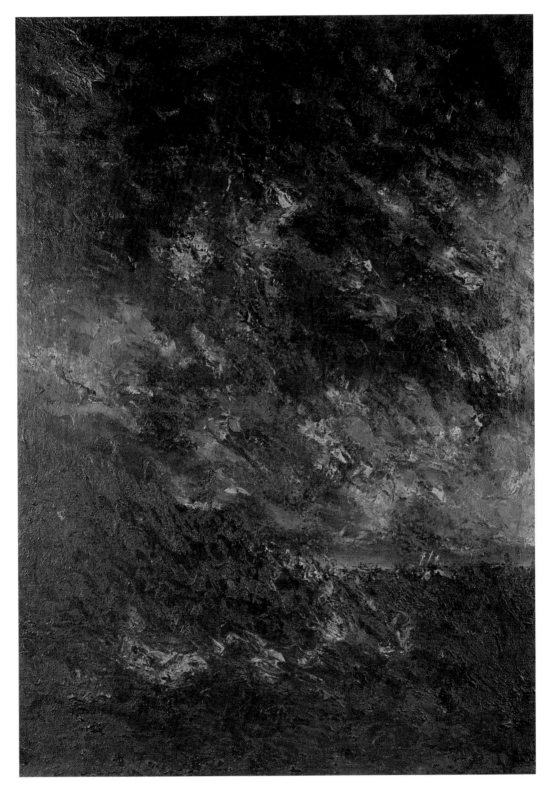

AUGUST STRINDBERG *Golgotha*, 1894 (cat.81)

Strindberg as alchemist: Drawing by Arthur
Sjögren for the Swedish edition of
Antibarbarus, Stockholm, 1906

Strindberg's remaining works in *Border Crossings* were painted in this spirit, first in Dornach with his new wife the journalist Frida Uhl, where he also wrote his first scientific treatise, *Antibarburas,* in which he sets out his new monist doctrine of unity; and later in Paris during his years of experiment and psychological disturbance, his so called 'Inferno crisis'. The Paris and Dornach period is one of profound reflection that finds Strindberg alone in his spartan room at the Hôtel Orfila. Here, this 'Zola of the Occult'[27] resembles Hamsun's hero in *Hunger*; malnourished and often suicidal, acutely aware of every psychological nuance that he then faithfully records in his Occult Diary, and which he elaborates to his soulmate and sounding board of the moment, the Theosophist, Torsten Hedlund. He composes 'chemical sonnets',[28] recipes for gold and sulphur among them. Nature no longer appears 'dead to him' as it had done in *Burn-Beaten Land* but instead offers a mass of 'correspondences': the kingfisher whose blue breast has taken on the opalescent hue of the water over which it perches; the mackerel that 'bears the marks of the billows';[29] the walnut shell that resembles the human brain,[30] and the sunflower whose petals reflect the shape of the sun itself.[31] 'My method is to see similarities everywhere' writes Strindberg, wondering whether Darwin might have considered, 'The role of chance in the origin of the species!'[32]

In the same way, Strindberg's paintings come to reflect, and may have even suggested, this indivisibility of the elements. A painting such as *The Shore*, 1894 (ill.p.39), mirrors Strindberg's thoughts, when he writes: '…when I see sea and sky merge in the blue air, making the horizon visible, it seems to me to be a single substance, all water, or all air, they are reflected in each other. And is it from the higher waters that clouds, rain, dew, *frost flowers* come? Is it possible that communication can take place between these realms?,[33]

In the Dornach and Paris period Strindberg takes up photography again, but this time it is to get a 'perspective into the secret places of nature'[34], to understand its 'microcosmic secrets.'[35] Like the crescendo of forces that are whipped up in *High Sea*, 1894 (ill.p.41), a silver bromide plate dipped in developer and held against the night sky could fashion a new and, to Strindberg, truer cosmic reality.

Douglas Feuk draws a convincing parallel not only between Strindberg's monist ideas and his paintings as a reflection of those, but also between his paintings from the 1890s – *High Sea* being a classic example – and his experiments, which take on the character of these same speculations. For art was to now imitate nature's hidden mechanisms. Feuk eloquently describes Strindberg's 'Inferno' period paintings as 'primitive and magical', as 'incantations'; at one point describing their surface as a 'vortex of sluggish blobs, a kind of boiling magma' and elsewhere as 'rough

quagmire' or 'a kind of primeval chaos of disturbed and dissolved matter'.[36] Feuk relates how in the process of attempting to understand the elements, Strindberg contemplates the contents of a crucible of burnt and encrusted sulphur which he records as being of a greyish violet colour.[37] The surface of *Golgotha*, 1894 (ill.p.35), could almost be composed of the same inert residue that Strindberg had laboured on and was musing over. To achieve a deeper shade of black Strindberg scorched the surface of *High Sea* and Feuk sees in it the 'more-or-less completely burnt deposits... the end product of his various chemical experiments.'[38]

Edvard Munch, August Stind(=fat)berg, 1896
Courtesy of The Munch Museum, Oslo

In Paris, Strindberg met Munch again, but this time their falling out was more notable than previous exchanges between them. Munch's famous 'Stindberg print' and Strindberg's subsequent message to Munch in which he tells the younger artist: ' Last time I saw you, you looked like a murderer',[39] are tangible signs of their enmity. More significant in 1896 for Strindberg is his meeting with Gauguin and the subsequent analysis of his art. Strindberg had travelled to Berlin and Paris, but now his northern soul could even imagine a 'border crossing' to Gauguin's Tahiti, in spirit at least. A letter, which Strindberg intended as something of a statement on Gauguin's art, and which is an extremely perceptive critique, concludes: 'For I too am beginning to feel an immense need to become a savage and create a new world.'[40]

This willing acceptance of Gauguin's exoticism has a parallel in Strindberg's fascination with Hinduism, sparked by a reading of a guide to the city of Benares by André Chevrillon. Strindberg had written to Torsten Hedlund: 'Today I finished reading a book about India and I no longer know where I am' and goes on to say that having reflected on his own writing he now feels as though he 'were someone else and that someone was a Hindu.'[41] The rotting malloworts of Strindberg's *The Wonderland*, 1894 (ill.p.38), mirror exactly Chevrillon's description of 'wells from which the stinking odour of rotting flowers arise... sacred jasmines rot in the waters of the Ganges which is then sprinkled on altars.'[42] Strindberg felt totally at home with the Hindu's organic relationship to the world, and the magical transformative qualities they attributed to nature. *The Wonderland* offers, in contrast to the others paintings by Strindberg in *Border Crossings*, a vision of certain hope. It is a painting he describes as 'a battle of light against darkness' in which a 'hole opens out into an idealised landscape where sunshine of every colour streams in.. Or the opening of the realm of Ormuzd and the exodus of the liberated souls to the land of the sun; under it the flowers... decay in *gnothi seauton* [know thyself] before the muddy water in which the sky is reflected...'[43]

A further signalling that the Inferno period is essentially one of 'renewal' (Robinson)[44] and personal 'transformation' (Feuk),[45] is evident in Strindberg's essay *The Death's Head Moth* (see p.40). Here, Strindberg describes the larva which is ' dead in the chrysalis' but which 'lives and

rises up from the dead, not as a regression to some lower mineral or elementary matter but as a higher form, in beauty and freedom.' Out of his inferno Strindberg discovers a personal God who created a world both unified and multifarious. In a letter to Torsten Hedlund, Strindberg tells him that he now perceives the existence of animals in a 'completely new light' and that his 'most recent view' is that God was the 'Great Artist, who made sketches, rejected them, began again, and developed both himself and his skills in the process.'[46]

(JA)

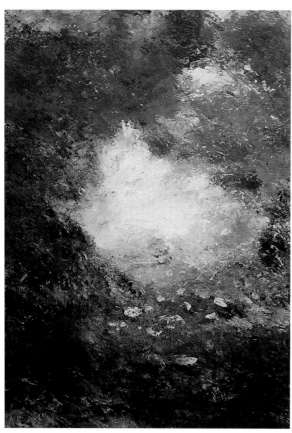

AUGUST STRINDBERG *The Wonderland*, 1894
Nationalmuseum, Stockholm

1. Originally published in Copenhagen, 1963, p.83. Translated by Peter Shield

2. Quoted in Rolf Söderberg *Edvard Munch and August Strindberg: Photography as Tool and Experiment*, Alfabeta Bokförlag, 1989, p.6

3. In 'August Strindberg and his Tradition in Swedish Literature' *Strindberg and Genre*, Norvik Press, 1991

4. More than a thousand performances of Strindberg's plays were given in sixty German cities during the years 1913-15

5. In correspondence, 22 July 1992

6. Letter to Leopold Littmansson, 31 July 1894, in Michael Robinson, Ed. *Strindberg's Letters*, The Athlone Press, 1992 no.332, p.494. Quoted in Robinson *Strindberg and Autobiography*, p.25

7. Originally published November 1894 in *Revue des Revues*. Re-printed in full in Douglas Feuk *Strindberg*, Format, Edition Bløndal, 1991

8. Quoted by Robinson, op cit, p25

9. Douglas Feuk *Strindberg*, op cit, 1991, p.24

10. 'Strindberg and Visual Imagination' in *Strindberg and Genre*, op cit, p.258

11. Quoted in Carlson, 'Strindberg and Visual Imagination', op cit, p.256 and Robinson in *Strindberg and Autobiography* p.20

12. Olaf Lagercrantz, *August Strindberg*, FSG, 1984, p224-225. Ernst Josephson (Swedish) 1851-1906 Anders Zorn (Swedish) 1860-1920

13. Occult Diary, 21 November 1900. Quoted by Lagercrantz, p.37

14. Quoted by Reidar Dittman, *Eros and Psyche:Strindberg and Munch in the 1890s*, UMI Research Press, 1976, p.50

15. Quoted by Ragna Stang, *Edvard Munch: The Man and the Artist*, Gordon Fraser, 1979

16. Quoted by Robinson, *Strindberg and Autobiography,* op cit, p.5

17. In September of 1888 Strindberg wrote to George Brandes: 'My spiritual being has received in its uterus a tremendous ejaculation by Freidrich Nietzsche, so that I feel as full as a pregnant bitch'. In November of the same year, when Nietzsche was on the brink of madness, he and Strindberg corresponded.

18. See for instance Lagercrantz, op cit, p.34

19. For Robinson's discussion on Strindberg and Freud, see *Strindberg and Autobiography*, chapter 'Writing out and Repetition,' op cit, pp.19-45

20. From Strindberg's *The Son of a Servant*. Quoted by Carlson, op cit, p.257

21. An interesting description of the 'Ferkel' by Stanislaw Przybyszewski is quoted by Dittman, op cit, p.79: 'The entire *Weinstube* consisted of two small rooms separated by a narrow serving counter overflowing with bottles containing all sorts of drinks. The entire area was so limited it could barely accommodate twenty persons. And by six o'clock in the evening, once Strindberg had begun frequenting the place, it was impossible to find a vacant square inch.'

22. Carla Lathe 'Munch and the Berlin Art World' in *Facets of European Modernism*, Norvik Press, 1985

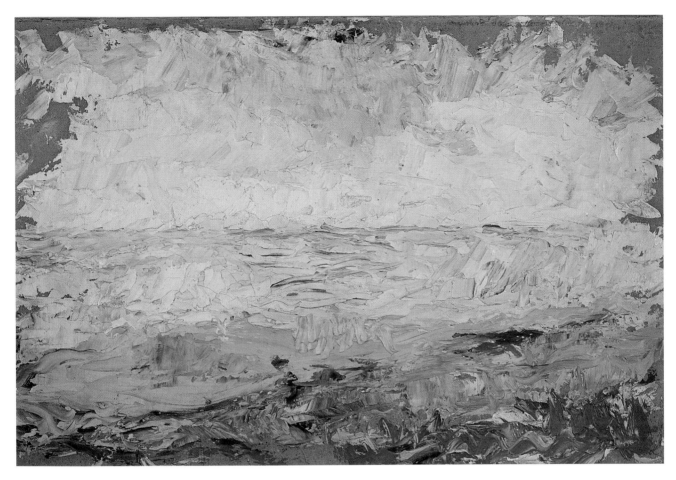

AUGUST STRINDBERG *The Shore*, 1894 (cat.83)

23. Ibid, p.110

24. From 'Questions and Answers' published in Bonnier's magazine, 1909. Quoted by Robinson, op cit

25. Quoted by Robinson, ibid, p.24.

26. Quoted by Lagercrantz, op cit p.271

27. Quoted by Evert Sprinchorn 'The Zola of the Occult' in *Strindberg and Modern Theatre*, Strindberg Society, 1975, p.101

28. Quoted by Lagercrantz, op cit

29. See *The Death's Head Moth*, p.40

30. See Carlson, op cit, p.262

31. In an essay entitled *The Sunflower*, c1895

32. In 'The New Arts! or the Role of Chance in Artistic Creation', op cit

33. Letter to Torsten Hedlund, 18 July 1896, in *Strindberg's Letters*, op cit, no.378, p.572

34. Quoted in Rolf Söderberg *Edvard Munch/August Strindberg; Photography as a Tool and an Experiment*, op cit, p.33

35. Ibid,p.33

36. Feuk, op cit, pp.12,13,22

37. Ibid,p.36

38. Ibid,p.34

39. Letter to Edvard Munch, 19 July 1896. *Strindberg's Letters*, op cit, no.380, p.581

40. Letter to Gauguin, February 1895. *Strindberg's Letters*, ibid, no.348, p.529

41. Quoted by Carlson, op cit, p.264

42. Quoted by Carlson, ibid,p.265

43. Letter to Leopold Littmansson, 31 July 1894. *Strindberg's Letters*, op cit, no.322, p.495

44. See *Strindberg and Autobiography*, p.42

45. See Feuk, *Strindberg*, p.38

46. 20 July 1896. *Strindberg's Letters*, op cit, no.381, p.583

The Death's Head Moth
An Experiment in Rational Mysticism

August Strindberg

The bleak, which lives at the water's edge and looks the sun in the eye, is silvery white and has only one bluish-green streak down its back. The roach, which keeps to shallow water, already has more pronounced colouring, in sea-green. The perch, which is confined to deep water with a stony bottom, is already darker, and the lines down its back are black like the outline of the waves on its sides. The tench and the flounder which grub around in the mud have become as dark as the olive-green mud itself. The mackerel bears the marks of the billows so clearly outlined on its back that a marine painter might copy them and present them in perspective on a canvas so that they reproduced the waves. But the golden mackerel which dwells in the crests of the waves has all the colours of the rainbow, with gold and silver as well.

What is this but photography? On its silver plate, which can be either silver chloride, silver bromine or iodyrite, since sea water is considered to contain all three halogens – or – on its albumen or gelatine plate, which is silvered, the fish catches the colours refracted through the water. Since it lives and moves in the developer, magnesium sulphate (iron) for example, the effect 'in statu nascenti' will be so powerful that the colour photography is accomplished directly. And the fixer, or natrium hyposulphite, should not be that remote for a fish that lives in sodium chloride and salt sulphates, and which also carries its own supply of sulphur.

Is this more than a metaphor invented by Niepce de Saint Victor and his followers? No doubt it is, although that is not the whole truth: it will surely prove difficult to demonstrate that a fish's shimmering silver scales are indeed silver to those who do not accept the premises, but that it could be tin, or one of the ethyl phosphines or amines, is something I have shown to be likely elsewhere.[1]

That the drum fish, 'Eques lanceolatus', has photographed the shadow of its great nape fin on both sides of its body, I have no doubt, no more than that the pipefish, which resembles an eel, has gone and helped itself to the vegetation of the seabed. I also believe that the kingfisher, which bears those brightly coloured feathers resembling scales on its throat and wings, acquired them from sitting and watching for its prey for hours on end, day in, day out. I have already indicated where the pheasant and the boa constrictor might have got their ellipses from, when I spoke about the eye markings on the tail feathers of the peacock.

Higher up, among the mammals, chemistry hardly suffices; the tiger has the small-leaved but long grass of the jungle down its flanks, and on its brow it bears a palm combined with a bamboo. The panther and the leopard reproduce the variegated shadows of the deciduous forest, while the lion has only the golden brown tones of the desert sand and the burnt rocks.

There can, of course, sometimes be other causes than the so-called chemical, but in the end they turn out just as mechanical. Thus the striped zebra lives on the plains. Shy by nature it is always ready to bound off, feeling the tigers claws in its tender hide, which it contracts into folds in order to find the speed to escape. The leopard has spots which may resemble the shadow of the foliage, but they are also deceptively like the footprints of a wet dog or cat. Could a pregnant female have once been in a fight, so branding her young, only for the spots to be found beautiful and preferred in selection? That is something which Darwin ought to have been able to say, even if he does deny such freestanding acts of creation, though not when he discusses the bull that lost its tail in the barn door and subsequently fathered a race of tailless cattle.

The role of chance in the origin of species!

That humming birds resemble flowers and flowers butterflies and other insects is well-known, of course, but how the death's head moth has acquired the skull upon its thorax no one perhaps knows.

I had never seen the 'Acherontia atropos', but had a suspicion that the reproductions in books were not exactly faithful. So I went and bought him from a dealer, only to discover that in reality the skull showed up far more clearly than in the illustrations. And then I read of him that the Bretons believe he betokens death; that he has a mournful singing cry; that his pupa is buried deep down in the ground; that the larva lives upon real jasmine, on beans and the beautiful but deadly thorn apple.

There was good deal for the imagination to be getting on with. The moth's burial ceremony, the funeral song, the poisonous food..., and in the midst of all this the beans, to all appearances so innocent, yet by the Danube a pious woman told me that beans were the heads of the dead, and I smiled, of course.

Reader! I have hitherto not been what one calls superstitious, but when, having amassed these details, I discovered that Réaumur, the famous physicist, had observed that this moth appears periodically and generally in conjunction with great plagues, I began to ponder if a connection might not be found between the skull on the thorax and the moth's habits.

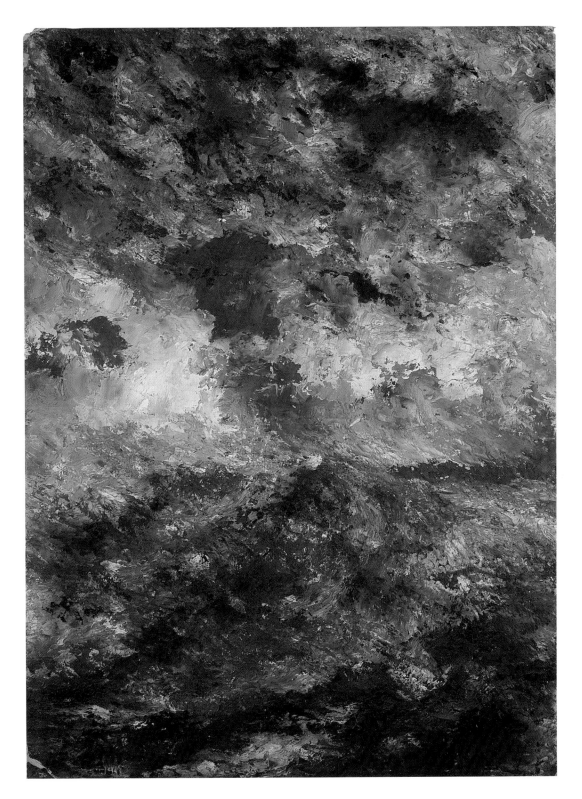

AUGUST STRINDBERG *High Sea*, 1894 (cat.82)

With that in mind, I put forward these premises as a starting point. The larva of 'Acherontia atropos' lives on the thorn apple, whose poison is called daturine and is said to be a mixture of atropine and hyoscyamine, the former from belladonna, the latter from henbane. Both these poisons are plant alkaloids, related to morphine, but also very similar to cadaverous poison. Cadaverous poison sometimes smells of jasmine (there's the jasmine!), rose, and musk.[2] There are carrion flowers ('Aroidaea', 'Stapelior', 'Orchis', and others), which smell of corpses, have the colour of corpses, and attract insects which otherwise seek out the carcasses of dead animals.

It is logical, then, for 'Acherontia' to be attracted to places where epidemics are raging, and corpses are to be found in abundance.

What is the origin of this moth, and from what kin?

His larva is very similar to the ordinary privet moth's, and he himself is so like this same moth that if one sees specimens of the two alongside each other the only noticeable difference is in size, a few nuances of colour, and the skull.

Since no one was present when 'Acherontia' was created, I am justified in making up this fairy-tale.

Once upon a time there was diurnal moth which lived on privet leaves, which are very innocent. But the privet leaves gave out in winter, and when the pupae hatched in the spring, there was nothing to eat. Since all moths are mighty botanists and recognize nature's families with the soles of their feet, they sought out lilacs, which are closely related to privet. But one day a moth flew astray in a region where no lilies were to be found and she laid her eggs on a plant which resembled the lilac in colour, but did not smell so pleasant. And then she died. When spring came, the larvae crept out and ate of the little tree of knowledge, of which they knew nothing. They spun their chrysalises and the moths came swarming out, all around the belladonna, where they had been born. But look, they could not longer bear the light of the sun, for the atropine had dilated their eyes so that they could not close them. And therefore they slept by day and only went out after the sun had set. This could have been the way nocturnal moths originated.

But when the privet moth began to eat of the thorn apple, he grew sleepy and slumbered all day, went out at night, but only before midnight. This made him fat and he began to grow, just like pigs in France, which are fed on the sleep-inducing seeds of the thorn apple. But when he left the delicious pink juice of the privet berries, he lost the pink stripes on his abdomen and grew as ugly as a drone.

When intoxicated by love and delirious from the poison, he did not always find the right poisonous plant, in spite of its flowers not emitting a fragrance until after seven o'clock in the evening, though its leaves stink throughout the day, and in the dark he was led to sites of carrion, to cemeteries perhaps, where there was nothing to light his way except bleached skulls, which was where he laid his eggs. The larvae ate carrion and solanine in turn, and when they were ready to

enter the chrysalis, they shunned the light and dug graves for themselves, for they had, of course, no inkling that they would be resurrected.

Given that no one knows what really happened when 'Acherontia atropos' was labelled poisonous, the way is open for all suppositions, mine included.

Since the above was written, I have read in Bernardin de St. Pierre that the death's head moth is called the Haïe in French because that is the sound it makes.

What sound? 'Ai!' The cry of pain among all peoples: The scream with which the sloth laments the pains of existence. The expression of loss which Apollo emitted after the death of his friend Hyacinthus, and which marks the flower that bears his name.

But there is another flower which bears this lament depicted at the base of its nectary, and which we all read as children, when we could barely read. That is the cyanic blue larkspur, which that consistent transformist Ovid says sprang from the earth where the blood of Ajax flowed.

Blood and cyanogen! Battlefields, cemeteries, cadaverous poison and death's heads! Ai!

But Bernardin de St. Pierre adds, quite scientifically: the flaky material from the wings of the death's head moth's is highly dangerous for the eyes.

I have examined this material, which consists of scales and hair, under a microscope. In the reagent it responded like a plant alkaloid, that is, like atropine, strychnine, etc, which is no stranger than that the sanderling ('Cicindela campestris') contains triethanol phosphine and that the Cantharides give cantharidine, which chemistry places among the alkaloids, immediately before digitalis.

If I now adopt a sceptical attitude towards these attempts at tracing the cause of the death's head appearing on the moth, the procedure is one with which I am quite familiar, having already had occasion to use it.

I start by saying: it is a freak of nature. A freak like the fact that the wasp builds its nest as an hexagonal, following the shape of its eye; like the fact that in bindweed the flower buds resemble the bracts of cereal; that a dog comes to resemble its master, as the master does his wife, and that Catarina von Emeritz gets the stigmata in her hands.

Morphologically-psychologically: the Sphinxes, to which Acheronia formerly belonged, are peculiar in that their larvae are able to withdraw their first segment and their head into the following segment, which is provided with spots that resemble eyes. Precisely why these creatures should have acquired protection for their eyes can, of course, depend upon the well-known effect of antropine on sight, but why has the rear segment, photographed the telescoped eye?

Atropine and morphine have been used as developers in photography!

Why do so many moths have eyes outlined on their wings?

What does the larva do in the chrysalis?

In scientific terms, the larva's tissues undergo a histolysis, that is to say, a fatty degeneration or phylogenetic necrobiosis. In translation: the larva goes through the same process in the chrysalis as a corpse in the grave, which is transformed into an ammoniacal fat.

Necrobiosis is in fact two words, of which the first means death and the second life. But according to the physiologists necrobiosis is the form of dying off that precedes casein degeneration (tubercularisation).

In short, the larva is dead in the chrysalis since it has lost all form and only consists of a lump of fat! But how can it live? How? It is dead, yet it lives! Perhaps there is no such thing as death? Perhaps the dead buried in their graves are not dead even though the doctors have certified 'livor mortis' and fatty degeneration.

There is a latent warmth which is cold, there is latent life in the seed though it looks as lifeless as a grain of sand and seems to have undergone an amyloid degeneration, there are forces that we do not feel, like the catalytic force in chemistry, where a body has a destructive effect merely through its presence, without it entering into any noticeable relationship with the body.

The larva dead in the chrysalis, but it lives and it rises up from the dead, not as a regression to some lower mineral or elementary matter but as a higher form, in beauty and freedom.

If this is merely a poetic image, then what is poetry worth?

A child asks: Where does the candle-flame go when it is extinguished? In the last century scientists would say that it returns to the primary light from whence it came. Our scientists, who pronounce energy indestructible, nevertheless say that it has ceased to exist!

Ceased to exist, to be perceived? But nothing can cease to exist.

Where did one moth get the eyes on its wings or the other the death's head on its thorax?

Trifling questions beside the great one, that larva is dead, physiologically, anatomically, completely dead scientifically, and yet it lives!

August Strindberg, 1895

1. That in Austria shimmering silver pearls are made from the bleak's scales shows that the scales have a metallic character of their own.

2. The genius 'Sphinx' among which the death's head moth was formerly accounted has species which smell of musk.

Translated by Michael Robinson

AUGUST STRINDBERG *Photogram of Crystallisation*, 1892-96.
Courtesy of the Royal Library Stockholm

AUGUST STRINDBERG *'Celestograph'*, C1894
Courtesy of the Royal Library, Stockholm

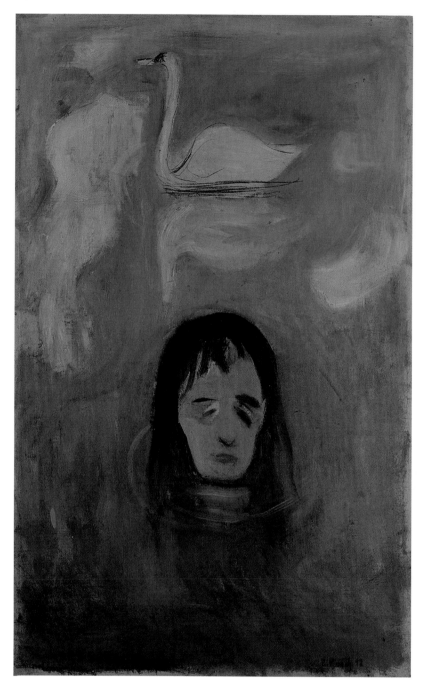

EDVARD MUNCH *Vision*, 1892 (cat. 59)

I WAS LYING IN MUD AMONG SLIME AND CREEPING THINGS – I YEARNED TO REACH THE SURFACE – I RAISED MY HEAD ABOVE THE WATER – AND THEN I SAW THE SWAN – ITS SHINY WHITENESS – I LONGED FOR ITS CLEAN LINES – I STRETCHED OUT MY HANDS TO REACH IT – IT APPROACHED, BUT NEVER CAME RIGHT UP TO ME – THEN I SAW MY REFLECTION IN THE WATER – OH, HOW SALLOW I LOOKED – WITH MUD IN MY EYES AND MUD IN MY HAIR – AND I REALISED WHY IT WAS SCARED – I WHO KNEW WHAT WAS TO BE FOUND BENEATH THE BRIGHT SURFACE COULD NOT BE UNITED WITH ONE WHO LIVED AMONG ILLUSIONS – THERE ON THE BRIGHT SURFACE WHICH REFLECTED THE PURE COLOURS OF THE AIR...

Edvard Munch (undated) (OKK 2782-ag)

From Arne Eggum *Edvard Munch: Paintings, Sketches and Studies*, Thames and Hudson, 1984

EDVARD MUNCH

(1863-1944)

THEATRE OF THE EYE

Strindberg is gone – A friend is gone...

At the end table in Schwarze Ferkel
surrounded by Germans Danes Swedes Finns
Norwegians and Russians – glowingly serenaded
by the young German poets...

And first performances of his plays –
The sentences fell like swordblows...
now like swords, now like daggers
– soon it seethed like the table wine –
glowing red glowing white dripping sweating
– burning all around him...
Inferno – and *Legends* –
Probably the most remarkable novels
since Raskolnikov

It began with *The Red Room* for us
Norwegians – the world that is named
Strindberg – the one who along with some
other writers contributed to make unrest –

Edvard Munch, 1912[1]

Much is made of the traces of Munch's relationship with Strindberg; the scant correspondence, Munch's rather poor portrait of Strindberg, the prints, the meetings, Dagny the shared woman. Not to mention the jealousy between the two and the unfortunate influence of Strindberg's misogyny.

What is significant is that Munch was evidently just as keen as Strindberg to make use of chance effect in his art; meeting him and discussing his ideas must have encouraged Munch in these practices, perhaps leading to an even greater freedom, a further loosening up. But it is also true that Munch's expressionist tendencies, have finally more to do with his desire to imbue pictures with greater meaning, to achieve some oneness with his subjects, than with spontaneity. He did, after all, in marked contrast to Strindberg, have a completely fixed idea of what he wanted to paint. The art historian Rudi Fuchs, in his recent book on Munch, has written of the artist's 'traditional understanding of art' which he believes precluded the experimental in favour of 'the meaningful *image*'.[2] Elsewhere, for instance in the recent Bergen exhibition *Deformation*,

I WALKED ALONG THE ROAD WITH TWO
FRIENDS – THE SUN WAS GOING DOWN
– I FELT SOMETHING LIKE A BREATH OF
MELANCHOLY. THE SKY WAS SUDDENLY
BLOOD-RED – I STOPPED, AND LENT
AGAINST THE FENCE, DEAD TIRED – I
SAW THE FLAMING CLOUDS LIKE BLOOD
AND A SWORD – THE BLUISH-BLACK
FJORD AND TOWN – MY FRIENDS
WALKED ON – I STOOD THERE,
TREMBLING WITH ANXIETY – AND I FELT
AS THOUGH NATURE WERE CONVULSED
BY A GREAT UNENDING SCREAM...

Edvard Munch, Nice, 1892 (OKKT 2636)

From Arne Eggum *Edvard Munch: Paintings,
Sketches and Studies*, Thames and Hudson, 1984

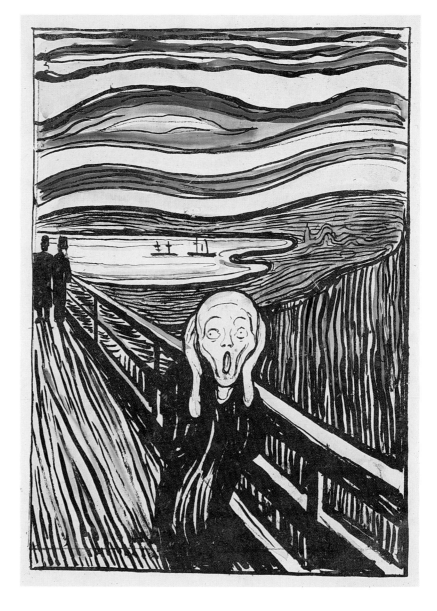

EDVARD MUNCH *The Scream*, 1895
(cat.60)

the exhibition curator, Øystein Loge, argues that Munch's distortions, his 'deformation', resulted from a profound personal response to the sublime in nature.[3]

Strindberg's influence is further signalled in Munch's aspirations as a writer and poet. In a curious exchange of personas, illustrative of the extent of their shared interests, Strindberg looked to painting as a way of reaching a deeper layer of meaning, whilst Munch writes in a staccato, stream of consciousness way that offers another outlet for his psyche, drawing threads between images. In 1896 Strindberg is thinking of illustrating his autobiographical account of his Paris period, *Inferno*, whilst only a year later Munch is toying with writing a novel, *Hell*.[4] The web of interconnections deepens; in 1896 Munch had acquired the original manuscript of Strindberg's auto-fiction, *A Madman's Defense* – his 'experimental psychological analysis' – and thereafter Munch begins to dream of writing his own *Diary of a Mad Poet*.[5]

Beyond this fragmented interchange, and the weaving of image and idea in its wake, there is a wider and more striking parallel that exists between Strindberg's overall project and Munch's

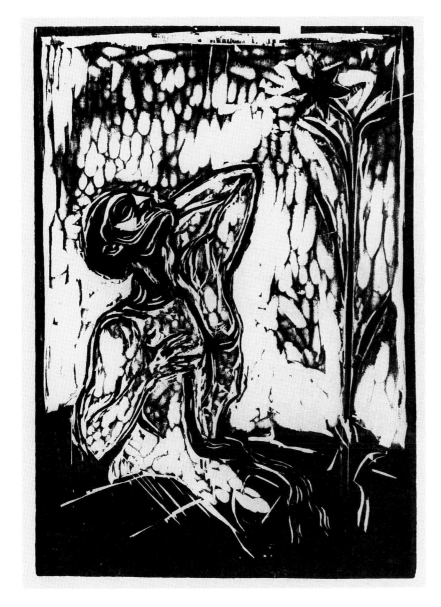

WHAT IS ART –
ART GROWS FROM JOY AND
SORROW – BUT MOSTLY
FROM SORROW –
IT GROWS FROM MAN'S LIFE –
IS ART A DESCRIPTION OF
THIS LIFE THIS MOVEMENT –
SHALL ONE DEPICT THE DIFFERENT
PLEASURES – THE DIFFERENT
MISFORTUNES – OR SHALL ONE
ONLY SEE THE FLOWER – WHOSE
NATURE SUBSTANCE AND VIBRATION
ARE DETERMINED BY
THE JOY AND THE PAIN –

I DO NOT BELIEVE IN THE KIND OF ART WHICH
HAS NOT FORCED ITS WAY OUT THROUGH
MAN'S NEED TO OPEN HIS HEART –
ALL ART LITERATURE AS WELL AS
MUSIC MUST BE CREATED WITH
ONE'S HEART BLOOD –

Edvard Munch, c1890-91 (OKK N 29)

From Bente Torjusen *Words and Images of Edvard Munch*, Thames and Hudson, 1989

EDVARD MUNCH *Blossom of Pain*, 1898 (cat.62)

visual programme. At the root of this is the 'self', the often fragile, fragmented interplay of memory and the unconscious, that is then countered by an interaction with nature in which a harmonious order and spirituality is sought.

In works such as *Encounter in Space*, 1898 (ill.p.51), and *Train Smoke*, 1900 (ill.p.52), as well as in many others to a greater or lesser degree, there is a poetry which tends to be over-shadowed by the psychological thrust, especially in the 1890s, of much of Munch's work. Later, after his nervous breakdown in 1908 Munch returns to an observed nature and seems to find some joy there.

Between these two worlds of the inner and the outer, the heart and the land, is the body; and in Munch's paintings this body is variously tremulous, erotic, aggressive, precarious, prone to inner forces; its skin pulled taut over a dynamic, pulsating centre. Self-portraiture is the arena of disclosure, and Munch parades the body as a vehicle to confront truth like Strindberg who proclaims 'a hazy desire to rip off one's clothes and go naked.'[6] Whereas the playwright had to

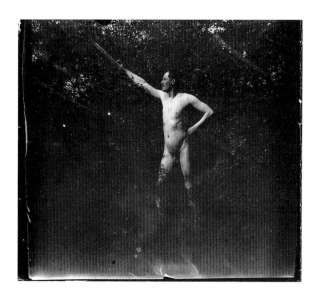

EDVARD MUNCH
Disclosing the self: *Munch at Åsgårdstrand*, 1904
Courtesy of The Munch Museum

find words to expose his innermost impulses, in Åsgårdstrand Munch actually did it.

Strindberg had written that his *'Inferno'* was concerned with 'our double existence, obsessions, our nocturnal existence, our bad conscience, our momentary baseless fears.' Munch's *Inheritance I*, 1897-99 (ill.p.49), an existential tour-de-force, mirrors Strindberg's aims exactly in its rekindling of childhood trauma and refracted self-portraiture – the eyes of the child are the artist's, as it asks; 'Why? – Why?.' The painting is reported to have resulted from a visit Munch made to a Paris hospital, but it is more than just the sum of its parts. Here, a broken straggly baby, exposed, syphilitic, the vivid raw spots a mark of its downfall. An inverted Madonna and child, a religious iconography too difficult for some people to take. And in it Munch's concentration on the eyes – a window to the interior, the focus of fear, the point where all feeling is concentrated.

A host of eyes stare out at us in *A Mysterious Stare* from Munch's *Tree of Knowledge of Good and Evil* (ill.p.56); 'the jealous one's... hateful and amorous' 'piercing' 'an essence.' Whereas in *The Vision*, 1892 (ill.p.44) the eyes are gouged out, bruised, redundant holes. As if Munch asks 'how are you then my negative image – there where my soul fits in.'[7] The painting, strangely hallucinatory, is an illustration of his desire to unmask an 'inner vision... on the other side of the eye.'[8] The swan variously symbolises sexuality, purity, beauty and light. All the smooth edges, the decoration, the fin-de-siècle twirls and posing of the European Symbolist School has been lost, to be replaced by Munch's rough handling. And the pool, the great Freudian sex-womb, almost smells in its rankness.

In another much later series of works from 1930 Munch is the artist-pathologist – echoes of Strindberg as 'poet-chemist' – scrutinising his own damaged eye (ill.p.58), visualising it and taking notes on its condition and changing character. The eye is now the great oscillating orb, with its hot white centre and orange concentric circles, an explosion of light, like the sun in his University mural from 1912. But these are needles of light, only to be transformed into the winged and hooked beak bird of Munch's imagination.

The autobiographical enterprise is of course a liberation, a catharsis. 'When I paint illness and vice it is a healthy release... a reaction from which one can learn and live', writes Munch[9] as he conjures up memories from the past to re-enact. Strindberg realised that his introspection and need to disclose, confess, was linked to 'Christianity's individualism, with its eternal burrowing into the self and its imperfections.'[10] It is no surprise then that both he and Munch came from strict pietist backgrounds.

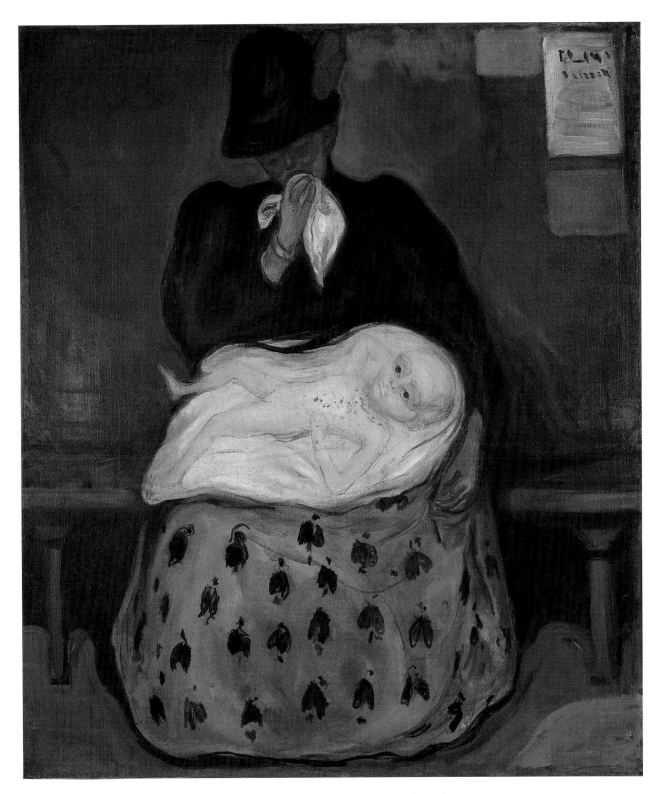

EDVARD MUNCH *Inheritance I*, 1897-99 (cat.61)

THE CHILD'S BIG EYES PEER INTO THE WORLD IT HAS UNINTENTIONALLY ENTERED — SICK AND FEARFUL AND INQUIRING IT STARES AHEAD, SURPRISED AT THE PAINFUL LIFE IT HAS ENTERED UPON, ALREADY ASKING WHY? — WHY?

Edvard Munch, c1897

From Arne Eggum *Edvard Munch: Paintings, Sketches and Studies*,
Thames and Hudson, 1984

EDVARD MUNCH *Mystery on the Shore/The Stump*, 1899 (cat.65)

DOWN HERE ON THE BEACH I SEEM TO FIND AN IMAGE OF MY SELF — OF MY LIFE ...

WAY WAY OUT THERE — THE SOFT LINE WHERE AIR MEETS OCEAN — IT IS INCOMPREHENSIBLE — AS EXISTENCE —

INCOMPREHENSIBLE AS DEATH — ETERNAL AS LONGING

Edvard Munch, 1892 (OKK T 2782-j)

From Bente Torjusen *Words and Images of Edvard Munch*,
Thames and Hudson, 1989

EDVARD MUNCH *Encounter in Space*, 1899 (cat.64)

HUMAN DESTINIES
ARE LIKE PLANETS –
WHICH MOVE IN SPACE
AND CROSS
EACH OTHERS' ORBITS –
– A PAIR OF STARS
THAT ARE DESTINED
FOR EACH OTHER

BARELY TOUCH ONE ANOTHER
AND THEN VANISH
EACH IN THEIR DIRECTION
IN THE VAST SPACE –
AMONG THE MILLIONS
OF STARS THERE ARE
ONLY FEW
WHOSE COURSES COINCIDE –

SO AS TO BECOME
ABSORBED COMPLETELY
IN ONE ANOTHER
IN SHINING FLAMES...

Edvard Munch, Paris 1896 (OKK T 2601)

From Bente Torjusen *Words and Images of Edvard Munch*, Thames and Hudson, 1989

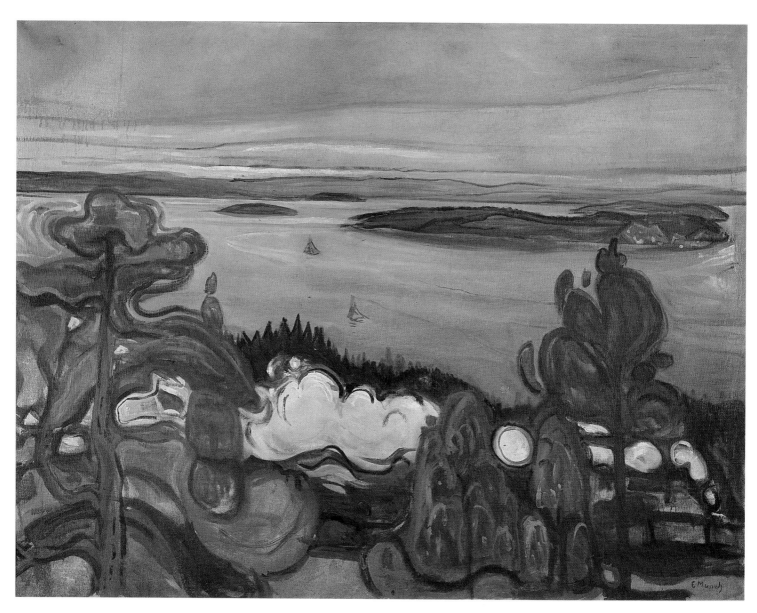

EDVARD MUNCH *Train Smoke*, 1900 (cat.66)

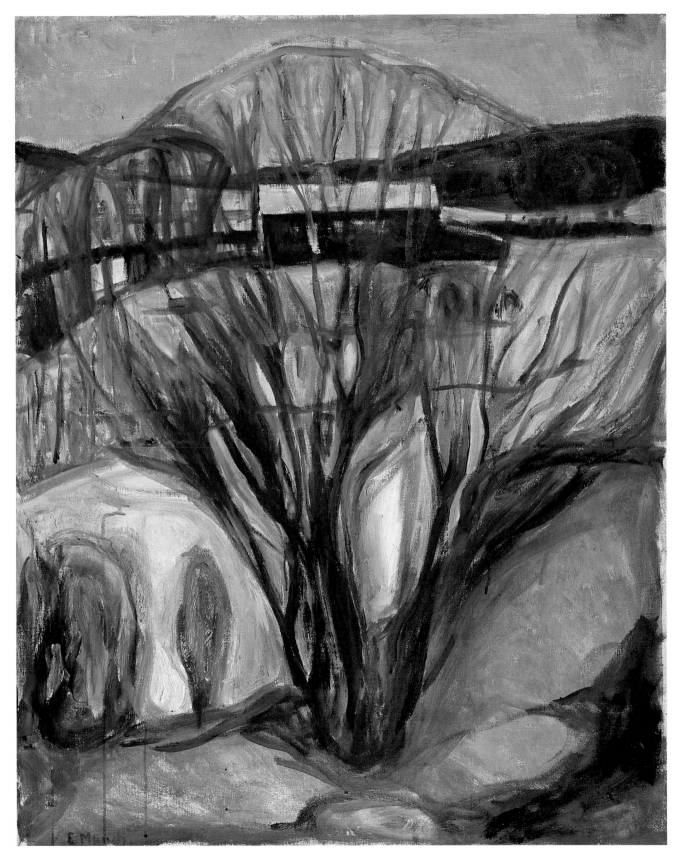

EDVARD MUNCH *Winter Night, Ekely*, 1931 (cat.72)

Fuchs understood the closed, limited repertoire of Munch's images to be the result of his isolation, his life within and surrounded by his paintings. He writes that for Munch 'painting was close to life itself. He lived *within* that life'. But is it not, at least in part, that the same questions of fear and longing are never fully resolved, and that painting provides a necessary point of mediation with the world, and with oneself.

The claustraphobic *By the Death Bed (Death Struggle)*, *c*1915 (ill.opp), is a subject which Munch drew and repainted on a number of occasions. The painting feels like an 'out of body experience', reflecting the sort of objectification that Nietzsche had described as 'the art of staging and watching ourselves'.[11] Munch's writings on his early illness confirm this: 'He crawled out to his father as if to seek protection... He coughed again and more blood came up... He felt the blood rattle in his chest... Jesus Christ Jesus Christ.'[12]

There is about *Death Struggle* something of Munch's later studies of his own damaged eye, with their concentration upon abstract optical colour floating on the pupil. The wallpaper is here like no other, so far removed has it become from reality; floods of psychedelic colour clot in great surging movements across the wall, all edges and corners disappearing under this mass of blotches. The red circles round the eyes of the mother are replicated in the jar by the bed, the head of the child and finally onto the wall, dispersing, multiplying like bruised skin, jam swimming in custard.

Looking at the world with the 'inner' eye, and a heightened sensory awareness had meant casting aside the tired naturalistic project, and finding new means of expression. By the time Munch and Strindberg had met, Munch had already made a break, via Hans Jaeger and the Kristiania Bohême, for a symbolic expressionism, taking on board their commandment that 'thou should write ones life.'[13] *Vision* was painted in 1892, the same year as Strindberg's *Burn-Beaten Land*, and shown at the infamous Berlin Artists Association exhibition that had made Munch the talk of the town. Although completely different in subject and treatment both are similarly radical.

By the early 1890s both men were struggling toward a metaphysical understanding of nature and existence, a cohesive structure. Strindberg in his 'Inferno crisis' dissected nature in the hope of putting it back together again, whole and beautiful. In Munch's *Vision* the essential duality of darkness and light, inside and out, is brought into play; here the artist is still submerged 'in mud among slime and creeping things' longing for the surface where he sees a swan, unobtainable and distant in its 'shiny whiteness' and 'clean lines.'

As Strindberg entered the climax of his 'Inferno crisis' in 1896, finding his God 'the great artist', Munch was beginning his adventure with woodcuts. It is as though Munch's great mastery of the woodblock took him back out into the open, into the light that is Strindberg's '*Wonderland*'. In Paris he had become familiar with the work of the 'savage' Gauguin, among other innovators of the medium and during the mid-to-late 1890s he goes on to create a unique body of work. Printmaking, especially the woodcuts, with their vastly simplified means of expression appear to have given Munch a fresh outlook, and to some extent an opportunity of breaking with the past. As a practitioner, printmaking allowed him to integrate his poetic sensibility in a wholly modern way.

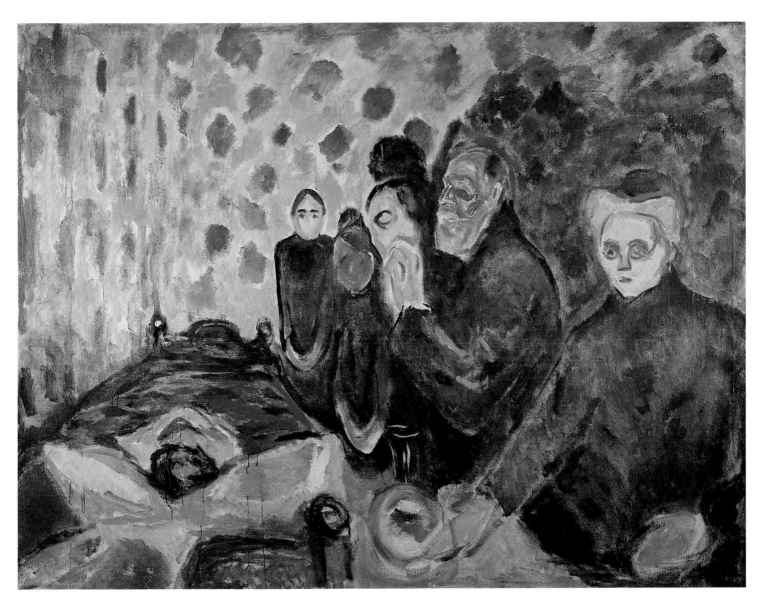

EDVARD MUNCH *By the Deathbed (Death Struggle)*, *c*1915 (cat.69)

SICKNESS AND INSANITY AND DEATH WERE THE BLACK ANGELS THAT HOVERED OVER MY CRADLE.

Edvard Munch (OKK T2759)

From R. E. Schreiner *Edvard Munch as we knew him* , Oslo, 1976

also, Ragna Stang *Edvard Munch*, Gordon Fraser, 1979

A MYSTERIOUS STARE OF THE JEALOUS
IN THESE TWO MADLY STABBING EYES
ARE CONCENTRATED AS
IN A CRYSTAL MANY RE-
FLECTIONS. – THE GLANCE IS
SEARCHING INTERESTED
HATEFUL AND AMOR-
OUS AN ESSENCE
OF HER WHOM THEY
ALL HAVE IN COMMON

Edvard Munch, c1912-15 OKK T 2547-a43

From Gerd Woll 'The Tree of
Knowledge of Good and evil' in Edvard Munch
Symbols and Images, Washington, 1978

EDVARD MUNCH *'A Mysterious Stare',
page from 'The Tree of Knowledge of Good
and Evil'*, *c1912-15* (cat.68)

Two Women on the Shore, 1898 (ill.p.2), and *Encounter in Space*, 1899 (ill.p.51), are each fine examples of Munch's total control and enjoyment of the woodcut medium. Art historians have often commented that woodcuts allowed Munch to utilise a full black to great melancholic effect, but this is off-set by his evident joy in the play of large expanses of pure colour. It is difficult to conceive that Munch could have in 1899 *painted* an image like *Encounter in Space*, where bodies become planets crossing in space and time and spermatozoa drift through a nocturnal void.

Resonances here of Strindberg peering into the night sky, thinking that he too might be able to somehow capture the mystery of space.

Fuchs believes that pre-1908 Munch suppressed light in his art, and argues that the post-mental breakdown years are when Munch comes truly into his own, as his experience of the real world allows light and feeling to flood into the pictures, transcending the psychological and the static symbolic use of motifs.[14] A related position is taken by Carla Lathe in her study of

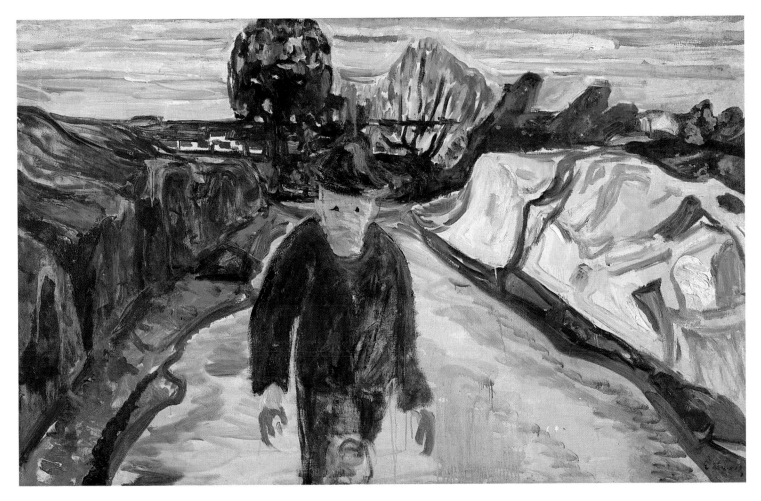

EDVARD MUNCH *The Murderer*, 1910 (cat.67)

We have an old proverb: There are many things hidden in Nature. For the attentive, searching man of today, fewer and fewer of these secrets remain hidden. One after another they are being brought forth for observation and identification. An increasing number of people who lead mental lives of great intensity, people who are sensitive by nature, notice the steadily more frequent appearance in them of mental states of great strangeness. It might be something completely inexplicable – a wordless and irrational feeling of ecstasy; or a breath of psychic pain; a sense of being spoken to from afar, from the sky, or the sea; an agonisingly developed sense of hearing which can cause one to wince at the murmering of unseen atoms; an unnatural staring into the heart of some closed kingdom suddenly and briefly revealed; an intuition of some approaching danger in the midst of a carefree hour...

Knut Hamsun, *From the Unconscious Life of the Mind*, published in Samtiden, 1890

EDVARD MUNCH *The Artist's Eye and
Threatening Figure of a Bird's Head,*
1930 (cat.71)

EDVARD MUNCH *Abstract, Optical Illusions from the Eye Disease,* 1930 (cat.70)

Munch's Berlin years, in which she writes of the 'myth' that surrounds Munch – the concentration on the bleaker existential aspects of his art at the expense of the lyrical.[15]

Munch's *The Murderer,* 1910 (ill.p.57) painted when Munch was supposedly enjoying the recuperative pleasures of Kragerø, presents us then with something of a conundrum, the same puzzle which is perhaps to a lesser extent posed by *Winter Night, Ekely,* 1931. Clearly neither picture, although partly modelled on nature, could be described as having been painted by someone totally at one with themselves and their surroundings. As well as confronting himself with his paintings, the images continually apprehend us, the onlooker; the great centre which Munch employs again and again, the lunging figure of the *Murderer* a classic example. This painting is in a sense a replay of *The Scream* (ill.p.46), only this time all passions, all anxiety, is trapped in the figure itself. The staring eyes of the child in *Inheritance* have become the black holes in the green mask; the dark unfathomable other which is the self. And in *Winter Night, Ekely,* 1931, the swollen looming presence of the tree could almost be Munch in yet another one of his guises.

The combination of acid colours, the exploding bush, the wild lime and violet streaked sky, the crazed brushwork, makes this one of Munch's most Expressionist works. One might be tempted to think that Munch was trying us out with a touch of irony here but the hands, like molten propelling claws, suggest otherwise.

The respective journeys of Munch and Strindberg draw to a close, both confronted by the mortality they had previously dreaded; Strindberg withdraws 'into the silence and purity of the printed word'[16] and Munch leads a precarious, isolated existence at Ekely. Fuchs has eloquently

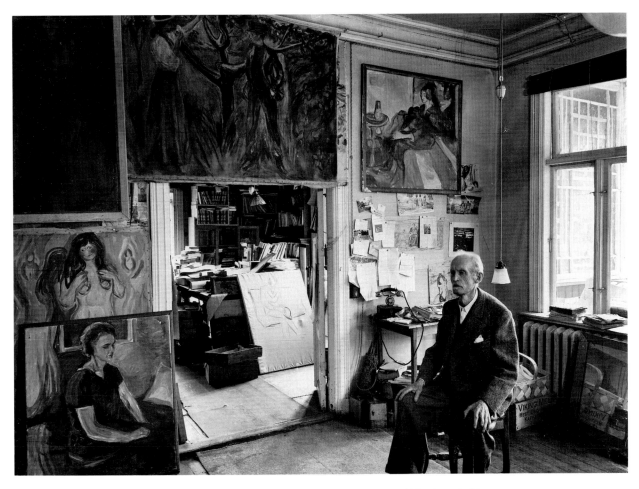

Edvard Munch in his studio at Ekely, 1943. Courtesy of The Munch Museum

described Munch 'enshrined in the studio that has now become his world, as well as the space of his mind' where he conducts an 'intimate dialogue with his life's work.'[17]

The most striking aspect of Munch's two late self-portraits (ill.pp.60-61) is that the artist seems to have already left his body. He is just a shell, an after-image, a shadow. The eyes a faint touch of brush on canvas.

(JA)

1. Quoted by Bente Torjusen *Words and Images of Edvard Munch*, Thames and Hudson, 1989, p.23

2. Rudi Fuchs *Munch*, Edition Bløndal (Format series), 1991,p.36

3. For instance on p.66 where Loge writes; 'the conception of the sublime inspired deformation. Deformation in art is an escalation of the aesthetic of the sublime. Like the sublime emerged as the antithesis of the beautiful, deformation is antithetical to classical ideas such as order and rationality.' Published by Bergen Billedgalleri/Dreyer, 1991

4. See Torjusen, op cit, p.28

5. Ibid.p.27

6. Quoted by Michael Robinson *Strindberg and Autobiography*, Norvik Press, 1986, p.14

7. Quoted in Torjusen, op cit, p.13

8. Warnemünde, 1907-8. Quoted in Torjusen, ibid, p.43

9. Quoted in Ragna Stang *Edvard Munch: The Man and the Artist*, Gordon Fraser, 1979, p.52

10. Quoted by Robinson, op cit, p.3

11. From *The Gay Science*. Quoted in Robinson, ibid, p.3

12. Quoted by Torjusen, op cit, p.55

13. One of the Kristiania Bohême's ten commandments.

14. See Fuchs, *Munch*, op cit

15. Carla Lathe 'Munch and the Berlin Art World', in *Facets of European Modernism*, Norvik Press, 1985

16. Robinson, op cit, p.71

17. Fuchs, op cit, p.17

OKK. no. that follows Munch texts is the ref. no. of the document in The Munch Museum, Oslo

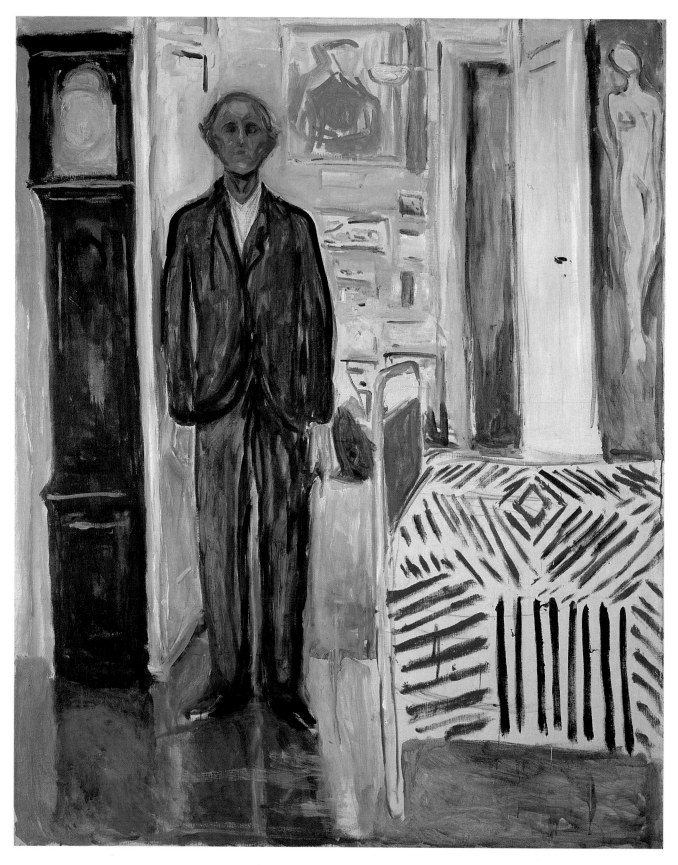

EDVARD MUNCH *Self-portrait between the Clock and the Bed*, 1940-43 (cat.73)

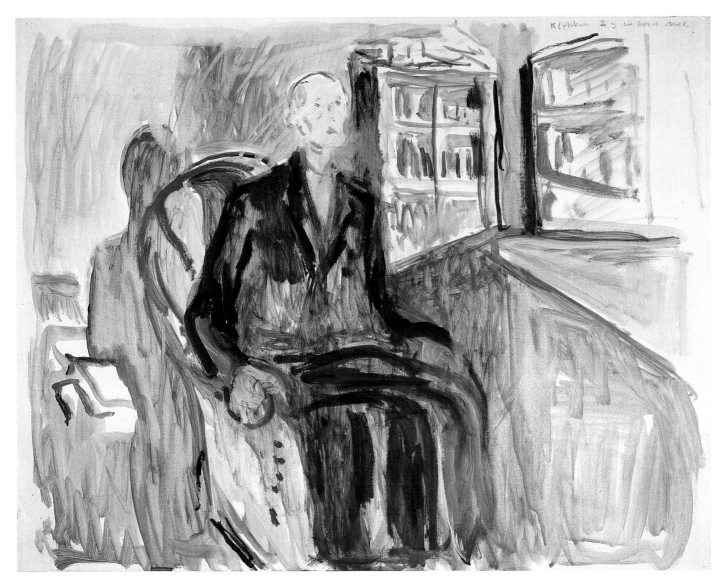

EDVARD MUNCH *Self-portrait at 2.15am*, 1940-44 (cat.74)

NOTHING IS SMALL NOTHING IS GREAT —
INSIDE US ARE WORLDS. WHAT IS SMALL
DIVIDES ITSELF INTO
WHAT IS GREAT THE GREAT INTO THE SMALL —
A DROP OF BLOOD A WORLD WITH ITS SOLAR
CENTRE AND PLANETS. THE OCEAN A DROP A
SMALL PART OF A BODY —
GOD IS IN US AND WE ARE IN GOD.
PRIMEVAL LIGHT IS EVERYWHERE AND GOES
WHERE LIFE IS — EVERYTHING IS MOVEMENT AND
LIGHT —

CRYSTALS ARE BORN AND SHAPED LIKE
CHILDREN
IN THE WOMB. EVEN IN THE HARD STONE BURNS
THE FIRE OF LIFE
DEATH IS THE BEGINNING OF LIFE — OF A NEW
CRYSTALLISATION
WE DO NOT DIE, THE WORLD DIES AWAY FROM
US
DEATH IS THE LOVE-ACT OF LIFE PAIN IS THE
FRIEND OF JOY
TO A WOMAN

I AM LIKE A SLEEPWALKER
WHO WALKS ON THE RIDGE OF A ROOF DO NOT
WAKE ME BRUTALLY OR I SHALL FALL DOWN AND
BE CRUSHED

From Edvard Munch's, 'The Tree of Knowledge of Good
and Evil' c1913-15, Munch Museum, Oslo (OKK T 2547-A31)

Translation in Sarah Epstein *The Prints of Edvard Munch:
Mirror of his Life*, Ohio, 1983

TYKO SALLINEN
(1879-1955)

Tyko Sallinen was an enigmatic character. There is little that gives us a real key to his way of thinking, and what we have leaves the impression of a man that was stubbornly rebellious, restless and independent – all the traits that no doubt encouraged him towards the radical currents of his time. Like Hill, Strindberg and Munch, Sallinen travelled southward to absorb what was happening in the centres of artistic activity, where he felt similarly encouraged to break new ground. But in the end Sallinen's paintings, as with those of these other figures, are coloured more by his own background than influences from abroad.

Sallinen's encounter with Fauvism liberated the possibilities of pure colour for him. Coupled with direct and forceful handling of paint, it added a vivid energy to his work. But what Sallinen came up with was a palette that shows a greater preponderance for intense almost unworldly blues and crystal whites; a range far removed from the warmer, sensual and oriental colouration of Matisse, and hardly the *joie de vivre* of Impressionism.

While his use of bold colour adds a feeling of life and even joy to some of his paintings, Sallinen can also use it to achieve an expressive effect of another kind. In his *Mirri in Green* 1911 (ill.opp.) for example, intensity of colour adds to the effect of this disquieting portrait. Mirri stares out of the picture away from us. There is no engagement, no indication of what she might be feeling or thinking, just her awkward pose, shoulders drawn back, her hair wound around her ears. The painting is raw and has a forceful directness that is alleviated only by the nuance of light falling across her shoulders.

Mirri in Green reminds us of Munch's more expressionist works in its free brushwork and pure colour. The strong blue of the background heightens the sensation of Mirri's forward movement, reminiscent of Munch's *The Murderer* 1910 (ill.p.57). While by no means so extreme as Munch's masked portrayal or his own self-portrait, Mirri's face is also reduced to the barest of features, becoming just the darker points of her eyes, nostrils and half open mouth. Undoubtedly Sallinen, like Munch, projects his own emotions and feelings into the painting and, as Leena Ahtola-Moorhouse points out, there is here an ambivalence. With sensual, delicate modulations of colour Sallinen gives almost a blush to Mirri's cheeks, and this combination of aggression and sensitivity leaves Mirri looking uncertain, vulnerable and exposed.

Sallinen's landscapes reveal a greater optimism. In the *Rainbow*, 1914 (ill.p.64) Sallinen paints a heightened, transient moment when nature's light and drama is most evident. The rainbow is emblazened across the sky, its pure colours reflected on the trees and the land. *Early Spring*, 1914, with its extreme contrasts and energised sky, reflects something of the intensity of Sallinen's desire to reveal the true character of his home country, Finland. Here, as in the *Rainbow*, his vigorous handling bears a relationship with both Strindberg and Hill's seascapes, where the same textured impasto and exuberant strokes are evident. (CB)

TYKO SALLINEN *Mirri in Green*, 1911 (cat.75)

TYKO SALLINEN *Rainbow*, 1914 (cat.77)

A STARK SENSITIVITY

LEENA AHTOLA-MOORHOUSE

Tyko Sallinen has a dominant role in the Finnish art of the 1910s and early 1920s. He became a figurehead for young artists, who strove to challenge the idealistic and heroic approach of the preceding generation, and show both the essence of painting and the real character of the people and landscape of Finland. These young artists mainly descended from common people, like Sallinen, who was a tailor's son and himself was able to earn his living with a needle when necessary.

He embodied both roughness and sensitivity. According to his biographers[1] he lived ascetically, but had occasional violent drinking bouts with his fellow artists. His ambiguous and passionate character reveals itself most openly in the portrayals of his first wife, Mirri. These paintings show at the same time a brutality and a tenderness, reflecting his own complex virile attitude to Mirri by exaggerating her fleshy and animalistic features. She was a fellow artist whom he had met at the Drawing School of the Finnish Art Society and fallen in love with. His tenderness towards her is apparent in the delicacy of colour juxtapositions and touch, although the scale is almost always cool. Indeed, the most striking of his colourist paintings are those which embody Mirri in some way, particularly the sensuous nudes of 1910 and 1911, with their distinct rose, white and violet hues that are subtly tender.

Sallinen was born into a family of extreme religious fanaticism and had a difficult relationship with his authoritarian father. He fled from home at the age of fourteen to become a roaming tailor's apprentice, staying in Stockholm for four years' where he visited its art museums and saw the large International Art and Industry Exhibition in 1897. He also lived in Denmark in 1904-05 while training in art and became acquainted with the Danish tailor, Rydeng, who was later to act as host for many other Finnish Expressionist painters in his Helsingör workshop. Altogether Sallinen's development was not easy, and when he made his artistic breakthrough in 1912, he was already quite mature in age. That year, he exhibited a group of paintings at the annual Finnish Art Society's spring exhibition which aroused tremendous public anger; his large raucous canvas *Washerwomen*, 1911, a particular target of outrage.

The work of Edvard Munch, which was shown in 1909 and 1911 in Helsinki, had a liberating effect on his art; likewise a sojourn of nine months in Paris with his newly-wed wife from the spring of 1909. The Fauvist painters, in particular Matisse and Kees van Dongen, made a significant impression on him. Sallinen abandoned his synthesist style in favour of crisp, cool, pure colour pigments and their special fresco-like effects, with translucent paint layered and scraped onto a rough canvas. *Mirri in Green* 1911 (ill.p.63) is a beautiful example of these new colourist discoveries.

His tempestuous character led him to attempt earning a living in Michigan, America, in 1912-13. The move was a mistake and he returned in autumn 1913 to his wife, whereupon he made an agreement with a young art dealer and reporter Gösta Stenman, who agreed to pay him a monthly salary in return for everything that he was able to paint. In 1914 he travelled again to France and very sucessfully exhibited in Helsinki and Malmö. *Early Spring* and *Rainbow* (ill.opp.) are both from this very fruitful year. *Early Spring* was painted in Finland with harsh and crisp gusto, whereas *Rainbow*, painted in Brittany's warmer climate, is more varied in colour. Both are reminiscent of Van Gogh's brushwork.

It was during this period of the 1910s that Sallinen was to make his best work, and by the late 1920s his dynamic power had already faded. His palette began to reflect sombre earth colours in 1916 as Cubism superseded Fauvistic fervour taking him in a quite different direction.

1. Aaro Hellaakoski, *T. K. Sallinen* Tutkielma, Hämeenlinna, 1921; Tito Colliander, *T. K. Sallinen*, Helsinki, 1949; reprint 1979 with new colour illustrations; L. Bäcksbacka, *T. K. Sallinen*, Hans studieår och koloristiska genombrott 1905-14, Helsingfors

EDVARD WEIE

(1879-1943)

POINT OF PASSAGE

Virgil being led across treacherous waters to Hades or Hell. This is the grand theme which Weie takes up in *Dante and Virgil in the Underworld*, (ill.p.73), painted after Delacroix, one of the great masters of Romanticism. Here, the three figures of Dante, Virgil and Phlegias, have been all but virtually absorbed into the painting, their only semblance passages of colour – warm yellows and earth reds engulfed in shadowy browns and indigo blue, formed from fluid brushstrokes in rhythmic, contrapuntal movement.

The whole has the translucence of a watercolour, yet it also has the turbulence, density and swirling movement of a Baroque painting and the plunging darkness of Delacroix's original. It has the air of a painting that is unfinished but which nevertheless has arrived at a crucial point, a moment of poise in a wider drama.

Painted between 1930 and 1935, this version on the theme of Dante and Virgil was made late on in Weie's career, at a high point when he was in his fifties, and was completed perhaps as little as eight years before his death. It is the last of the four paintings by Weie that are included in *Border Crossings* which together trace a particular path in his artistic development and chart the themes that pre-occupied him through his life.

Weie, though little acknowledged outside Scandinavia, has long been recognised as a key figure of early modernism in Denmark. His painting developed from an initial naturalism to become increasingly expressive, all the while moving toward richer and purer colour. Until recent years, Weie's work had been discussed primarily in terms of a reduction to essential formal elements and to clear planes of lighter, joyous colour; the harmonious culmination of a modern aesthetic. However, while such stylistic changes are undoubtedly there, particularly in his still lives and radiant landscapes, to concentrate upon these rather than his more turbulent figure compositions is to ignore the ideas and personal tensions that underpinned Weie's aims as an artist. As Per Kirkeby has commented, by carefully avoiding the motifs of his work, critics '...have skirted the real tension in Weie's art and a strange tame savouring of colour has become the appurtenance of his art.'[1]

Lennart Gottlieb took the opportunity to revise the traditional perspective of Weie on the occasion of the major retrospective of his work at the Statens Museum for Kunst, Copenhagen in 1987. Here Gottlieb examined in greater depth the pointer given by Kirkeby,

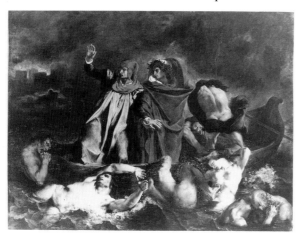

EUGENE DELACROIX *Dante and Virgil* 1822
Courtesy Musées Nationaux, Paris

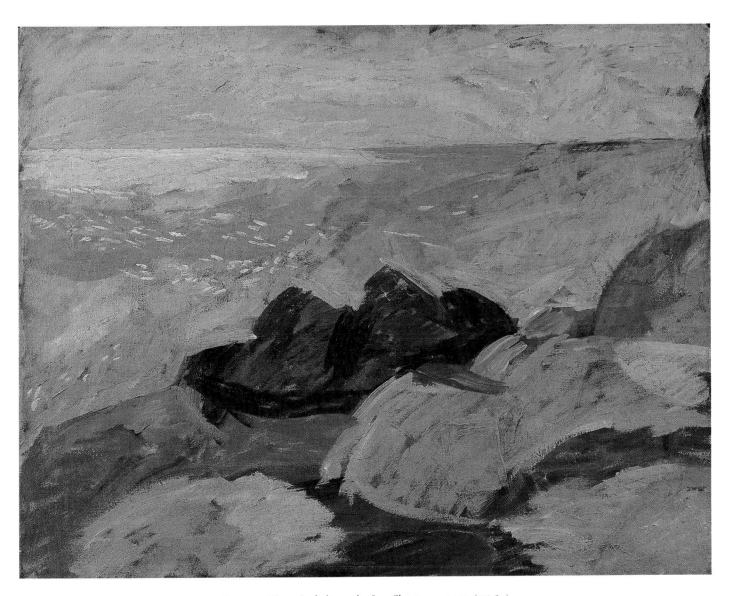

EDVARD WEIE *Sunlight on the Sea, Christiansø*, 1913 (cat.84)

EDVARD WEIE *Faun and Nymph*, 1940-41
Statens Museum for Kunst, Copenhagen

and made a claim for the underlying human aspects of Weie's art, stressing the need to focus on the meaning of the image itself.[2]

The position becomes clearer if we consider Weie's high regard for Cézanne. While he must have inspired Weie toward a use of pure colour and structured form, it is highly significant that it was Cézanne's darker, more impassioned paintings made before 1872 that Weie clearly looked to. It was in this early period that Cézanne had copied Delacroix's Dante and Virgil in the Louvre and was painting other romantic works. Lawrence Gowing's description of Cézanne's approach at the time is illuminating when taken in relation to Weie, pointing to the sensibilities and emotional strains that also emerge in his painting:

'Cézanne's work found shadow while other painters... sought light. Its emotional expression was often grievous. Death and mourning were its common states. Love in it was inseparable from violence... Its portrayal of his world ...seemingly haunted by a spirit that is unexplained. Its movements writhed like snakes.'[3]

And to know that Weie's most famous painting, his *Faun and Nymph* of 1940-41 (ill. above), often seen as the harmonious culmination of his career, is based on Cézanne's *The Rape*, c.1867, where violence and eroticism are closely entwined, surely shifts our perception. Kirkeby has noted that Weie here finds his way out of the shadows of Cézanne's original,[4] and so transforms the painting into a glorious open network of colour. Yet even if seen as an optimistic passage, bathed in light, the underlying theme nevertheless remains in essence romantic – a portrayal of the struggle between life and death.

If Cézanne was able to set such imagination on one side, sublimating his energy within a more controlled and rational objectivity (describing his later method as one 'based on hatred of the imaginative'[5]), Weie was never quite able to leave it – despite his fine paintings of the Langelinie, a harbour promenade in Copenhagen, imbued with the light and the cool greens of summer. Indeed, late on in life, Weie was to see the many landscapes and still lives that he painted as a sideline, a commercial divergence from what he felt were his most significant endeavours – his figure compositions on literary and mythological themes in the grand tradition, 'painted from the imagination'. And it is here that Weie's true spirit comes to the fore.

Weie seems to have been driven by the need to reach ultimate clarity in his paintings. His constant re-working of sublime themes, his dissatisfaction with his own work, revising, even cutting up his canvases and re-shaping them into new configurations, testify to the restless tension that finds expression in his work and which seems never to have been finally resolved. Uncertainty and doubt remained with him to the end of his life.

Weie's earliest works were grounded in a traditional naturalism and have a feeling of density

and sense of enclosure that was to continue for some years. It was only following his return from a three month stay in Italy that Weie's characteristic deep olive greens and earthy reds began to lighten and that he handled paint with a greater freedom of touch. From 1911 he began spending the summer months painting from nature on the island of Christiansø where he met, amongst others, the painter, Karl Isakson,[6] whose own interpretations of Cézanne must have left a strong impression on him. Weie travelled that year too, to Paris, but suffering one of the periods of acute depression that were to plague him through his life, he was forced to return to hospital in Denmark. By all accounts a difficult man, self-centred and hyper-sensitive, it is hard not to feel that his own suffering and inner struggles, to some extent at least, directed the dialogue with his chosen medium.

It was on the island of Christiansø that Weie painted *Sunlight on the Sea*, 1913 (ill.p.67), which reflects his more expressive and rhythmic brushwork of the time, presaging the tense energy of later paintings. More textural and impasted, this work is a reminder, in handling as much as subject, of Strindberg's *The Shore*, 1894 (ill.p.39), and Hill's *The Beach, Luc-sur-Mer*, 1876 (ill.p.18). A pool of brilliant sunlight almost dissolves the distant horizon and glimmers across the water, in contrast to shadowed sea and land; despite its light, the work has a note of melancholy.

Nature continued to be of profound importance to Weie and he never lost his belief in it as a vital basis for art. Yet he also strove toward a higher achievement: to give visual form to the irrational and what he felt was the spiritual essence of reality. That he looked to classical mythology, to literature, and the painters before him to do this, in what must at the time have been a highly unmodern approach, marks above all, the scale of his ambition.

Weie had already begun working with such subjects, destroying his first major Arcadian landscape, but going on to paint a number of canvases inspired in part by Turgenev's *Two Brothers* in which 'love' and 'hunger' in the novel are transposed to night and day, or life and death, embodied by two male nudes on the classical model. Weie also began working with the theme of Poseidon while on Christiansø, and in *Poseidon Rushing over the Sea surrounded by Nereids and Tritons*, 1917 (ill.p.70), Weie's pre-occupation with the human body tested by, and in conflict with the turbulent forces of nature comes into full force. With the same firm and impasto-like use of materials as in his earlier seascape, his fleshy creams and dense greens, Weie now creates a dynamic space filled with figures tossed by a churning sea.

Here Weie turned to Rubens[7] and to Böcklin[8] for inspiration; to their sensuous and surging energy, and their passionate paintings that, at heart, concerned human destiny. His choice of Böcklin as a model, unfashionable as it was at the time, points to an affinity with Munch, who, among the outstanding figures of the period, selected Böcklin as being 'high above all contemporary painters.'[9] Strindberg, too, was drawn to Böcklin, particularly his painting *The Isle of the Dead*, 1880, which prompted him to say: 'Death is only the gateway into a new form of existence for man, who in the Isle of the Dead finds peace and deliverance from the dualism and darkness of his own earthly soul... from the animal and the animalistic, from the flesh and the fleshly.'[10] Strindberg here touches upon a major theme on the grand scale that Weie, with his high aims, also felt bound to deal with.

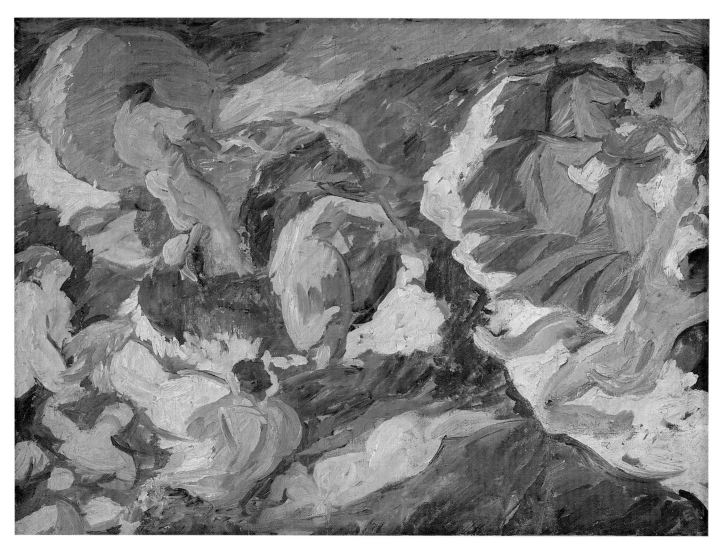

EDVARD WEIE *Poseidon Rushing over the Sea surrounded by Nereids and Tritons*, 1917 (cat.85)

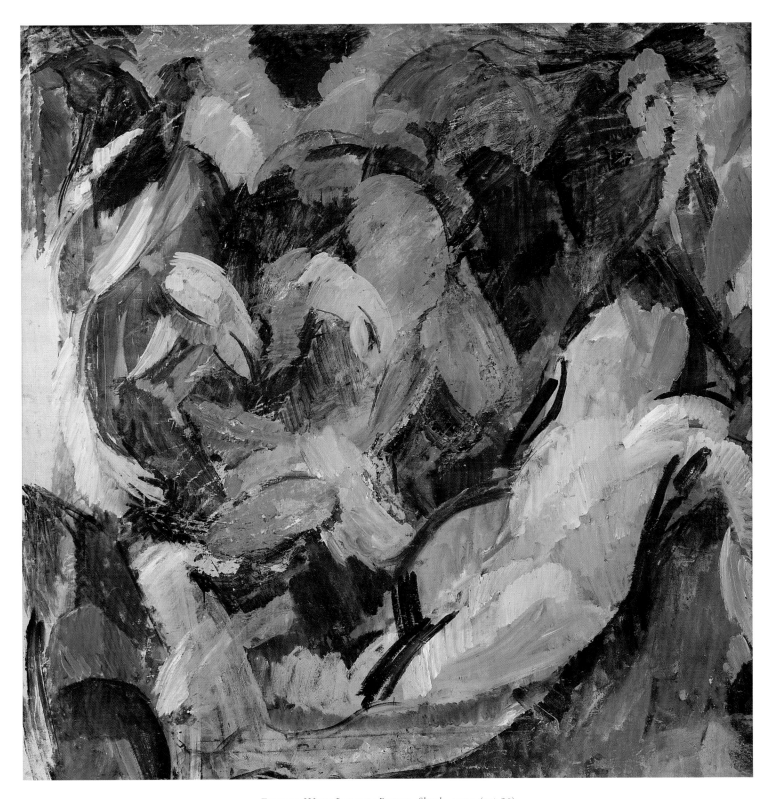

EDVARD WEIE *Romantic Fantasy, Sketch*, 1920 (cat.86)

By the time Weie had reached the conclusion of his Poseidon series figure and sea were barely separate entities. The spiralling movement and fragmented chaos that he created in *Nereids and Titons* is taken a step further in the *Romantic Fantasy* of 1920 (ill.p.71). Here a nude female figure and surrounding abundant nature are closely integrated into layers of loosely hatched paint. The whole is energised by inflexions of colour and rhythmic strokes creating a romantic idyll that is riven with conflicting tensions.

Weie went on to make studies after Delacroix's painting of Dante and Virgil from around 1924-25. Although he denied its significance the subject must nevertheless have been of suitable import for his high purpose, and was a theme to which he returned, all the while painting his much lighter landscapes. In working in serial form through different versions, it is as if Weie was trying to reach a closer and closer understanding, both of his subject and of the medium, until the two were integrated.

Inspired by music, especially Beethoven and the Romantics of the nineteenth century, Weie hoped to transpose his theme into compositions orchestrated in colour alone, eradicating Delacroix's narrative. In attempting to define or embody his subject more exactly, to truly find its visual equivalent in paint, Weie came virtually, though never completely, to total abstraction. By the time this version of *Dante and Virgil* was painted in 1930-35 (ill. opp.), the motif seems to have been so familiar to him that, in a heightened moment, he could integrate all previous memory and experience in this one apparently rapid painting. Spiralling forms, hinged around a point of terracotta, seem (in Kirkeby's words) to be 'fighting themselves out of this shadow space ...in such a way that the shadow space itself is to be effaced. The fight is underway...'[11] against the narrative and with it the shadows.

In later works such as *Faun and Nymph*, Weie wins, to quote Kirkeby a further time, 'a freedom in sun and gold,'[12] but *Dante and Virgil in the Underworld* marks the point of passage, the threshold to the other side. Consequently it has a crucial tension between subject and medium. Here Weie creates a painting that is special in its fluidity and abstraction but one that is fired by the importance of what he hoped to achieve, in which all his aspirations and deepest concerns are expressed.

(CB)

1. Per Kirkeby, *Edvard Weie*, Edition Bløndal, 1988, p.27

2. See Lennart Gottlieb, in Exh. Cat. *Edvard Weie*, Statens Museum for Kunst, Denmark, 1987. Kirkeby had commented upon Weie's work in *Bravura*, 1981.

3. Lawrence Gowing, 'The Early Work of Paul Cézanne' in *Cézanne, The Early Years 1859-1872*, Royal Academy of Arts, London, in association with Weidenfeld and Nicolson, London, 1988, p.5.

4. See Kirkeby, op cit, p.17

5. See Gowing, op cit, p.11

6. Karl Isakson (1878-1922), Swedish

7. Peter Paul Rubens (1577-1640), Flemish

8. Arnold Böcklin (1827-1901), Swiss

9. Edvard Munch in a letter to Johan Rohde in 1893, quoted by Arne Eggum in *Edvard Munch, Paintings, Sketches and Studies*, J.M.Stenersens Forlag A.S, Norway, 1984, p.98

10. Frida Strindberg, *Strindberg*, p.100, quoted by Reidar Dittmann in *Eros and Psyche, Strindberg and Munch in the 1890s*, UMI Research Press, Ann Arbor, Michigan, 1982, p.101

11. See Kirkeby, op cit, p17

12. See Kirkeby, ibid, p.18

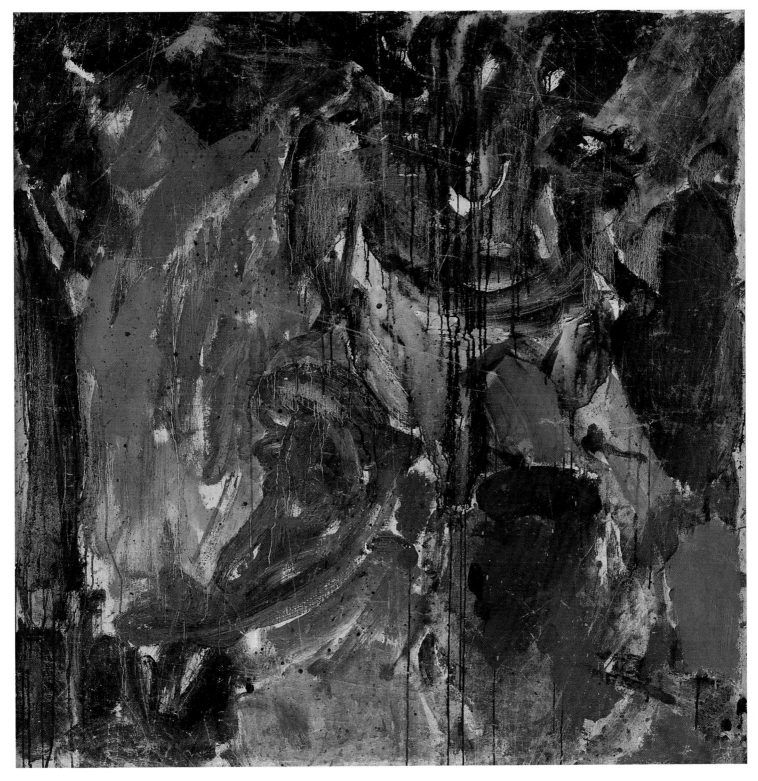

EDVARD WEIE *Dante and Virgil in the Underworld*
Study after the Painting by Delacroix in the Louvre, 1930-35 (cat.87)

JÓHANNES KJARVAL
(1885-1972)

NATURE'S SONG

'Regin was the best of craftsmen, and his size was that of a dwarf. He was wise, cruel and skilled in magic.'

<div align="right">From the Icelandic Sagas[1]</div>

Encrusted, byzantine Madonna. A boat of all boats carries her to a distant shore. On a sweeping river born of a snow laden interior, the boat and its ferryman, Regin, makes the perilous crossing, whilst benign guardian spirits the life-force of the land itself watch over. The fish, symbol of Christ, signals a blessing in Kjarval's *Sailing of Regin*, 1938 (ill.p.76). On one level the painting refers to the historic settlement of Iceland in the late ninth century by Norse explorers and their celtic slaves. But it also has a personal aspect, for this Stella Maris is Kjarval's wife, and Regin, Kjarval himself.

The artist's golden boat is the symbolic vessel of Laxness'[2] dream world – a conveyor of aspirations and hopes. Its great rounded hull transports Regin and the black Madonna, enclosing and protective – a womb or pod – suggesting a passage of both life and death, a journey into the past and to the future.

Matthias Johannessen, a journalist and friend of Kjarval's, tells how in the spring of 1914, a young Danish girl, Tove Merild had a dream which went like this:

'I was sitting in a boat out on a green ocean. I was being carried toward a coast. Bearded and weather beaten men were rowing, dressed in rainwear. In the boat there was a small naked human form that had such beautiful opal colours that they could hardly be of this world. After the boat reached the coast, the four men carried the small body ashore, obviously feeling that the burden was not light. But it seemed to me that I was left alone in the boat.'[3]

Tove had become engaged to Kjarval in Denmark and he, at the time of the dream, had recently set sail on the return journey to Iceland. Naturally concerned for news of his safe arrival his journey had triggered the dream imagery. In the Icelandic Sagas there is a belief in the power of dreams as portents of future things, and perhaps in this way the young woman had anticipated, as she later suggested, her eventual separation from Kjarval. *The Sailing of Regin* is a remembrance of this dream, painted 13 years after the couple parted, whilst it also evokes in the physical distance between the two figures, Kjarval's own feelings of loss at their parting. The painting was delivered by his son to Tove as she lay dying in Denmark in 1957. So, at least, the story goes.[4]

Kjarval is symbolically adrift in his golden boat. For he is the voyager, the wanderer. Of all the artists in *Border Crossings* Kjarval is surely the most attuned to nature; with his eyes cast down to the secret world of pools and stones. 'Listen to the quiet. Can you hear anything? Can

you hear the golden plover or the curlew. Can you hear the growing of the flowers and the breathing of the moss' asks Kjarval.[5] Elsewhere, in conversation; 'have you noticed how tame the stones on the landscape are? have you tried stroking them? Have you seen how the way they feel alters as different people walk by?'[6] In his 'Inferno' Strindberg had asked Torsten Hedlund if he had seen a seal weep, and among other intuited correspondences, described a lump of coal that cracked open like a troll in the light of the sun.[7] But Strindberg had to work hard to cast aside his urban, intellectual mantle in the hope of discovering a unity in nature. When Munch listened to nature he experienced its great scream, whilst Kjarval heard it sing.

His is an animated landscape. In *The Sailing of Regin* and *Yearning for Flight*, 1935-54 (ill.p.77), Kjarval, with antennae extended, seeks to interconnect with a hidden strata of feeling and perception. The energy, the magic pulse, which he experiences in nature constantly manifests itself in the strange paradoxes and mystery of the Icelandic landscape in which elemental forces are everywhere apparent – literally bubbling to the surface. Vast plains are cut by torrential rivers, frozen land is punctured by clear pools of hot, crystal clear water. The Icelander Magnus Magnusson writes of the 'wild hinterland' where there are 'strange and mystic places, weird shapes and curious rock formations.'[8] The folkloric tradition, Magnusson explains, is a means whereby Icelanders have been able to give 'meaning and proportion to the vast and inexplicable.'[9] It is this well-spring that Kjarval taps.

According to legend it is told that in Iceland mountain lakes are the home of wishing stones that might float to the 'water's edge on hallowed nights, on Midsummer's Eve, and those who found one would be granted everything their hearts had longed for.'[10] And so it might be that the finder of this stone would wish to fly to distant shores across the deep and endless sea that separates Iceland from its neighbours. This same reverie infuses Kjarval's painting, *Yearning for Flight*.

Munch's '*Vision*' (ill.p.44) was of a swan that stood for an unobtainable otherness bound up with beauty and freedom. In Kjarval's picture a similar longing is underlined by an eroticism reflected in the swan's proud demeanour and the transparent veiling of wing against skin. After Tove had gone Kjarval is reported to have 'renounced physicality' and love became 'ethereal, reminiscent of the fleshless commune of "hidden people".'[11]

Both of Kjarval's paintings shown here are sumptuously ornamental. The fabulous gold of the black Madonna's halo, the crystal ice-nuggets reflected in the wings and neck of the great swan. In some places Kjarval has applied paint direct from the tube, and has allowed it to drip and run in a manner reminiscent of Edvard Weie's *Dante and Virgil in the Underworld*, c.1930-35 (ill.p.73), in layer upon layer of translucent colour.

Kjarval also painted pure landscapes which combine a carefully observed rendering of natural phenomena with a monumental simplicity. *Yearning for Flight* and *The Sailing of Regin* although quite different rely on the same immediate experience of nature. It is well known that Kjarval spent long periods camping out in all weathers with his canvas and paints. He also drew from life and both of these paintings illustrate his skills as a draughtsman. The combination of exquisite line and rich decoration links Kjarval's imaginative figurative works, not only to European Symbolism, but to a rich tradition of folk art in Iceland (see for instance ill.p.133).

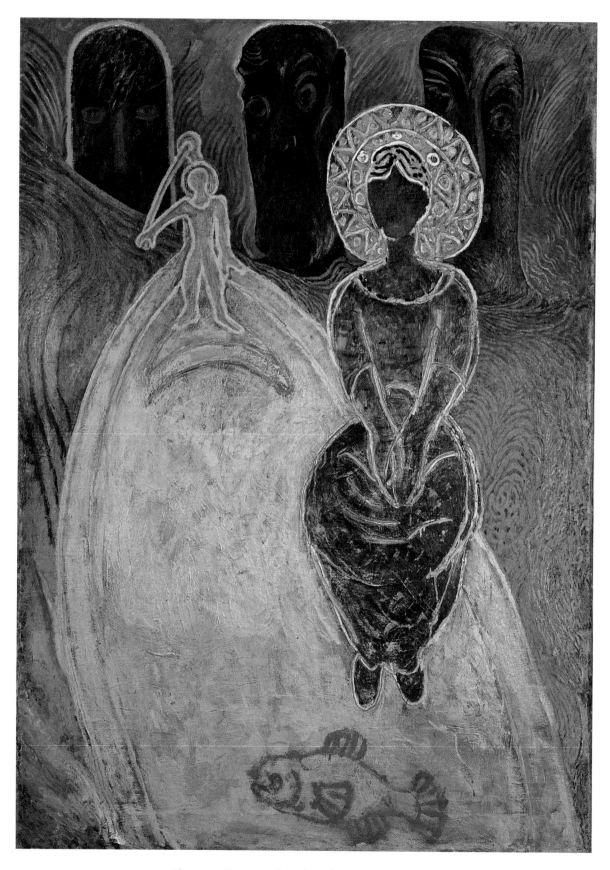

JÓHANNES KJARVAL *The Sailing of Regin*, 1938 (cat. 52)

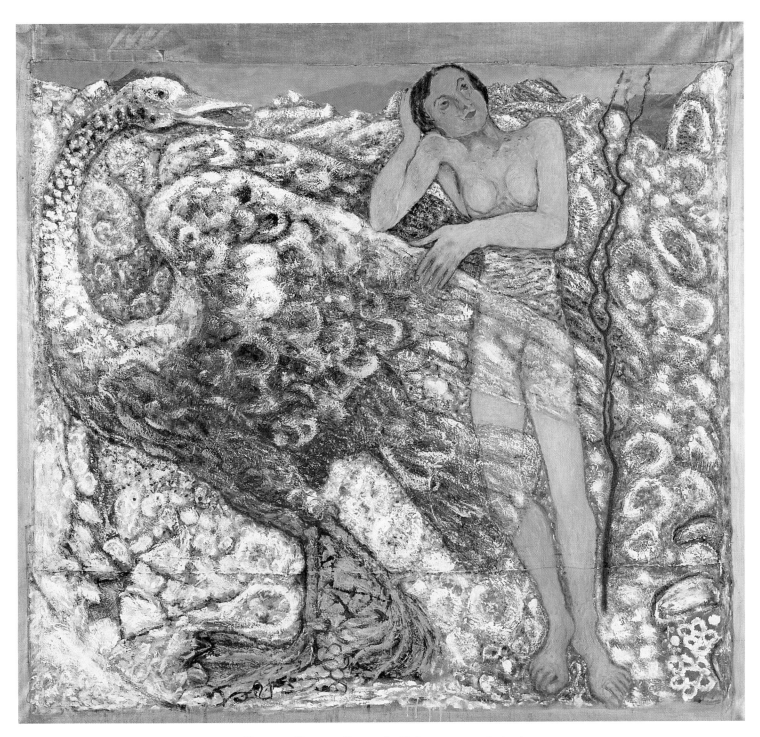

JÓHANNES KJARVAL *Yearning for Flight*, 1935-1954 (cat.51)

Throughout his long career Kjarval experimented with many different styles, although not always successfully, his work crossing easily between landscape and figurative subjects. *The Sailing of Regin* and *Yearning for Flight* are certainly among his finest works, but unfortunately the two alone cannot do justice to the whole range of his output – some 6,000 paintings and drawings. He is the most celebrated of Iceland's twentieth century artists, a lone spirit with a courageous, independent vision who succeeded in capturing the spirit of his country. Matthias Johannessen has concluded that 'Kjarval painted Iceland for those who own it. Every one of his pictures contains something that truly belongs to all of them.'[12] (JA)

1. Quoted by Matthias Johannessen in *Kjarval: A Painter of Iceland*, Iceland Review, Reyjkavik, 1981, p.37

2. Halldor Laxness, Icelandic poet and writer

3. Quoted by Johannessen in *Kjarval: A Painter of Iceland*, 1981, op cit, p.36

4. Ibid,p.37

5. Quoted by Johannessen, ibid, p.40

6. Quoted by Gudbjörg Kristiánsdottir in 'The Living Landscape'in Exh.Cat. *Kjarval Centenary Exhibition*, Municipal Art Gallery, Reykjavik, 1985,p.25

7. 18 July 1896, *Strindberg's Letters*, The Athlone Press, 1992, no.378,p.573

8. In 'Foreward', Exh. Cat. *Landscape from a High Latitude: Icelandic Art, 1909-1989*, Brighton Polytechnic Gallery/Lund Humphries, 1989, pp.7-8

9. Ibid

10. Ibid

11. Matthias Johannessen, 'The See-through Mask' in Exh.Cat. *Kjarval: Centenary Exhibition*, op cit, p.16

12. Johannessen, *Kjarval: A Painter of Iceland*, 1981, op cit, p.43

JÓHANNES KJARVAL *Flowering Head*, c1940
Reykjavik Municipal Art Gallery

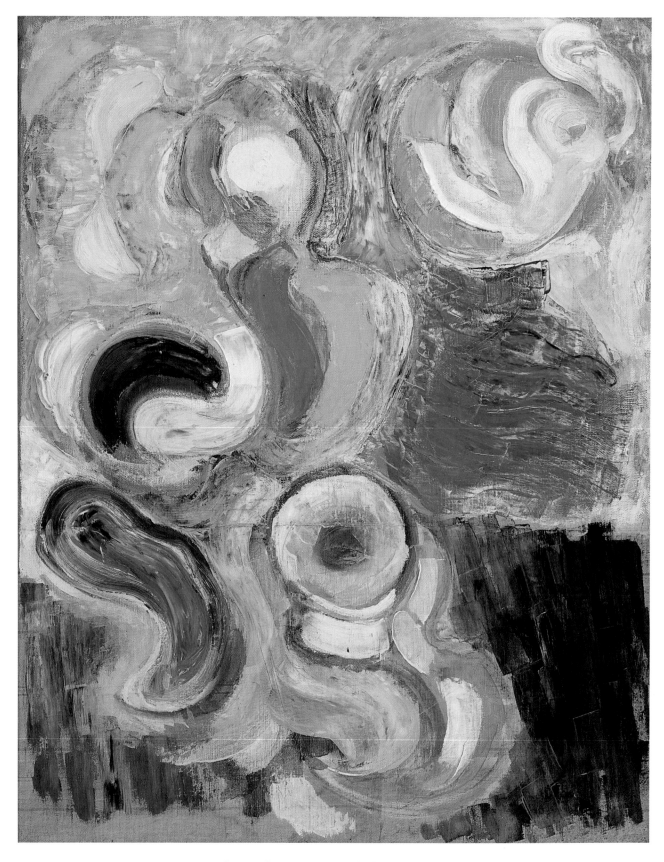

Svavar Gudnason *Storm Clouds*, 1944 (cat.9)

SVAVAR GUDNASON

(1909-1988)

STORM MAN

'The living human being is always going to manifest himself, if the fjord be bright and sunlit or the sea in a boiling rage. He will lift himself up, rise like a visionary figure, and reach to the skies, and yes maybe even into the Heavens.'

Svavar Gudnason, from *What is near and what is far away*[1]

Memories of Iceland conjoin in Svavar Gudnason's *Storm Clouds*, 1944 (ill.opp). Great swathes of colour make it a joyous rhapsody to nature's shifting perspectives: the sea, the sky, the wind, the sun, the moon – the clouds; all caught up in the tumult. The writer, Thor Vilhjálmsson, who knew Gudnason and shares his poetic spirit, writes of how the 'storm clouds in Svavar's art are whipped downwards by chill winds far above, and we are no longer confined to a flat earth but touch the floating heavens; all at the same time, we feel the artist's medium bowing to his command, sense his motivation, hear the music in his solid compositions.'[2]

Storm Clouds has further mysteries to uncover. Looking again, could it not be a running figure – the storm man – moving from right to left, caught up in this same whirlwind; a personification of the land. Or, is this puff-ball, this gyro-racer the artist himself, on the uplift, propelled by the currents behind him?

For Gudnason there were two impulses at work in his art; 'emotion and reason.'[3] *Storm Clouds* marks the beginning of a period, up until 1946, when Gudnason cast aside his rational inclinations and allowed his feelings to take precedence. He had always held within him a poetic, even mystic understanding of nature, the result of an Icelandic upbringing in the south-eastern region of the island, from where his fellow painter, Kjarval, also hailed.

Storm Clouds was painted in Denmark where Gudnason had been studying and where he soon found himself at the cusp of developments. Here he mixed with those artists, Ejler Bille, Egill Jacobsen and Asger Jorn,[4] among others, who were forging a new art based on the unconscious, as well as primitive and mythological sources. They respected the work of Picasso, Kandinsky and Miró above other contemporaries, but gave equal credence to folk art seeing there something fresh and untainted. In short, they stood for a new directness, an energy that was to become in 1948, Cobra.

The War was on, and Denmark occupied by the Nazis. Somehow Gudnason summoned up all his creative energies to paint his most lyrical works, the so called 'fugues',[5] *Storm Clouds* among them. The power and optimism of Gudnason's works at this time is due to the emergence of a collective need among Scandinavian artists working in Denmark to rediscover, and assert their separate identity, their Nordic roots (see Jorn's texts pp.90-93), as a counter to the propaganda machine that was set on confusing Nordic and Teutonic cultures for its own purposes. During these challenging times, like-minded artists rallied around the publication,

Helhesten [*The Hell Horse*] (1941-44), to which Svavar contributed many graphic works. Kjarval and his predecessors had already embarked upon the same nationalistic exploration. The special qualities of an Icelandic folklore and literary culture, combined with the all embracing status of nature meant that Gudnason was well placed to enter into this dialogue.

The harmonious accord was not to last. In 1945 Jorn and Pedersen[6] began to take a more aggressive tack linked to the psychological, whilst Gudnason and Jacobsen moved toward a more lyrical abstraction. That same year Jorn had written, by way of an ongoing manifesto: 'our art is without ties or guidelines of any aesthetic, emotional or other higher nature but is based rather upon a purely vital experiment.'[7] Fourteen of Gudnason's contemporaries signed Jorn's text but his name was not among them. He had ducked out, increasingly at odds with the ideas being expressed, returning home to Iceland to set his spirit free.[8]

Gudnason had been away for 11 years. His first exhibition on home soil introduced the Icelandic public to abstraction, and proved 'a turning point in the nation's art history; arousing either unbridled admiration or maddened outrage.'[9] Here in Iceland, at the peak of his career, Gudnason paints his most intense expressionist work: *Mountains of Gold*, 1946 (ill.opp).

This canvas surges with a great up-sweeping energy. Slabs of pure colour are scraped over the surface in an almighty crescendo of forces, driven by some internal, unseen force. The same basic expressive impulse that drove Munch, Strindberg, Lundquist, Jorn most obviously, and even Weie; the 'passion and despair'[10] in Gudnason's art that his contemporary, Jacobsen had understood.

Gudnason returned to Iceland for good in 1951 where he continued to explore colour and form, never in a totally abstract way, but rather in relation to his own moods and the changing complexion of the Icelandic seasons.

Vilhjálmsson tells of how Gudnason spent 'whole nights with his fishing companions speaking only occasionally, listening to the bright night and to all of nature.'[11] One of those companions, quoted in Vilhjálmsson's book offers further testimony to Gudnason's closeness to nature, in his assertion that he had 'never felt nature open itself the way it did in Svavar's company... it was a sheer revelation to be part of it by being with him and feeling his tenderness toward everything. He was so sensitive about all that was happening in nature that you were swept along into a strong, deep feeling for it too, just by being close to him.'[12]

In Denmark his name and work are still revered for his contribution there, especially in the War years when ideas were still fresh, and the art itself charged with a spirit of resistance. And in Iceland his paintings are legendary; his reputation surpassed only by Kjarval. (JA)

1. Quoted in Thor Vilhjálmsson *Svavar*, Edition Bløndal, Format series, 1992, p.63

2. Ibid, p.59

3. Quoted by Júliana Gottskálksdóttir, in 'The Art of Svavar Gudnason: Spontaneous Expression and Disciplined Thinking' in Exh. Cat. *Svavar Gudnason*, National Gallery of Iceland, 1990

4. Ejler Bille (b.1910) Egill Jacobsen (b.1910)

5. Suggestive of the rhythmic structure in music, with repetition of forms etc. Coined by Gudnason's friend, the philosopher and musician, Erlender Gudmundsson. See. Gottskálksdóttir, op cit, p.60

6. Carl Henning Pedersen (b.1913)

7. Quoted by Peter Shields in 'The Connections with Denmark' in Exh. Cat. *Svavar Gudnason*, op cit, p.101

8. See Peter Shield, ibid, pp.101-102

9. Quoted by Vilhjálmsson, op cit, p.27

10. Gottskálskdóttir, op cit, p.63

11. Vilhjálmsson, op cit, p.56

12. Ibid, p.56

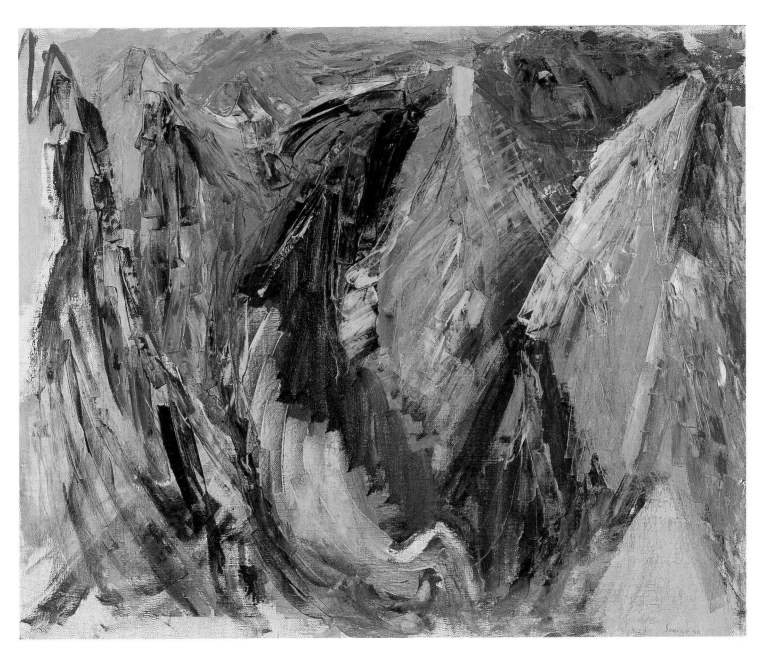

SVAVAR GUDNASON *Mountains of Gold*, 1946 (cat.10)

ASGER JORN

(1914-1973)

NATURAL SUBVERSIVE

During every really creative act, the artist finds himself homeless (*dépaysé*). To overcome this state he has to call up his last reserves of strength. This mobilization of all his creative and formal resources, this passionate struggle with the medium, cannot be imitated. It is every man for himself.

This explains the magic power of art.

In every real experiment there is a zero point, where absolutely nothing can be predicted.

A creative train of thought is set off by: the unknown, the unexpected, the accidental, the disorderly, the absurd, the impossible.

The measure of genius in a work of art is its power always to remain an enigma.

Tolerance is the only intolerable thing in the field of art.

Art cannot be argued.

from *Pour la Forme* 1958[1]

Asger Jorn, writing at a crucial moment in his career, here makes his claim for the irrational and the intuited. This emphasis on the importance of the subjective, both in his method of working and as an intrinsic quality of art, was central to Jorn's way of thinking, and led him, as it had earlier Strindberg, to a use of chance effects in painting. These two artists share a delight in the unexpected and take pleasure in a 'natural art',[2] one that Strindberg describes in his essay 'The Role of Chance in Artistic Creation': 'where the artist works like capricious nature, without a prescribed goal.'[3] Jorn, taking this much further, pioneered a spontaneous, painterly abstraction in the late 1940s in which he tried to divest his mind of all associative and rational thinking. This intuitive way of working was what he called 'empty creation',[4] a kind of automatism in which the imagination was to be given free rein in response to materials.

These radical explorations were made just prior to the formation of the international Cobra movement (1948-1951) of which Jorn was a founder and leading member. Formed in a spirit of revolt, Cobra was intended to be 'an organic, experimental collaboration which will avoid all sterile and dogmatic theory…',[5] and the provocative approach it espoused was to remain essential to Jorn. Together with his fellow members, he was drawn towards the expressive energy of primitive art and responding, in part at least to this, he began to introduce similarly forceful figures and motifs conjured up from his imagination, also revealing his interest in Klee and Miró and his fascination for Nordic folk art.

Out of the unconscious, Jorn gave form to an array of grotesques, reflecting what were to him the bestial origins of mankind. But in tapping this mysterious underworld, Jorn didn't

express raw emotion or anxiety alone. His bleaker moments, indeed, his more magical or spiritual elements, were counter-balanced by a fiendish and mischievous humour that sprang not least from a desire to provoke.

Playful, contrary, and irreverent, Jorn used these characteristics in his painting not only to introduce an everyday humanity but more to do battle with the constraints of objective reason. Jorn was hell bent on overturning accepted notions of beauty and art, attacking traditional principles in his book *Risk and Chance* (1951-52). The same critical stance comes through in what are probably Jorn's most blatantly provocative works, the series of so-called 'Modifications' that he made in the late 1950s. In these he re-worked, or rather 'sacrificed'[6] paintings that he had bought, over-painting them with animals and mock heroes with a subversive irony, questioning the unthinking and clichéd use of traditional imagery. The group of 'Disfigurations' that followed are more sinister in tone, particularly *Ainsi on s'ensor*, 1962 (ill.p.91), where Jorn suggests a grim way out of this world.

With tongue in cheek, Jorn points to options other than the rational order that was commonly advocated. What he proposed instead was an aesthetic that would be drawn from an indefinable world of the subjective spirit such as he found in mythology but which he felt had been long overshadowed in contemporary life.

Jorn's spontaneous methods were a means to this end. By suspending his own rational being at the 'zero point' that he referred to in *Pour la Forme*, and calling up all his creative energy, he allowed images to flow freely from his imagination to form what he called a 'chaosmos'.[7] A 'world caught in the act of becoming and retaining the quality of impermanence'[8] as Guy Atkins, friend and writer on Jorn, described it. A reminder again of the ecstatic heights that Strindberg experienced in the face of nature's chaos and endless transmutations.

Jorn offers us then enigmas and inconsistencies rather than solutions, and yet his approach is not anarchic. There is underlying purpose to this madness, borne of the belief that 'It is the task of art to create possibilities, not to realise them.'[9] He wanted to express all aspects of human life, the whole gamut of experience with its multiple meanings, its discontinuities and countless possibilities.

The great drive behind Jorn's art is surely this desire to restore the basic ties between art and life in its fullest form – the links that he felt had existed 'among primitive people' but which had been '...broken and shredded in our modern society to the detriment of humanity...'.[10] Like an ethnographer, Jorn gathered together material on past cultures, particularly from his own Scandinavian heritage, building a bank of information which he had intended to publish. In so doing, Jorn was not attempting to preserve Nordic culture as a fossilised relic, but rather to recognise it as a continuing inspiration. 'It is not a matter of standing guard over Nordic art' he said, 'but of opening chests and drawers and buying our freedom with it...' (see p.92)

Against this background, the works by Jorn that are included in *Border Crossings* can be seen as a reflection of his passionate defiance of classical idealism (rational order) and his determination to re-instate the inner spirit in art by confronting the 'naked field of the imagination' and his Nordic sensibility. (see p.93)

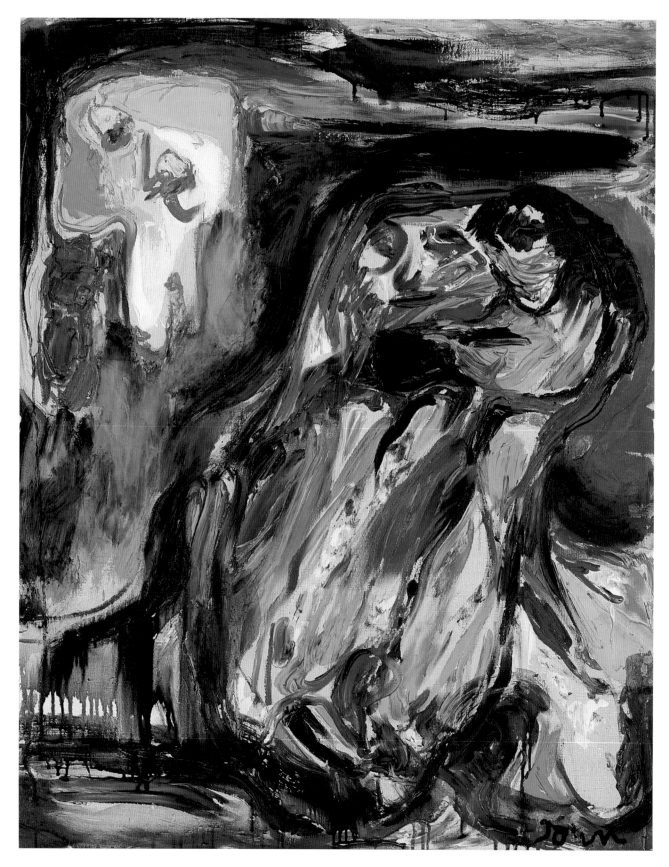

ASGER JORN *Wiedersehen am Todesufer [Re-encounter on the Shores of Death]*, 1958 (cat.42)

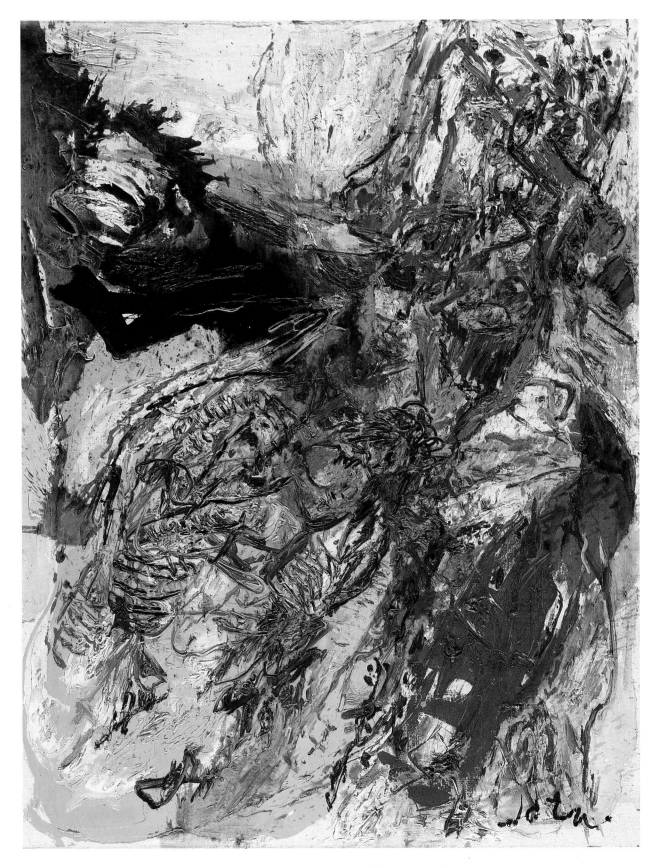

ASGER JORN *They Never Come Back*, 1958 (cat.43)

1958 – the year in which he wrote *Pour la Forme*, found Jorn at a critical point in his life, with his second marriage in tatters and periods of manic depression interrupting the flow of his work. Yet it was during this time that he produced some of the most important works of his career, making a series of tragic paintings that were, if not inspired by, then certainly deeply effected by personal crisis – amongst them *Re-encounter on the Shores of Death* (ill.p.86) and *They Never Look Back* (ill.p.87).

Troels Andersen, long-standing friend and colleague of Jorn, has commented upon how, early in the '50s, not long after the major Munch retrospective in Copenhagen in 1946, Jorn had brought a more personal dimension into his canvases heralding his new phase of figuration.[11] Whilst it would be wrong to overplay this influence, there is nevertheless a related psychological tension that recurs in Jorn's work. *Re-encounter on the Shores of Death* with its shrouded figures and evident mood of anxiety is surely one of the clearest echoes of Munch to be found in his career.

Locked in a strange and fearful embrace, their eyes staring wildly, two figures recoil from a disembodied form, a face or skull, that hovers before the receding shoreline. Forms emerge and dissolve into one another as if created from a state of flux and continual motion. A fluid contour, remembrance of the auras that Munch used to denote inner emotional charge, traces and binds the figures, then continues, marking the symbolic interface of land and sea.

They Never Look Back is more frenzied, even violent in its emotion. The gliding movements and figurative forms of *Re-encounter* are here replaced by a more energised and agitated stroke, cumulative touches of paint expressing the anger, pain and sense of loss that the title suggests. In its handling, and as an expression of individual agony, the painting has resonances of the even more abstracted *Stalingrad*,[12] arguably Jorn's most significant work – his own 'Guernica' transposed into a deeply-felt personal examination.

Less the product of chaos and violence is the later evocative and more fluid painting, *As if the Swans Sing*, 1963 (ill.p.94). In Munch's *Vision*, 1892 (ill.p.44), the swan, with its many poetic associations, becomes a symbol, possibly of harmony to be attained, and though Jorn's painting contrasts in its vibrancy and its sensual bestiality, there is a link here, and also with Kjarval's *Yearning for Flight*, 1935-54 (ill.p.77).

The Lucid Luxury of Hyper-Aestheticism of 1970 (ill.p.95), is one of the major paintings that Jorn made in the last few years of his life and is extraordinary for its clarity and strength. Jorn here reduced his work to its most essential elements. The flowing, broad strokes of *As if the Swans Sing* and the lighter, though now less turbulent, markings of *They Never Look Back* are combined, and focused around the dynamic diagonal axis that also underpins *Re-encounter*. Jorn again confronts us with a dramatic, bestial presence, its energetic thrust in counterpoint to the indeterminate bird-like spirits that ascend almost weightless. Once more Jorn charges his painting with irreconcilable opposites: with light and dark, with 'the human animal and the angel'.[13]

Defiant and unreasonable, Jorn, as artist-magician, challenges us to open ourselves up to the secrets and paradoxes of existence. 'Art is power'[14] he says – a 'magic' power which enabled him to express all the energy of nature's mysteries. (CB)

1. Asger Jorn, in the essay, *Pour la Forme*, 1958. Quoted by Guy Atkins in *Asger Jorn, The Crucial Years: 1954-1964*, Lund Humphries, 1977, p.127

2. August Strindberg, 'The Role of Chance in Artistic Creation' (1894), quoted by Douglas Feuk in *August Strindberg*, Edition Blondal, 1991, p.III

3. Ibid

4. Quoted by Troels Andersen in 'Asger Jorn: The Formative Years', Exh. Cat. *Asger Jorn*, The Solomon R. Guggenheim Museum, New York, 1982, p.24

5. from 'The Cause was Understood', a text drafted on 8 November 1948 by the founder members of Cobra, quoted by Jean-Clarence Lambert in *Cobra*, Sotheby Publications, 1983, p.95

6. Asger Jorn, quoted by Atkins, op cit, p.65

7. Asger Jorn, see Atkins, op cit, p. 97

8. Ibid

9. Asger Jorn, 'De Divisione Naturae', quoted by Hans Kjærholm in *Asger Jorn: Malerier*, Silkeborg Museum, 1964 p.76

10. Asger Jorn, 'Magic and the Fine Arts' 1948/1971, p.10; quoted by Graham Birtwistle, *Living Art: Asger Jorn's comprehensive theory of art between Helhesten and Cobra (1946-1949)*, Reflex, 1986, p.1

11. See Andersen, op cit

12. The painting *Stalingrad*, now in the collection of Silkeborg Kunstmuseum, Denmark, was begun in 1956 and was re-painted by Jorn many times, last touches being added only a few months before he died. Its starting point relating to the Spanish Civil War, Jorn considered it an '*inner record of a historical event*'. A discussion of the work including a paraphrased version of Jorn's own comments on the painting is given in *Asger Jorn, The Crucial Years 1954-1964*, Lund Humphries, 1977, p.47-50

13. See Birtwistle, op cit, p.50. From Jorn's description of a drawing by Paul Klee *Demons at the Entrance*, 1926, as 'An attempt to dissolve the conflict between instinct and thought, between spontaneity and construction, between the human animal and the angel.'

14. See Birtwistle, op cit, p.89

FROM ALPHA AND OMEGA

ASGER JORN

As the essence of art in Scandinavia lies in an interaction of moods from laughter to tears and from tears to lethal rage, one can understand how dangerous this art is, because we can be tyrannised by a cynic who has art in his power. Much has been said about this fantastic demonic power. This is the reason for the hard demands made upon the artist to bear the responsibility for the moods he evokes by, at least, containing them within himself, by **knowing them himself.** This psychic strain on the artist is what, in so many cases, explodes his mind and gives our culture its reputation of madness. Only if one denies the richness of meaning which lies in **felt nonsense** and thus adopts the Latin form of art, does one not run this risk. The danger is even less in Byzantine art. However, the attitude of the people has not changed. It is this psychic demand upon both artist and beholder that **makes** so-called Expressionist art so hated amongst worshippers of beauty and formalists. Johannes V. Jensen traces this tradition back to shamanism and I believe that he is right.

From *Alfa and Omega*, Copenhagen 1980 (written 1963-64), p. 165
Translated by Peter Shield

ASGER JORN *Ainsi on s'Ensor [Out of this World – After Ensor]*, 1962 (cat.44)

From Alpha and Omega

Asger Jorn

I have been asked whether there is anything in Nordic art to stand guard over, but how is it possible to stand guard over the Nordic in art at all? For fifteen years I have accordingly churned the question of whether I should talk about the Nordic in art or not over in my mind, for I know that this talking at the same time sacrifices something, is a **sacrifice,** perhaps of the best, the most essential.

Whether there is anything Nordic to stand guard over in art, consequently meant for me, that it might not be better to let the whole thing look after itself. But then came the demands of politicians in Norway and Denmark that we should give up our sovereignity and enter into a union of "European" states. With this the secret became a burden, because no one abroad reckons that guard is stood over anything in Scandinavia because it is done discreetly and without words. That this discretion has even convinced our own politicians, even our own peoples, that they have nothing to answer for, means that the situation is completely changed. Today the question has been reversed. Today it is: can our art protect the Nordic against extinction. If this is possible then we must mobilise it right from the time of Arild up to today, for it is the only means we own to demonstrate what we are and what we have always wished to be. If we then have to sacrifice the whole of our artistic past by throwing it on the altar of public opinion, then this sacrifice is not great enough.

I do not know how much Nordic art is worth in others' eyes when they really get to know it. Today it does not exist in cosmo-political art life. I don't care. The only important thing is that one learns to understand that here is something not to be mistaken, that it is as it is and that it is as **we** are. Thus it is not a matter of standing guard over Nordic art but of throwing it into the scales, of opening chests and drawers and buying our freedom with its help...

Thus to stand guard over Nordic art means in reality to hold it down and only let it grow unnoticed underground. But why should we do that? Because Nordic art is a dangerous art, perhaps the only art that can really with right be described as dangerous because it concentrates all its power **in ourselves**. It is not an art that gathers around the enjoyment of the direct emotivity of sensory impressions. Neither is it an art which speaks to objective perception through a clear and conscious symbolism. The Danish author Jacob Knudsen has probably touched upon the essential point when he says that Nordic art has **mind**, is the expression of mind and affects **the mind** more than the senses and perception and is thus a symbolically informal and anti-symbolic art.

From *Alfa and Omega*, Copenhagen 1980 (written 1963-64), pp. 156-7

Translated by Peter Shield

SCANDINAVIAN POVERTY

ASGER JORN

I am of a far-off race: my forefathers were Scandinavians: they pierced their sides and drank their own blood – I am going to make gashes all over my body, I am going to tattoo myself, I want to become as hideous as a Mongol: you'll see, I shall yell in the streets, I want to become quite mad with rage.

I listen to him glorying in infamy, and turning cruelty into his charm.

<div align="right">

Arthur Rimbaud, translated by Oliver Bernard.
In Rimbaud's original, the last sentence comes first.
Jorn often 'mangled' quotations.

</div>

But how does Danish and Scandinavian high culture stand in this context [against French, German and English cultures]. Well, no European cultural history has wished in earnest to recognize the existence of such a phenomenon except as an imitation. The Scandinavian countries belong amongst the oldest and most intact culture-countries in the world and yet it is only in Sweden that there are tendencies towards a purely non-folk oriented cultural environment. **Our gift for admiration, which hinders us in choosing but lets others do it for us, is our most pronounced aesthetic characteristic. If one can call England Europe's centre of refinement, then one could call Scandinavia the dream centre of Europe,** if dreams have had such a thing. One of the first things that civilised history tells of the meeting with the Scandinavians is that they were such big gamblers that they not only gambled all their possessions away but also pledged themselves. **Hamlet** and **Peer Gynt** are typical of these peoples who live in an unreal stage setting meant to represent Europe but which seen at its most profound is just as much oriental as occidental. It is this cultural attitude which forms the basis of our study.

What Almqvist calls **the blessing of poverty** has been bestowed upon us, both materially and spiritually, in rich measure, whereas the curse of poverty, which in England became the grotesque opposite pole of refinement, human debasement, to a great degree was unknown. In no place in the world do the aestheticians go **to the depths** in madness and poverty so often and so compellingly as here. We are brought up in it.

This delight in the dream has given the Scandinavians this instinct that everything ideal is first and foremost imagination and thereby literally makes our cultural picture immune to the aesthetic or classical high culture's principle, which rests precisely upon the opposite principle that it is the ideal which is to form the imagination. This lack of classical tradition is the reason why Thorvaldsen was able to produce pure ideal-imagination or **imitation**. In the North, we are not only at the cold frontier of civilisation but of existence, truth and life themselves. **The naked field of the imagination.**

<div align="right">

From Asger Jorn: *Held og hasard* (Risk and Chance),
Copenhagen, 1963, pp. 150 – 151.
Translated by Peter Shield

</div>

ASGER JORN *Commes si les Cygnes Chantent [As if the Swans Sing]*, 1963 (cat.45)

ASGER JORN *La Luxure lucide de l'hypersthésie [The Lucid Luxury of Hyper-Aestheticism]*, 1970 (cat.46)

EVERT LUNDQUIST
(b. 1904)

A FRUSTRATED CLASSICISM

Evert Lundquist's studio lies among woods at the bottom of his garden at Kanton in the grounds of the Royal Palace at Drottningholm, outside Stockholm. It was here that the artist met me, framed by the doorway, under the shadow of trees. Now a gentle old man of 88, frail, with failing hearing and eyesight, Lundquist has worked here in this disused transformer station since 1953. Together we entered into the high and rather dark room of Lundquist's history. It was overcast that day, but I could imagine that when the sun shone, light would stream in through the vertical arched windows that punctuate the upper reaches of three out of the four walls, too high to see out of. And in this way moving shafts of light would variously illuminate Lundquist's objects and images of desire: a family photograph, a candle, a book, objet trouvé, a faded reproduction of classical remains. Each would in turn be lit up and then once again fade into the shadows. The light might even penetrate, just for a moment, a dark corner where an axe rests.

These objects are clues to Lundquist's art and are the models that find their way into his pictures, but light and darkness remain his principal subjects. The three strikingly different but nonetheless related works in *Border Crossings* by Lundquist; *Columns, Sicily*, 1957-58 (ill.opp), *Leg I*, 1968 (ill.p.99) and *Man on the Hill*, 1975 (ill.p.101), were painted at Drottningholm.

Together they span Lundquist's most successful years as an artist, in which all the essential ingredients and tensions that go to make up his art are evident. An account by the art historian, Erik Blomberg, who became a friend, and biographer of the artist, places Lundquist's essential objectives alongside those reflected by the shift to content and feeling in Swedish art in the 1950s which replaced the rational, constructivist tendencies of the 1940s.

Lundquist travelled extensively in the early 1920s, most significantly to Germany, France and Britain. In Germany he discovered Schopenhauer, Kant and Goethe and as Lundquist writes 'preserved from that time – at the bottom of my soul – strong impressions of German Romanticism and the German mentality as a whole.'[1] In Paris he decided to become an artist, and later came under the spell of Chardin, whose use of colour Lundquist feels 'has an almost moral aspect, both an outer and inner light.'[2]

Evidently, a serious and sensitive young man, Lundquist's interests ranged widely across philosophy, music and the plastic arts.

Inside Lundquist's studio at Drottningholm
Courtesy of Statens Konstmuseer
Bildarkiven, Stockholm

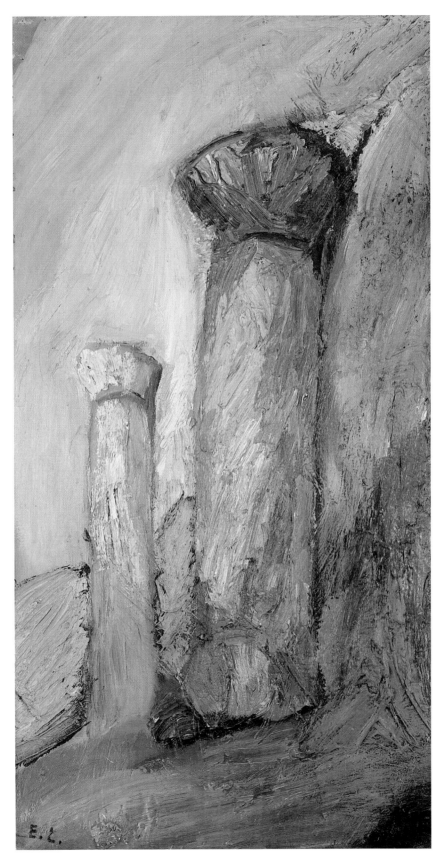

EVERT LUNDQUIST *Columns, Sicily*, 1957-58 (cat.53)

His first tentative steps as an artist – he had begun drawing earnestly in 1919 – were characterised by a youthful blend of classicism and naturalism, which was slowly but surely superseded by a craving for essential meaning and a 'monumental expressiveness.'[3] On his return to Sweden Lundquist found a model of 'simpified and expressive colour and draughtsmanship' in Munch.[4] At the same time bouts of depression in the late 1920s and 1930s brought about a darker more personal vision.

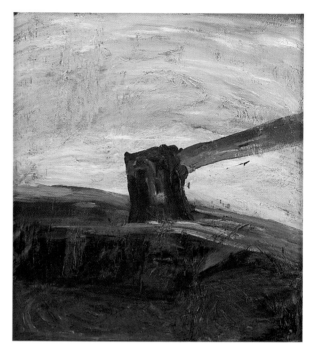

EVERT LUNDQUIST *The Axe*, 1973
Statens Museum for Kunst, Copenhagen

Munch had undergone a comparable transformation, a process which Ulf Linde, in the preface to Lundquist's 1974 retrospective exhibition at the Moderna Museet, Stockholm, described in terms of a 'recurring sacrifice'[5] – a necessary deformation, the prerequisite of which is a denial of naturalism or academicism in favour of a highly individual, expressive language. Apart from one especially difficult personal crisis in the late 1930s which heralded a macabre phase of Ensor-like figuration, Lundquist's canvas becomes the focus of a determined yet often fraught manipulation of pigment.

As a child, Lundquist had lived in the same street as Strindberg. He read the playwright's autobiographical novel *The Red Room* as a teenager, and since then Strindberg has been close to his heart, both as a man of ideas and as a painter.[6] In particular he came to applaud Strindberg's idea that the image might take form through the act of painting itself. For Lundquist and Strindberg this results in the constant annihilation and recreation of the image, a struggle which Blomberg relates to a universal unease and sense of loss.[7]

The drama acted out on Lundquist's canvas requires that there is some point of focus, in which the chaos of passions can be stemmed and harmony restored. Increasingly, single objects emerge out of Lundquist's ploughed surfaces – here in *Border Crossings*, the classical column, leg, lone figure in landscape. Many, perhaps most, of Lundquist's still-life subjects are chosen for their simplicity; for instance, the cup, the ladder and the spade. These banal objects (which nonetheless retain some significance to the artist) are employed in order to maintain a hard won balance between dark and light polarities, as in *Columns, Sicily*. However, many of his paintings are more overtly melancholic or anxious in subject, for instance an arm with a dagger, a fragmented body, or an ominous black bird hanging in a violet sky.

By the mid-century Lundquist's art was about to come into its own. More than any other artist in *Border Crossings* Lundquist attempts to reduce the elements in his art to a single motif, in search of a 'timelessness' (Linde)[8] or 'eternal and essential truths' and 'a greater cosmic coherence mirrored in simple shapes'(Blomberg).[9] Like Munch in his studio at Ekely, Lundquist

EVERT LUNDQUIST *Leg I*, 1968 (cat. 54)

EVERT LUNDQUIST *Hand*, 1974

attempts to assuage darker forces by means of nature and light although ultimately cannot help but reveal himself. Taking into account the dark aspect of paintings such as the early Munch-like, *Death*, 1943, and the more recent, *The Axe*, 1973 (ill.p.98), Lundquist's striving towards harmony and universal coherence appears constantly frustrated.

In 1922 Lundquist visited the British Museum and was overwhelmed by the Parthenon Frieze and the shattered beauty of the Greek bust of Demeter, which Linde believes Lundquist 'regarded – and still regards as the expression of human life at its fullest, as purified sensuous dignity, beyond the reach of irony.'[10] In *Columns, Sicily* we can see how this quest for a classical integrity manifests itself in his work but also how it is again underwritten, by a more northern, human aspect. The columns in the painting, take on a sensuous, even erotic quality. As in all of Lundquist's work carefully applied sheaths of colour delineate form, this time the translucent layers of ochre and purple bind the columns like a skin.

Whereas Lundquist's earlier paintings of the human form include the whole body, most usually a female nude, his extraordinary *Leg I* from 1968 shows only a dislocated fragment. For Lundquist this image must relate to studies from the antique, but here the leg is altogether more sinister and curiously animated. In the end, it is as if Lundquist, as Linde has suggested, is a 'medium for impulses the objectives of which he neither can nor will unmask.'[11]

Finally, the most recent painting of the three collected here is a return to the romantic subject, revealing Lundquist's true heritage. It's subject, the lone wanderer in nature, the quintessential romantic hero, is a recurring theme in his painting. But whilst the subject might be a familiar icon of the romantic dream, Lundquist's 'man on the hill' is uniquely his. Silhouetted against a surreal violet-tinged sky saturated with light, the stooping figure is firmly embedded in the surging mass of paint that goes to make up Lundquist's hill. If Strindberg's aim was to imitate nature, Lundquist wishes to be at one with it. The distinction between body and land is finally blurred, as the figure – and it must be a projection of the artist himself – is united with the dynamic, overwhelming forces of nature.

(JA)

1. Quoted by Eugen Wretholm, *Evert Lundquist*, SAK, Stockholm 1977, english version, p.12

2. Quoted by Wretholm, ibid, p.10

3. Quoted by Wretholm, ibid, p.17

4. Quoted by Wretholm, ibid, p.17

5. Ulf Linde, Exh. Cat. *Evert Lundquist*, Moderna Museet, Stockholm, September 1974, p.69

6. In conversation with the artist, 2 July 1992

7. Erik Blomberg, 'Evert Lundquist' from *Svenska målarpionjärer*, Bonnier's, Stockholm 1959. Also reprinted in *Evert Lundquist:Malerier of raderinger*, Kunstnernes Hus, Oslo, 1985

8. Linde, op cit, p.74

9. Blomberg, op cit

10. Linde, op cit, p.70

11. Ibid, p.68

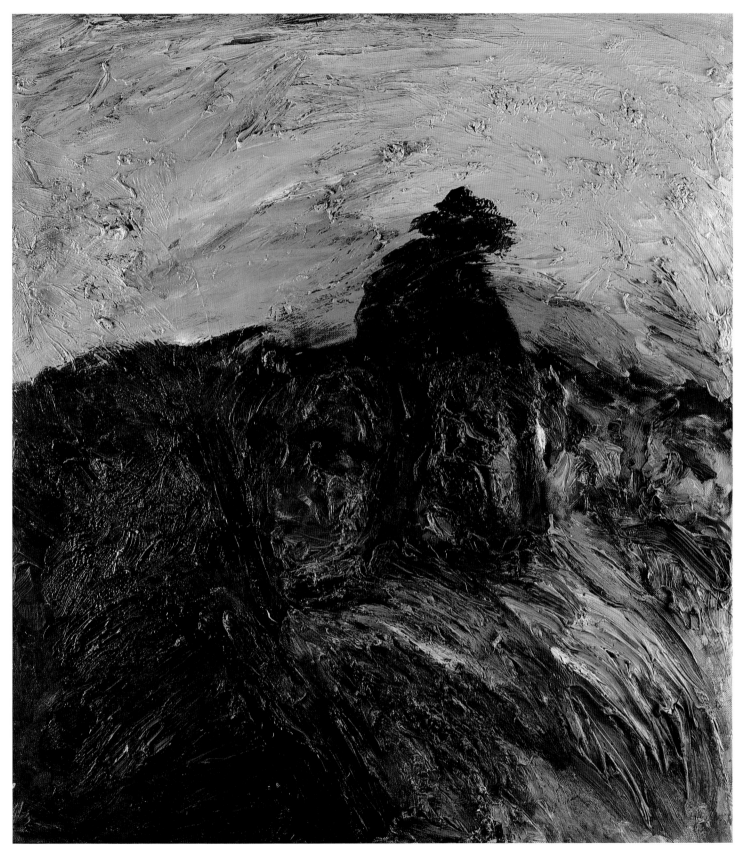

EVERT LUNDQUIST *Man on the Hill*, 1975 (cat. 55)

PER KIRKEBY

(b.1938)

WITH THE INTENT OF AN EXPLORER

I remember...once in the Central American rain forest, it was in Yachilan, a hardly visible exchange between the man-made and nature, a Maya ruin glimpsed at the end of a long tunnel. The wizened ochre remains of the chopped down materiality made up the floor of the tunnel...But the dizzying view into the ruin, a path that did not allow foot to set upon it, guarded as it was by these wizened snakes and by the scorpions of the ruin's stones, this view in turn was met by a gaping door opening in the centre of the ruin. The view was turned inside out. I thought we were in a cave looking out, but now it was we who were being seen from another cave.

from *Selected essays from Bravura* 1982[1]

Untitled, 1978 (ill.opp.). Here we have a passage, an inside out view, and a giddiness such as Kirkeby describes; a painting that almost sucks you in, yet which emits a searing light. While clearly this is not a depiction of an actual scene, the painting's earthy terracottas, greens and sumptuous oranges, are suggestive both of nature and of the warm colours one might find in central America, distant from the grey tonalities of the north. We look out beyond a framework of white, tessellated lines, a kind of mapping, an abstract decoration or hieroglyph, which are also a reminder of the crumbling blocks of a ruin. Veils of thin paint drip down over dark, dank spaces returning us to the analogy of the cave.

Kirkeby likens these caves or 'holes in the materiality,'[2] and his paintings of the time, to 'remarkable vertiginous views through the material. The desperation of the nebulae,'[3] moving quickly from the particular to relate visual experience to a universe in flux. These evocative notations are telling of the way that Kirkeby interweaves responses to the natural world with memory, suggesting the many layers of meaning and enigmatic references that inform his paintings.

With this particular sensitivity to the workings of nature, it is no wonder that Kirkeby, himself, should point to a kinship with August Strindberg and the group of cave-like paintings he made in the 1890s, particularly *The Wonderland,* 1894 (ill. p.38). Strindberg's description of this work as 'light's fight against dark'[4] could equally well apply to Kirkeby's own paintings, especially *Untitled* 1978, in which there is the same sense of polarities.

The close relationship between Kirkeby's paintings and the natural world has been much discussed. However, it is worth re-iterating that, for all the beauty of Kirkeby's flowing washes of paint and his gorgeous colours, this is no easy lyricism, no reverie. It is rather more that Kirkeby has found an inner pulse; the friction that makes fire as well as nature's ebb and flow. He plays upon a tension of opposites, introducing discordant, even aggressive notes that give his

PER KIRKEBY *Untitled*, 1978 (cat.47)

paintings an awkwardness. These intrusions can be disconcerting; puzzling irritations that can get in our way, causing a 'mental stumble' as Peter Schjeldahl has described it.[5]

The disruption is undoubtedly deliberate on Kirkeby's part. He admires both Turner and Delacroix for the same, commenting that both artists 'were always on the brink of doing something unacceptable' so that even today their landscapes make you feel 'uneasy'.[6] There is something of this resistant spirit in his provocative comment that 'the true inner necessity is actually when you outdo the sensitive, with violence if necessary.'[7] In this, and in his need to break the bounds of what is considered 'good taste', Kirkeby comes close to his older compatriot, Asger Jorn, with whom he has much in common even though the resulting paintings are so different.

Both are multi-faceted as artists, and have written extensively (perhaps using their writing as Strindberg used his painting, equally as an alleviation from, and illumination of the other). Both have deliberated upon their Nordic roots (with some ambivalence), but also work within an international arena; they share an interest in past cultures; and make a seemingly incessant enquiry into the workings of the world (despite Jorn's rejection of objective enquiry) – reflecting a need to fathom existence in all its multifarious forms. Kirkeby's matter-of-fact, and very human allusion to always tidying up, but never succeeding in throwing anything away, gives a pointer to this desire for some order or understanding. But he recognises that 'clarity is' of course 'only glimpsed in the intention' and that, in the final analysis, the all important factor is the moving about itself, the search, of which his paintings form a part, for the ever elusive truth.[8]

Where these two artists begin to part company is in Jorn's greater interest in the unconscious and his more primitive energy, while Kirkeby, though drawing upon inner tensions, shows a closer connection with nature. Kirkeby is also more conceptual in his work than Jorn, never relinquishing the rational to the same degree. Yet he too speaks of needing to set objectivity aside in order to paint, reflecting on the need for artists to 'think with their hands.'[9] Furthermore, in his comment: 'I do not seek truth before bravura, I seek it on the other side,'[10] there is the same sense that, as Jorn, Kirkeby summons up all his resources to work in a spontaneous way in order to get to the real subject of his paintings, their deeper meaning. Yet he is aware of the risk he is running: '...the eternal insecurity...but it is the only way of escaping good taste and narrow certification. The light of ambivalence is a heavenly one.'[11]

The resulting paintings with their overlaid patches of colour, scribbled lines and ambiguities, reflect this intuitive approach, more reminiscent of the shifting and uncertain aspects of nature than any calm, re-assuring continuity. *Untitled*, 1980 (ill.opp.), exemplifies this state of flux that Kirkeby evokes. Brushed areas of colour are swept over one another in a circular movement around a point of calm grey at the centre which acts as an anchor, a rich velvety red hinging the vortex at one side. The painting reveals the same sheer delight in effects of colour and flow of paint that we find in Weie's painting *Dante and Virgil in the Underworld*, 1930-35 (ill.p.73). Only Kirkeby does not begin with a subject such as this, working instead directly in response to the medium, fulfilling Jorn's description of the Nordic painter's 'desire for a substance which can liberate the imagination for new interpretations.'[12]

PER KIRKEBY *Untitled*, 1980 (cat.48)

However, Kirkeby has commented upon how his loose-handling of paint and gestural strokes can be misleading, suggesting a rapid expressionist process. Whereas his work is formed more slowly, through a layering that he relates to 'geological strata with cracks and discordances.'[13] He begins with a memory, but this is only 'the occasion, the entrance to the world'[14] — just the starting point for the 'long journey of painting'[15] during the course of which he brings in other images. Recollections of everyday occurrences and feelings are brought into play as a means of finding his '"deeper" and indescribable subject' which then 'lives with the external subject like a good skin against its environment.'[16] These elements form subjective layers which modify the character of the painting, effect its course and remain present, even if only as a remembrance, in the final work.

His approach is further illuminated by Troels Andersen, who relates that on the occasion of his first exhibition in Copenhagen in 1965, Kirkeby referred to a lengthy quotation from Gogol, written to the nineteenth-century Russian artist, Aleksandr Ivanov, in which he advises: '...not until you collect your whole self, and push yourself onwards, will you know what is inside yourself...not until you have done badly...will you do well. You will torture yourself and for several days all your efforts are concentrated upon one part...only when it [the whole] incessantly moves in front of your eyes and speaks about its imminent realisation will work progress. For in the soul outburst and inspiration move, and by inspiration much is achieved that cannot be achieved by any scientific efforts.'[17] And so an essential truth was passed from Gogol to Ivanov and on to Kirkeby; words that could equally well have been spoken by Jorn. Kirkeby shares this same need to force himself and the medium, coloured further by a will to 'work hard and honestly, with the sole desire to confer solidity to things'[18] that stems from a basic suspicion of anything that comes too readily. But finally, all these endeavours are then risked in a moment as he disrupts the painting with rapidly made marks, what he calls 'tattoos', that punctuate the surface leaving a permanent stain. Only at this point Kirkeby says, does the painting reveal 'its true identity.'[19] Thus the painting goes through a whole cycle of realisations; ideas which are thwarted in the next moment only to give rise to new creations, until a hard-won clarification is reached.

Kirkeby's painting *Shadow*, 1986 (ill.p.109), bears all the traces of this evolution. Its shifts and changes of form, its animated surface, suggest that we are looking at a figure or form in various stages of its existence, like some bizarre trinity, a chrysalis or death's head moth. Here Kirkeby returns to light — or, rather, its inverse — to find his subject. The cave motifs that anchored his earlier work here give way to dramatic vertical forms which are invigorated by energised lines — his tattoos — that suggest a vibrant sensitivity.

Munch stands upright in his late *Self-portrait between the Clock and the Bed*, awaiting death to come, time ticking away. In Kirkeby's *Shadow* there is a related sense of foreboding. But if Munch's painting reveals an acceptance of that state of death to come, Kirkeby's is very much alive. Munch's contour, the line that is the reverberation of the inner state of mind, is now in Kirkeby's painting loosened from the body, and is more aggressive and staccato in effect. The painting evokes the feelings and sensations of a living being and yet there is this consciousness of a threatening presence. Perhaps it is simply the fundamental truth that an awareness of darkness

is critical if we are to appreciate light – hence Kirkeby's statement that 'the only way you can define beauty – in a tree for instance – is to know that death is hiding behind it.'[20] A sense of danger heightens the intensity and precious tangibility of existence.

Kirkeby begins his book *Natural History and Evolution* by saying: 'If everything is ceaselessly in motion yet nevertheless repeating itself and there is no reason or beginning to anything, then this is a spiral. Where the innermost convolutions never reach a point but just twist themselves tighter and tighter and vanish from the eye's horizon.'

For Kirkeby, paintings are like 'knots' in 'the wall of the spiral … crystallization points.' They take form at 'the point where everything that has collected, half-organized, like… a night, or a ferry crossing, suddenly falls into place in a fraction of a second and gives off light… And it is this that moves further out through the spiral (to nothing, not even a cave entrance), it is this that is full of life.'[21] Moments of clarification within a wider flux. (CB)

1-3. Per Kirkeby, *Selected Essays from Bravura*, Van Abbemuseum, Eindhoven, 1982, p.64

4. Ibid., p.65

5. Peter Schjeldahl, 'The Kirkeby Effect' in *Threshold*, The National Museum of Contemporary Art, Oslo, 1990

6. From an interview with Michael Peppiatt, *Art International* 14, Spring/Summer 1991, p.45

7. See Kirkeby, op cit, p.94

8. 'Border Crossings' in *Natural History and Evolution*, Haags Gemeentemuseum, 1991, p.90

9. From an interview with Eddy Devolder in *Per Kirkeby*, Philippe Guimiot Editeur, Brussels, 1991, p.71

10 & 11. See Kirkeby, op cit, p.7

12. Asger Jorn, from *Alpha and Omega*, quoted by Kirkeby, ibid, p.115

13. See Kirkeby, ibid, p.83

14. See 'Border Crossings', op cit, p.91

15. See Devolder, op cit, p.65

16. See 'Border Crossings', op cit, p.91-92

17. Gogol, quoted in Exh. Cat. *Per Kirkeby*, Fruitmarket Gallery, Edinburgh, 1985, p.7

18 & 19. See Devolder, op cit, p.69

20. See Peppiatt, op cit, p.45

21. See *Natural History and Evolution*, op cit, p.11

PER KIRKEBY *Look Back II*, 1986 (cat.49)

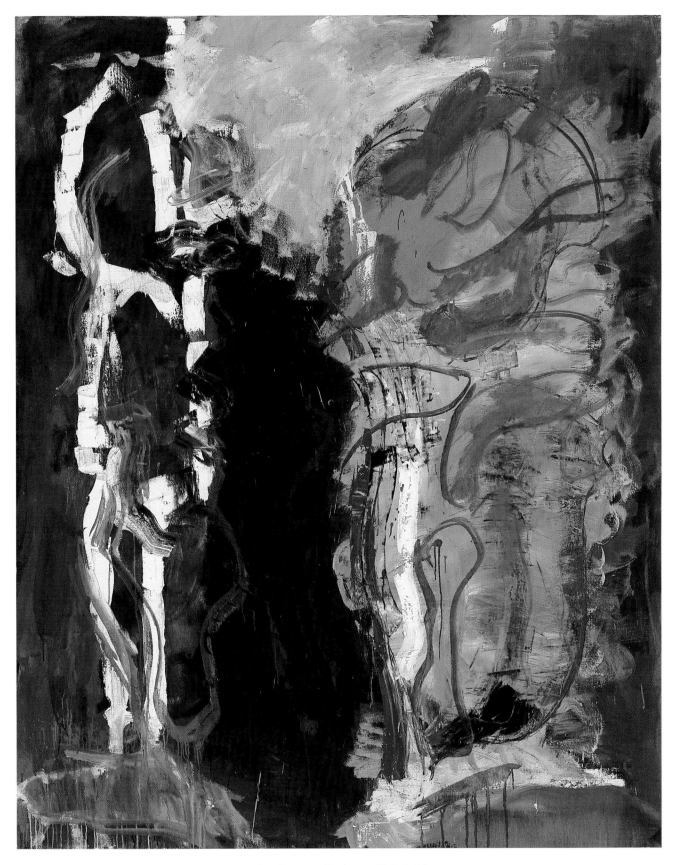

PER KIRKEBY *Shadow*, 1986 (cat. 50)

GEOLOGICAL FAULTS

PER KIRKEBY

Berlin is, of course, just as provincial as Oslo, or Christiania. That all places are provincial lies in the movement of thought between the places. Thus artists are always moving in certain stages of their life. The German wants to go to Italy and the Scandinavian to Berlin. More in order to follow the movement of thought than to get there precisely because it is there or thereabouts.

These momentous movings about are different from other journeys or tourism and holidays. They are an expression of the ability to track down an 'inner necessity'. In principle one could really just as well live in one place as another. All provinces are just as good (almost, all that about returning comes later).

Moving and the 'inner necessity' thus belong together: the 'inner necessity' suffers by being stuck in immovable structures. Only in those pictures where the structures are sliding and changing deep down under the 'surface', only there is the place to be (even if they are, paradoxically enough, pictures with an almost petrified surface and a caricatured subject – from Runge to Munch). Such a disquieted 'inner necessity' compels an important moving about. Which is more important, more dangerous and less chic than travelling to 'where it is all happening now'. This is not the leap of the cockerel.

That this is the way it is, one can see from the remarkable spaces that such movings about create. The Germans in Rome; not all of those who travelled for the colouristic possibilities but just the Nazarenes. And Thorvaldsen from Copenhagen to the Rome of the Germans. And Munch and Strindberg in Berlin. Zum Schwarzen Ferkel. Strindberg and Munch to Berlin; that is a moving about that really crosses frontiers. They did not travel to anything, they created something by moving. Zum Schwarzen Ferkel became the German-Nordic space of 'Symbolic Expressionism' (dreadful terminology, I would really rather say Zum Schwarzen Ferkel).

These spaces that arose from the border crossings are what is 'above' the provincial. It is the movement of thought, it is the sliding structures. And there is nothing about grasping something in flight, one must oneself slide with it.

So always take note of the foreigners. Amongst them are some who have moved about so that it creates pictures. There are also, of course, many burnt-out tourists in the artistic area.

The best always turn back home, back to where they came from. This move is just as important as the outward journey. For those who turned back have an opportunity to measure 'the slide'. And only by turning back does one thus cut all ties, overstep the borders in earnest. He who comes back is a border crosser. 'Do you notice the stench' said Munch, when he was back in the rooms at Ekely.

And if, however, one is that far out, one could just as well renounce completely all reasonableness and understanding. In that way a shocking Spätwerk* like Munch's occurs. Work that is far from understood in its full insight and pain. A concentration that is often misinterpreted as practiced arrogance or decline of ability. Germans move about too little, they travel around enough but those decisive movings about are rare and neither are there to be found very many appreciable Spätwerks in the Munch sense in German art history.

But – as the Danish poet Drachmann wrote home to the newspaper in his Berlin letter of 1894, 'Currently the world is Berlin. And this world does not open itself up just as easily for all Scandinavians'.

Thus, as a sort of resumé: I believe that there is something 'Nordic', a spirit, a light, a quality of colour, that says all. But I also believe that the Nordic can only become visible in the border crossers. Like Munch, Jorn. Only by stepping over the frontier to the south is the painter liberated from another Nordic characteristic; carefulness, 'sense', the need for legitimation. Only by travelling from this neo-Nordic 'virtue', does the painter achieve the freedom to let the enormous Nordic banality come into sight.

From *Natural History and Evolution*. Translated by Peter Shield
Haags Gemeentemuseum, 1991
Originally published as *Naturhistorie* (1984)
and *Udviklingen* (1985) by Borgens Forlag, Copenhagen
*Late work

LIGHT

PER KIRKEBY

The world is chaotic, physical, incomprehensible – darkening fog. Incomprehensible – like meditation's attendant. But quite certainly chaotic and physical. It is not 'reality'.

Here a circle of order can be tentatively created. A cave of light. Because it almost always looks like a cave. Caves are set-pieces. ('The scene is where the light is lit.' Peter Laugesen). The light from the cave opening, the light that is often reflected up into the cave's inn'ards, the inner light; this light seems to promise visions. But in the light in the cave opening there is always another cave opening. A dark pane, a door in the wood. Of course the light is, in the nature of things, an illusion. An illusion to be painted. Strindberg's forest tunnels. A cave with openings at both ends is a tunnel. The reflected light from sources in the end inexplicable is the clair-obscur metaphor.

The light of the opening advances in the hermits' caves with the passage of time. Glows in the depths of the forest, in Claude's setting sun. Peeps out in Turner's youth, advancing more and more into his cave, too late to spread itself as sole ruler of the whole surface. Terror and mirth. The late almost-monochromatic Turner paintings, where the trembling touches of uncertainty, of being so much alone with the unseen, make ripples, they can become monsters. Monsters of the surface, not firm structures pretending to be in control of the surface, but the surface's own protuberances.

Another great surface, a great light is found in Mondrian. In Mondrian we have this apparent rule of that stormy, seeping light. Especially in the serious paintings from the thirties. There it is firmly held and with what moral seriousness. Later and especially, of course, in the New York paintings it breaks down. The light conquers the grid with a charming and close grimace. But look how, in the beginning, the light advances in Mondrian. The strident coloured symbolic-naturalistic things are without much light. Then comes the tree series, that long succession of indicative nature studies, that are always arranged as if it is the branchwork of the tree that is stylised to the horizontal and vertical lines. But I think the critical part is what is happening between the branches. It is the light pushing forward. It is reflected so that the paint stops being coloured and becomes mild and full of light: the light's dustlike materiality advances, making the strokes thin. Between the strokes there is light, as with Hammershøj. The light is about to win, to push out over the whole surface, but by a moral exertion Mondian is successful in establishing the black grid. The moral in the exertions is a conviction about the new order.

From *Bravura*, 1981. Translated by Peter Shield
Published in English in *Selected Essays from Bravura*, Van Abbemuseum Eindhoven, 1982
Translator's note: Peter Laugesen (b.1942), contemporary Danish poet. Vilhelm Hammershøj (1864-1916), Danish painter with a finely nuanced and restrained palette.

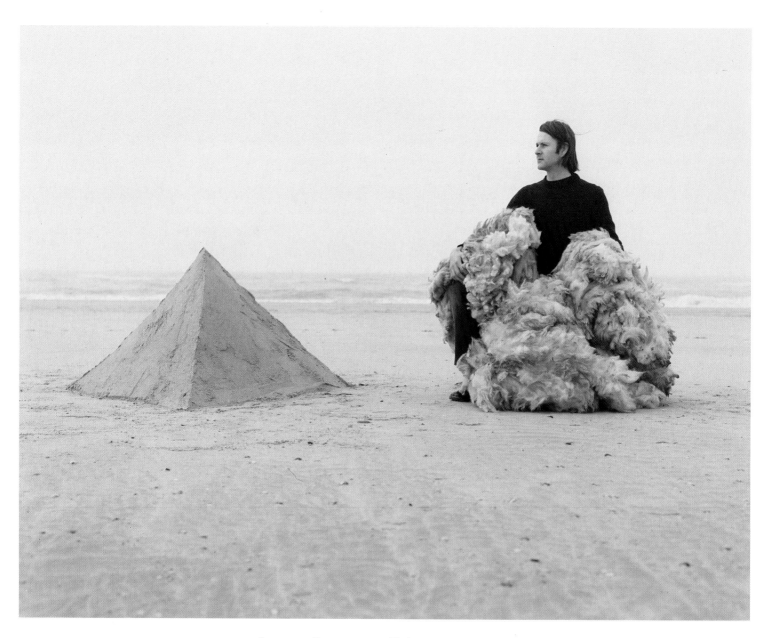

SIGURDUR GUDMUNDSSON *Mathematics*, 1979 (cat.6)

SIGURDUR GUDMUNDSSON
(b.1942)

HOCUS POCUS

'For what is art if not the chemistry, the hocus-pocus which warms and energises us.'

Sigurdur Gudmundsson, 1991[1]

A flat northern shoreline, the sea, with its sliver of white foam edge cuts the image in half. The horizon line is punctuated twice; to the right, by a man posing for the camera – Sigurdur Gudmundsson the artist – chieftain-like, in a black turtle neck pullover with a fleece of wool draped over his knees. He gazes along the coast, eyes slightly screwed. To the left, a pyramid of sand, solid against the chill air. A pale light pervades the whole. The image is *Mathematics* (ill.opp), one of a group of photographic 'Situations' by Gudmundsson dating from the 1970s.

'My art begins where my thinking leaves off' declares Gudmundsson.[2] Like a mysterious evocation, Gudmundsson believes that the meaning of his works can only be intuited, and that they remain impenetrable to all but those who love them. In *Mathematics* there is an echo of Munch's *Two Women on the Shore* (ill.p.2) or any one of his images which play upon the symbolism of the shore as a boundary zone between this world and the next, between rational experience and the subjective world of dreams and emotions. For Munch also dealt in images from the unconscious, shapes and forms that he only half understood. And yet there remains in both works the traces of an idea, a residual concept – a symbolic idea if you like. The only artist to whom Gudmundsson has made a literal reference in his work is Munch. In *Landscape – Glass* from 1986 (ill.p.123), Gudmundsson has taken Munch's famous 'moon column' and made it hang in real space; organic, fragile and transparent.

Hamsun understood that the heart held an otherwise 'closed kingdom' that might suddenly reveal itself to those who searched hard enough.[3] In the same way Gudmundsson believes 'a good work of art is the finger print of a soul.'[4] He describes his work as being in search of a truth, and talks of how: 'It is life itself that urges me to make art; it is the ebb and flow, day and night, sun and rain, love and grief. To listen to these voices is like assuaging an appetite. My art is to do with things that actually exist, but that I do not yet know.'[5]

Cue Strindberg as 'rational mystic', whose writings and investigations into natural phenomena (see p.40) mix a potent brew of science and poetry, and we see something of Gudmundsson's sensibility here also, as in *Collage*, 1979 (ill.p.119), for example. He starts with an idea which has crisp, conceptual boundaries but the final work itself defies rational interpretation and the truth which emerges is beyond language.

In *Event*, 1975 (ill.p.10), Gudmundsson, in a raincoat, buries his head under a wet paving stone – a monument to late twentieth-century angst. These 'Situations' of his make us smile and at the same time applaud this theatre of the mind and body, in which the artist himself takes

centre stage. Resonances again of Munch naked in his garden at Åsgårdstrand in the summer of 1903 (ill.p.48); so too, of Strindberg picturing his life at Gersau in 1886 (ill.p.29) in a series of dramatic tableaux. For these too are performances of sorts. And yet, Gudmundsson is no Nietzschean super-hero and his photo-works have none of the same drive to disclosure and confession that operates with these other two *Border Crossings* protagonists. A Dutch art critic, Lily Van Ginneken has called Gudmundsson an 'exotic' and spoken of the 'enticement' of his work,[6] alluding to the way his images cast spells on us all too readily smitten beholders. The simple poetry of his images, like Munch's woodcuts from the 1890s, embed themselves in our subconscious playing upon unspoken desires and lost memories.

Other writers have talked of Gudmundsson as a shaman mediating between the elements, the earthly and the cosmic, the material and the spiritual. An interpretation which is borne out by Gudmundsson's tale of his coming of age as an artist: 'I was baby-sitting for a couple I knew. It was the evening and I was sitting on the arm of a chair... then suddenly, from one moment to the next, I experienced a surge of well-being in my head, in the form of a clarity which I had never known before. I had the idea that I could understand countless different things at the same time...'[7] A striking parallel is suggested by the extraordinarily prescient passage from Hamsun's *From the Unconscious Life of the Mind* (see page 57), in which he describes the artist as someone who is susceptible to 'wordless and irrational feelings of ecstasy... in the midst of a carefree hour.'

Tellingly, Gudmundsson draws a parallel between his own attitudes and that of the medieval Icelandic Saga writers. He recognises their poetic spirit with its lack of sentimentality in his own work. Unlike those nineteenth century Romantics, Friedrich and Dahl[8] among them, who trembled beneath storm driven skies and stood precariously on the edge of turbulent seas, gazing out into the unknown in wonder, Gudmundsson places himself within, and not in conflict to nature. Images like *Mathematics*, *Composition* and *Collage* suggest a kind of courtship ritual with the elements, one in which Gudmundsson is equal partner.

It is well known that Iceland, in which nature is palpable and so particular, exerts a powerful pull to those who have left it in search of new horizons, and commentators have been quick to point to an evident longing in his work for his country of birth. Most Icelandic artists, like Kjarval and Gudnason travelled abroad but ultimately returned to stay, but for Gudmundsson this turning back remains, as yet, something only dreamt of. He, himself, quite freely admits that his work is partly motivated by homesickness.[9] In a work such as *Molecule*, 1979 (ill.p.121), his passage is made real, a journey which Gudmundsson explains as 'a consequence of a nostalgia which relates to both the future and the past', where he anticipates 'a memory for something which has yet to happen. An ability to remember the future.'[10]

Admirably idiosyncratic, Gudmundsson's photographic 'Situations' result from his distinctive sensitivity, humour and imagination. But the qualities to be found in them also arise out of the fusion of influences in his art, of which there are two principal, not unrelated aspects. The first is his essential poetic spirit, to which we have already made reference, and that links him indubitably to the whole, much elaborated, Northern Romantic tradition. The other, is his debt to Fluxus, an international movement dedicated to liberating art from its traditional association with the object.

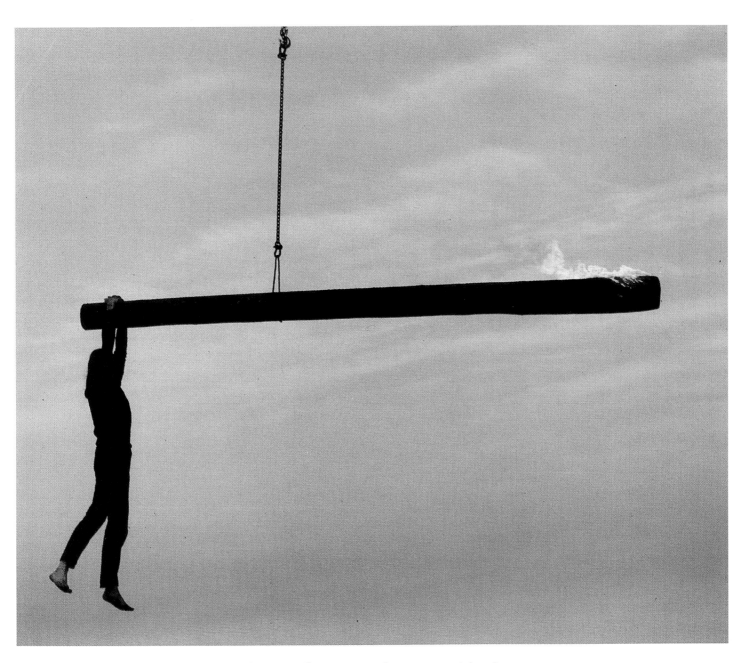

SIGURDUR GUDMUNDSSON *Composition*, 1978 (cat.3)

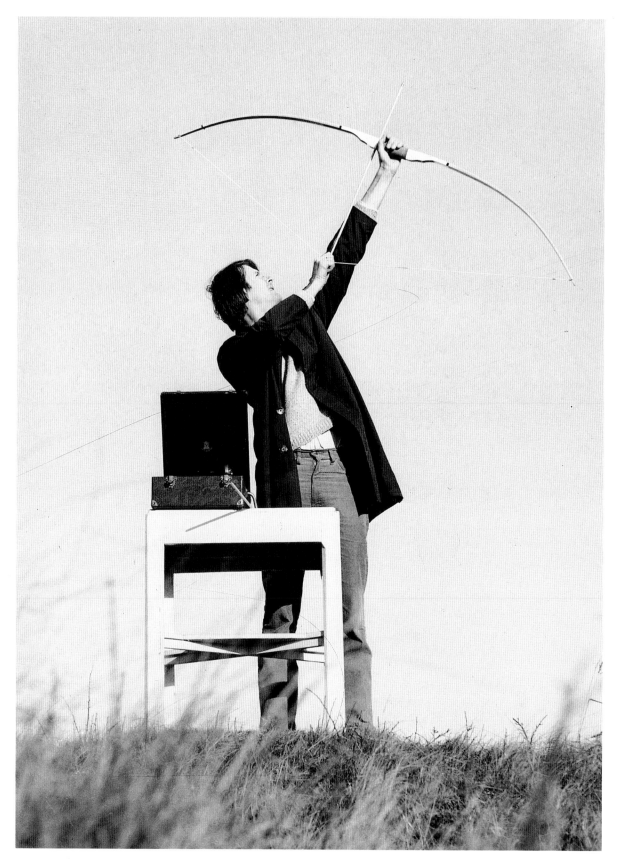

SIGURDUR GUDMUNDSSON *Hommage à Grieg*, 1971 (cat.1)

SIGURDUR GUDMUNDSSON *Un mobile*, 1979 (cat.4)

Anarchic and performance orientated, the proponents of Fluxus stressed immateriality and ambiguity over the cool rationality that characterised it's off-shoot, Conceptualism, and the reflection of affluence and throw-away culture engendered by Pop. Fluxus was altogether more literary than these other artistic tendencies that criss-crossed the Atlantic, and as such, struck a chord with Icelandic artists whose sensibilities were already heightened by the vivid and passionate world of myths and legends told in the Sagas.

Gudmundsson remembers becoming 'weak at the knees'[11] on seeing a photograph of Joseph Beuys with his bleeding nose in the 'Crucifixion performance' at Aachen in 1964. The appeal of Beuys' performance lay in its combination of darkness and humour. Like Beuys, Gudmundsson's project in the 1970s was to place the poetics of human experience at the centre of art, an attitude consistent with Munch's existential aesthetic, and his belief in the mystical world of 'newborn thoughts still not properly formed.'[12] But it was the German artist, Dieter Roth, who introduced Fluxus to Iceland in the mid-1950s acting as an intermediary between the burgeoning, vital art scene in Iceland and contemporaries on the continent such as Beuys, Daniel Spoerri, Robert Fillious and Emmett Williams.[13] These artists, among others, showed work

SIGURDUR GUDMUNDSSON *Homage to Henri Rousseau*, 1980 (cat.8)

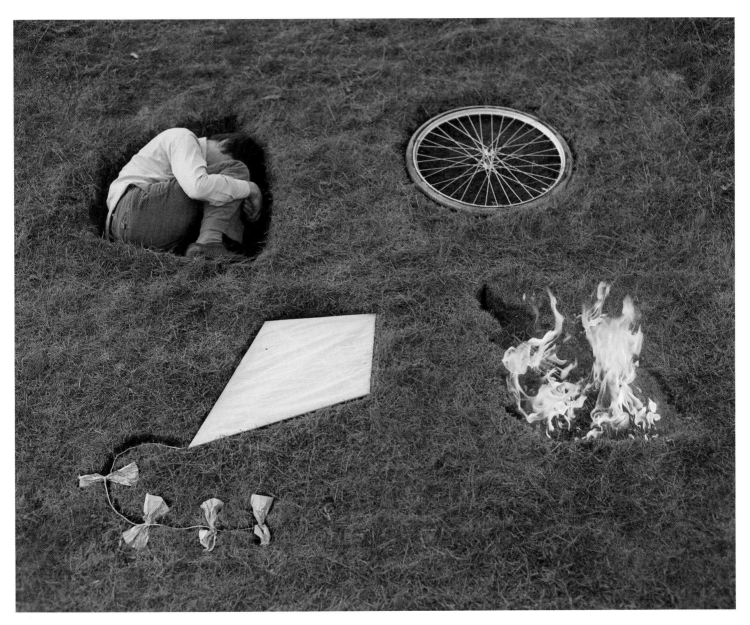

SIGURDUR GUDMUNDSSON *Collage*, 1979 (cat. 5)

alongside Gudmundsson and Roth at the international *SÚM II* exhibition in 1969. Gudmundsson had returned to Iceland from The Netherlands in 1966 and during the next four years he and his brother Kristján were at the forefront of radical developments there.

Fluxus, as described by one of it's founders, George Maciunas, was to be 'simple, amusing, unpretentious, concerned with insignificances, require no skill or countless rehearsals, have no commodity or institutional value.'[14] This kind of thinking is more apparent in Gudmundsson's work from the Icelandic years, 1966-70, but the 'Situations' too have an extraordinary freshness. In *Event* for example, Gudmundsson's debt to Maciunas' credo is clear, in particular the artist's keen wit off-sets any easy romantic interpretation. Notable too is the fact that Gudmundsson's 'Situations' were printed as unique objects and not multiples. He has never been concerned with the technical or reproducible potential of photography.

By the early 1980s Gudmundsson felt that he had taken the 'Situations' as far as he could. The Fluxus artist Nam June Paik had declared that if something is too involved, too elegant, too professional, then something is wrong.[15] And so it was with Gudmundsson. Presumably this theatre of the self no longer held the same magic for him. Since the beginning of the 1980s Gudmundsson has developed his ideas in absentia, apart from a recent work *Encore*, 1991, which marks Gudmundsson's long awaited return to the photographic stage. (JA)

1. From 'Dear Marlene, Dear Siggi' in Exh.Cat. *Sigurdur Gudmundsson*, Má og menning, Reykjavik, Vitgeverij Van Spijk, Venlo, 1991, p.236

2. From *Notes 1974-1980*, see p.122

3. Knut Hamsun *From the Unconscious Life of the Mind*, see p.57

4. From *Notes 1974-1980*, see p.122

5. Quoted by Lily Van Ginneken, in Exh. Cat. *Sigurdur Gudmundsson*, 1991, op cit, p.70

6. Ibid,p.70

7. Quoted by Robert-Jan Muller in 'The Shaping of the Artist', Exh.Cat. *Sigurdur Gudmundsson*, 1991, op cit, p.6

8. Johan Christian Dahl (Norwegian, 1788-1857) Caspar David Friedrich (German, 1774-1840)

9. See, for instance Exh. Cat. *Sigurdur Gudmundsson*, 1991, op cit, p.228

10. Ibid.p.228

11. Interview recorded in Amsterdam, December 1988. Published in Exh. Cat. *SÚM 1965-72*, Municipal Art Gallery, Reykjavik, 1989, p.161

12. Munch wrote: 'the mystical will always be with us... a whole mass of things that cannot be rationalised – newborn thoughts that are still not properly formed', Nice, January

1892. From Munch's *'Violet Book'* (OKK 1760). Quoted in Ragna Stang *Edvard Munch: The Man and the Artist*, 1979, p.74

13.Adalsteinn Ingolfsson has written at length about the importance of Roth's presence on the SÚM group in Iceland, see *Northern Poles*, Bløndal, Copenhagen, 1986

14. Quoted by Adalsteinn Ingolfson in 'Iceland' *Northern Poles*, Bløndal, 1986, p.87

15. Discussed by Per Kirkeby *Bravura*, Van Abbemuseum, 1982,p.24

SIGURDUR GUDMUNDSSON *Molecule*, 1979 (cat.7)

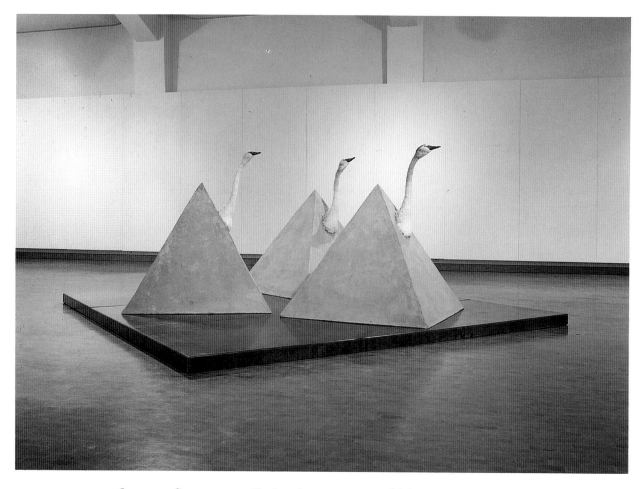

SIGURDUR GUDMUNDSSON *The Great Poem*, 1980-81, Stedelijk Museum, Amsterdam

My art begins where by thinking leaves off.

Feeling is more precise than the intellect.

All destinations are provisional, everything which has been achieved then disappears.
That is why God cannot believe in God.

Art is a product of feeling and can therefore only be consumed intuitively.

My work is not the result of a study of expressive means but rather a consequence of an attitude to life.

Just as fire cannot burn on its own smoke, I cannot use my work to advance anywhere.

The impulses to make art come to me less and less from what happens in art. I get them almost exclusively from daily life: from ebb and flow, sun and rain, day and night, love and grief.

Only by loving and cherishing the work can you travel through the landscape of art. Therefore my work can only be understood by those who love it.

The quality of every work has to do with the relationship between the maker and the result.
A good work of art is the fingerprint of a soul.

With every work I make I feel that I am becoming wiser, as if my soul had acquired a new wrinkle.

Each new work, no matter how unsuccessful and stupid, stands at the tip of the pyramid of everything I have made.

I see being an artist as a large one-man enterprise. Large, because art itself can engage with everything. One-man, because admission to this 'everything' is an intimate occasion.

Sigurdur Gudmundsson
Notes 1974-1980

Landscape by the sea

Sigurdur Gudmundsson

The Queen of Beauty is a remarkable phenomenon. In the world of religion and politics she was often taken for a whore – not that anybody in those circles knew her personally, but it was known that she had relationships with both men and women and that everybody who wanted to be her lover had to pay for the privilege. That was the explanation.

When I first met her, I was in a sort of landscape by the sea. She was standing ankle-deep in water, behind her there was a sea with an endless horizon. I looked at her and felt a mixture of infatuation and physical desire. Agitated and diffident, I stood facing her. She stood still and showed no noticeable interest in me. Her stance was expectant, clearly I had to take the initiative. I embraced her and now I too was standing in the water. She blew in my ear – it was her condition – the price. I obeyed, erased my past and made love with her.

I am not telling fables here – a good detective could still find evidence now, twenty-five years later, of this encounter.

I have met her a few times since then. The meeting place is always a different landscape, but always beside the sea. Each time she makes her condition and demands something from me which I would have preferred to keep, something I considered indispensable to my continued functioning. Submissively, I have had to relinquish it.

Recently, she took my total vision of this life. Before this, she had taken away my taste and, something which I find quite embarrassing, my creativity. Her demands are pitiless, there can be not bargaining with her, her word is law.

In order to continue being her lover I have to keep going further into the sea. It is as if she has a plan. Perhaps she wants to entice me to an uninhabited island and if that island is far from my coast, then I will arrive without baggage.

Berlin, September 1987

Sigurdur Gudmundsson *Landscape – Glass* 1986
Private Collection, Switzerland

MARIKA MÄKELÄ

(b.1947)

SOMEWHERE WITHIN

The secret world that many of Marika Mäkelä's paintings inhabit is an enclosed and enveloping space. It may be the deepest and darkest interior of a wood, where only the slightest glimmer of light penetrates through the high, leaf-clad branches.

A slumbering animal awakes, a flower opens into stillness.

Or is it a tomb with its damp silence and signs of remembrance. Hidden in time: sacred heiroglyphia, the stories of past lives.

Somewhere in India a woman drops an amulet into a deep well.

This interior realm is also the womb – the precious centre, where life begins, the root of all mystery.

Somewhere within, she felt its movement, the first stirring of new life.

Now, the quiet rhythmic processes of nature, the ceaseless passage of life and death – the vast undercurrent. Listen: somewhere in the north the wind catches the upper reaches of a pine and a small speckled egg falls to the ground and breaks.

Encrustations of gold, swathes of lapis lazuli. A centre of ecstasy. A complete fulfillment.

Mäkelä's is undoubtedly the subtly intuited and erotic response of a woman. (JA)

MARIKA MÄKELÄ *Signed Place II,* 1990
(cat.57)

MARIKA MÄKELÄ *Signed Place III*
1990 (cat.58)

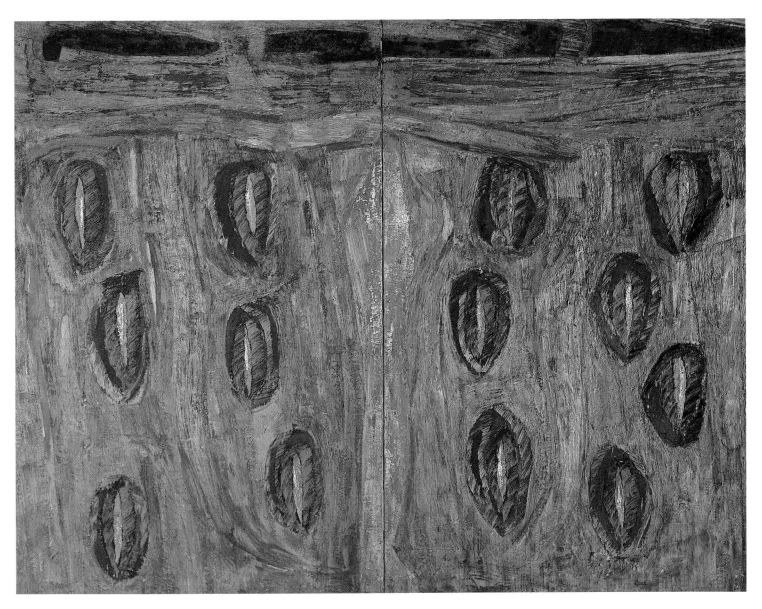

MARIKA MÄKELÄ *Small Sacrileges*, 1990 (cat. 56)

OLAV CHRISTOPHER JENSSEN

(b.1954)

SECRETS

A lightly layered and tactile surface gently resonating with modulations of colour. This first impression of a painting by Olav Christopher Jenssen is of something mysterious but familiar in its organic formation, where residues of pigment coalesce around enigmatic embryonic shapes. It is as if matter has crystallised around a central focus, or gradually been deposited in the way that stalactites and stalagmites form, growing slowly and imperceptibly. Yet the analogy may suggest a solidity and permanence that does not belong to Jenssen's paintings. His forms are often ghostly and insubstantial, like ether, suggestive of fluctuation; an integral transience.

The process of discovery that we go through in looking at Jenssen's work, in which the hidden properties of the painting gradually begin to reveal themselves, is akin, in some ways at least, to the development through which Jenssen takes his works. A creative course in which a series of reflections and shifting phases gives form to paintings which are neither wholly abstract nor figurative.

Immersing himself in painting, Jenssen works close to his canvases until they are complete, all the while an observer of the effects and changes that arise during the course of his work, nurturing images into existence. Jenssen begins with a memory, an association, or perhaps just an evocative phrase or string of words. Each is then given form intuitively on canvases laid out on the floor of his studio in Berlin. Jenssen works in a quiet mode that allows a thought, an intuition, to develop slowly over time, through a period of gestation, which may finally be resolved spontaneously and quickly. Doris Drateln has described this emergence of the work as a 'fermentation'[1] in which the substance of his materials is allowed to evolve and transform itself, changing its nature in a kind of effervescence. Such parallels with the intricate workings and constructs of nature, and their constant state of flux, are readily evoked by Jenssen's methods.

But this is not to suggest that, for Jenssen, the process of painting is a hermetic one, purely based around chance effects or the intrinsic qualities of matter. The idea or feeling that sparked the inception of the work continues to infuse and modify the painting in its making. Further responses and associations, as well as experiential memories in a broader sense, are inevitably called up as a part of the continuing process.

In so doing, of course, Jenssen draws from his own being, but this is not the enlarged 'self' projected onto nature, nor the confessional urge or examination of the ego that Strindberg or Munch went through. The time is a different one and Jenssen's personal sensibilities are interwoven more closely as part of a natural current, in a more positive affirmation of existence.

Yet there is something in Jenssen's intuited, almost instinctual approach that he shares with these earlier figures. His work suggests an intimate world of inner feeling and inflections of emotion, a reminder of the desire expressed by Hamsun, one hundred years previously, to call

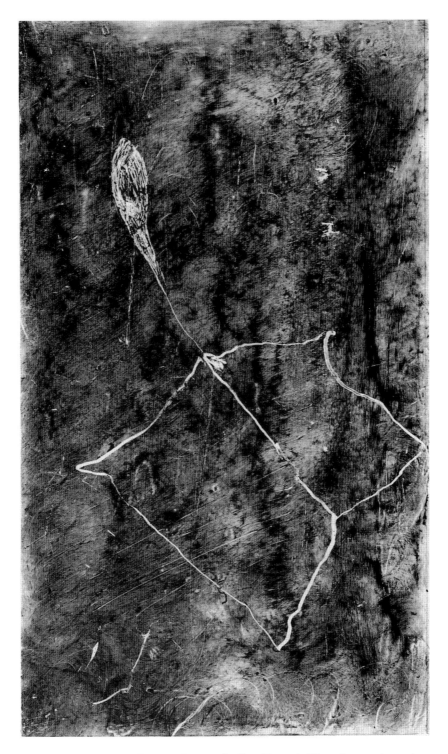

OLAV CHRISTOPHER JENSSEN *Drawing for Knut Hamsun's 'Hunger'*, 1990 (cat.39)

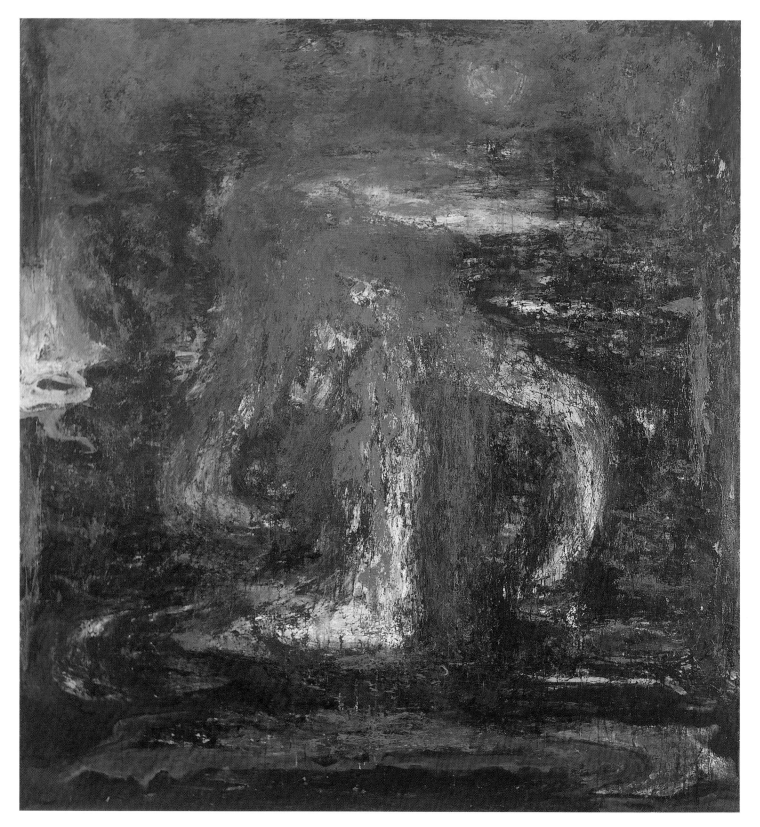

OLAV CHRISTOPHER JENSSEN *The Great Icelandic Poet*, 1986 (cat. 37)

up the very 'whisperings' and 'subjective knowledge of the blood'; to explore the 'fragile fantasies that exist within us.'[2] This underlying affinity must be one of the main factors that recently led Jenssen to make a series of drawings as illustrations for a new edition of Hamsun's novel, *Hunger*, in which the interior world of the soul is laid bare.

In Jenssen's delicate and intimate drawings for *Hunger*, the inner states of being that Hamsun describes with such intensity are transposed into organic form. The scale of these works determines that you peer into them, as you look into a microscope, to find fragile criss-crossing lines hinging around a singular motif. Images that also suggest fossils bearing the imprint of a fern or some past organism. (ill.pp.127 & 130)

In their biological simplicity, Jenssen's drawings for *Hunger* bear a striking resemblance, though not a consciously made one, to Strindberg's experiments in quite another medium – photography. Strindberg recorded night-time skies and cloud formations, hoping that his 'celestographs' would capture the true essence of natural phenomena. He also made photograms of ice crystals and hoar frost in different temperatures and conditions in order to, similarly bring out the 'microcosmic secrets'[3] of nature (ill.pp.4 & 43). Though made without such direct reference, Jenssen's drawings have the same intricate, crystalline and cell-like structure as these photograms; a microcosm of nature.

Other drawings by Jenssen, where similar organisms and cellular shapes appear, give an indication of the kind of layering of images that he uses to make up his paintings. Underlying traces of earlier formations are partly hidden, partly revealed, beneath the semi-opacity of their waxy surface which adds to the evocative quality of the whole. His paintings are, in the same way, a culmination of a series of fleeting moments each of which have left their mark. Paint residues and thin washes build the surface and the image emerges, as if from within.

The painting *The Great Icelandic Poet*, 1986 (ill.opp.), bears all these qualities and has a fiery resonance; like a black crystal, even its surrounding darkness resonates with colour, and an energised touch suggests imminent change. The central image is inexplicable, an enigmatic figurative presence. Jenssen has named the painting after a friend, the Icelandic poet and painter, Sigurdur Gudmundsson, also shown here in *Border Crossings*.

My Father's Land, 1987 (ill.p.131), has resonances of Munch in its evocation of a landscape of watery pools and mountains. In this magical, moonlit scene, Jenssen refers in part, with a longing or even nostalgia, to his homeland, Norway. The mood of the painting is calm and pensive; it has the quality of a dream or memory. Images have no fixed shape or definite meaning, but are strangely poetic. The focus an oval, womb-like form, shrouded and protected, the painting is suggestive of the mysterious power of nature, and its potent equilibrium. (CB)

1. Doris V. Drateln, 'Be strong and pass by', in Exh. Cat. *Olav Christopher Jenssen*, Galleri Riis, Oslo, 1990 p.13

2. Knut Hamsun, in *Samtiden*, 1890

3. August Strindberg, quoted by Rolf Söderberg in *Edvard Munch, August Strindberg, Photography as a Tool and an Experiment*, Alfabeta Bokförlag, 1989, p.33

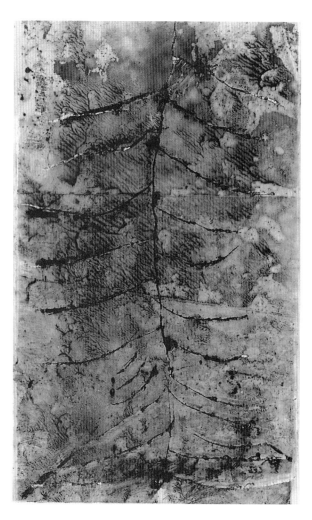 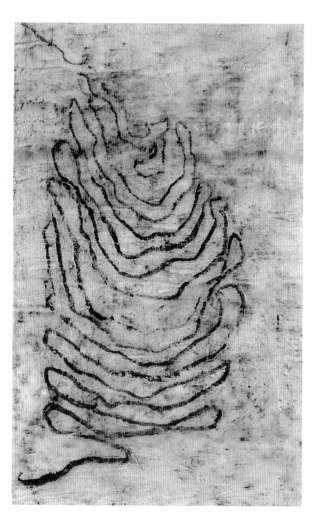

OLAV CHRISTOPHER JENSSEN *Drawing for 'Hunger'*, 1990 OLAV CHRISTOPHER JENSSEN *Drawing for 'Hunger'*, 1990
(cat. 39) (cat. 39)

OLAV CHRISTOPHER JENSSEN *My Father's Land*, 1987 (cat.38)

HULDA HÁKON

(b.1956)

LOOKING TO THE SKY

Heidi Berlin, the German shepherd, walks with me every day to the studio. She is my good friend and most obedient model.

This old lady died in my house. I think she is still around.

The drift ice that comes from the arctic is beautiful, but its turquoise colour is not convincing.

Comments by Hulda Hákon, 1990 [1]

Hulda Hákon speaks of life with a matter of factness that acknowledges the reality of the ordinary, the every-day. But with equal ease she talks about spirits as if they were of no greater, nor lesser significance than walking the dog. It seems quite appropriate then that here, in one of her major works to date, *Self-portrait with Seven Ghosts*, 1988, (ill.p.134-5) she should portray herself in such company – with her ancestors perhaps, or the spectres of her imagination.

In her reliefs or tableaux of painted wood and modelling paste, Hákon presents incidents in which ordinary people are confronted by nature in all its awesome force, or are set beside imaginary figures born of stories and dreams. More evocative than literal, the tales that Hákon tells in these enigmatic scenarios have an absurd and gentle humour. They provoke us to question what two women are doing 'taking advantage of a situation beside the waterfall',

HULDA HÁKON *Looking to the Sky*, 1989

(ill.p.133), and to wonder at the outcome of a 'meeting between two men, a woman and a sea monster.'[2] But her humour is also accompanied by a quiet and thought-provoking lyricism. Both *Self-portrait with Seven Ghosts*, 1988, and *Looking to the Sky*, 1989, where gazing figures float weightless in seemingly endless space, are suggestive of an existence beyond the rational and material.

This is not the unrestrained expression of emotion that we find in Strindberg, nor the extraordinary intensity that we associate with Munch. Nevertheless, Hákon seems to share with these artists a belief in the intrinsic importance of the subconscious and intuition, which for her, is bound up with the myths

and legends of Icelandic culture. She delights in the possibilities that are opened up by irrational feelings and the mysterious stories or fables with which she grew up, relating childhood memories of her grandmother, who told her to 'keep quiet around certain stones on her farm' so as not to 'disturb the elves.'[3] It is as if the magical is always close at hand and the uncanny commonplace.

Echoes, again here, of Munch, who drew from the unconscious and readily spoke of the transformation of nature into imaginary beings, describing 'strange rocks which mystically rise above the water and take the forms of marvellous creatures which ... resembled trolls...'[4]

HULDA HÁKON *Two Women taking advantage of a Situation by the Waterfall,* 1990

Hill's world, too, is peopled by beasts and demons that sprang from the darker side of his imagination. His prophet-like figures facing the maelstrom of the flood have the semblance of legendary characters caught up in an eternal battle. More dream-like and lyrical in approach, Kjarval fuses Icelandic legend with personal experience. The ritual passage from life to death that he describes in *The Sailing of Regin,* 1938 (ill.p.76), with its symbolic, protective guardian spirits, finds a resonance in Hákon's *Self-portrait with Seven Ghosts* and her ghoulish fellows of an interim world.

Having been brought up in Iceland, Hákon went to New York, initially to study, in the early 1980s. Icelandic mythology was already an important element in her work, partly, as Halldór Björn Runólfsson has observed, out of nostalgia and a longing for her home country, but also 'in order to maintain close ties with a popular culture whose poetic and eccentric authenticity she revered.'[5] Her own wooden constructions with their fanciful figuration do seem to be rooted in traditional practice, resembling the polychrome altarpieces that once hung in Iceland's protestant churches, and nineteenth century folk art, of which the painted wooden sculpture illustrated here is an example.

Sculpture on gable end of a farm building, South-Tingey district, Iceland

An illuminating parallel is also found in Asger Jorn, for whom the subjective spirit was also linked with the power of mythology. Fascinated by primitive societies, he saw folk art as an expression of a collective unconscious. He hoped to tap this essence in his own work, seeking archetypal symbols that would be capable of liberating the imagination. By evoking a similar kind of dream world, Hákon places herself within a re-assuring continuum in which mythology plays a vital and enduring role as a means of embodying the unspoken desires, fears and emotions that direct us.

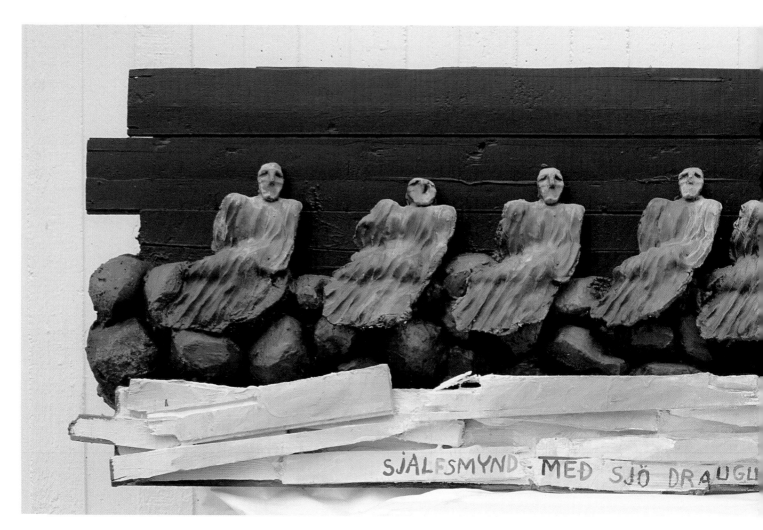

HULDA HÁKON *Self-portrait with Seven Ghosts*, 1988 (cat.11)

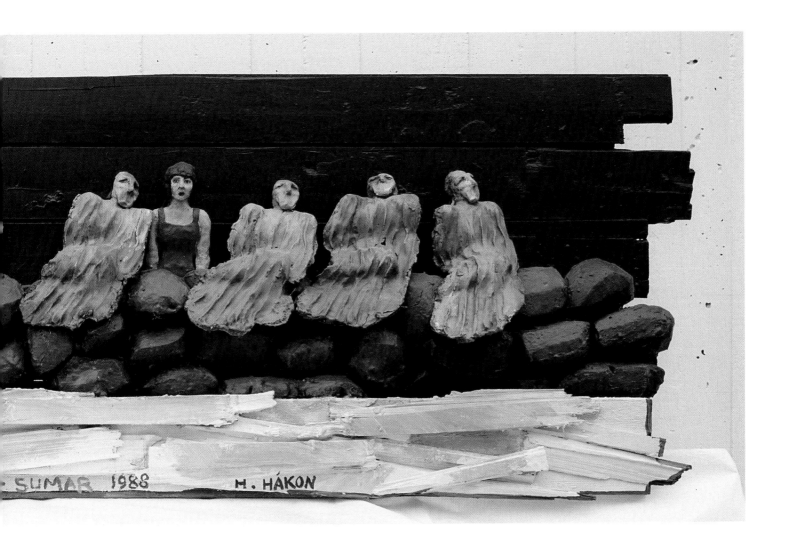

On returning to Iceland, Runólfsson notes that Hákon became more critical 'Not of the myths in themselves, but of their appropriation and incessant exploitation...'[6] and this stance may well be one of the factors that has given her work its critical and ironic edge. As Maaretta Jaukkuri has noted, the central role in most of these staged dramas is played out by a 'nicely-behaved, proper person.'[7] Hákon depicts these controlled, 'normal' individuals as being evidently of the present day, in contrast to the timeless spooks of her imagination. With their bland suits, plain dresses and blank expressions, they seem to indicate the uniformity of society and its indifference to essential values. Taking *Two Women taking advantage of a Situation by the Waterfall*, 1990 (ill.p.133), as an example, the two participants here confront one another, static, oblivious to, and seemingly unaffected by the tremendous force beside them.

However, Jaukkuri has also proposed that 'Hákon is in no sense a moralist in her art,'[8] that she feels a sympathy for her characters and their eternal search for happiness. Indeed, the stormy skies, cascading waterfalls, and burning fires in her reliefs can be seen as motifs that she uses not simply as a telling contrast to the mood of her characters, but to indicate the potential of these passive figures to experience extraordinary emotion.

Such references to the raw energy and apocalyptic power of nature take us back to Hill and especially to Strindberg, with his interest in natural phenomena. Importantly, they also act as quotations from a romantic tradition, as notations of the sublime, where the individual stands in wonder before the great unknown, overwhelmed by the scale and incomprehensibility of the universe. Halldór Björn Runólfsson in 'Fire, Fire, Burning Bright...'[9], relates Hákon's 'prophetic' and 'portentous' works to Turner, whose own spectacular, elemental motifs express the mysterious power of nature. In her work, such imagery provides a key note; an atmospheric and psychological charge that engenders a sense of prescience and foreboding.

Yet there is also a playfulness in Hákon's allusions to nature and its wiles that reminds us of the poetic work of her compatriot, Sigurdur Gudmundsson. Indeed, her approach shows something of the same sensibility as Iceland's Fluxus inspired artist's of the 1970s – Gudmundsson included – whose resistance to rationally defined meanings finds a sympathy in her own sense of ambiguity.

Language is one of the means Hákon uses to suggest possibilities rather than fixed definitions. Each relief carries an apparent description, but her phrases are like riddles, containing puzzling paradoxes that prompt further thought. Hákon combines this as a factor alongside mythology, the sublime and her observations of behaviour, bringing these elements together in what Jaukkuri has aptly described as a 'multi-layered discussion between the concepts of the true and the dreamed, the imagined and observed.'[10] As she does so, balancing poetic intimacy with a more measured approach, Hákon calls into question the very nature of what is 'real'. In *Self-portrait with Seven Ghosts* she, as Gudmundsson, stages the self, and in placing herself somewhere between this world and the next, among spirits, she questions our perceptions of reality and offers the imaginary as an essential part of existence. Hákon touches on matters of significance, but never loses sight of the ordinary, which like her humour, acts as a mainstay. As she says:

'My grandmother wants me to make nice pictures.

I try.

Being pretentious in an unpretentious way.'[11] (CB)

1. Hulda Hákon quoted in *The Readymade Boomerang*, 8th Biannale of Sydney, Australia, 1990

2. The full title of the work made in 1989 is *Meeting (Two Men One Woman and a Monster from the Sea)*

3. See Hákon op cit

4. Edvard Munch, as quoted by Bente Torjusen in *Words and Images of Edvard Munch*, Thames and Hudson, 1989, p.121

5. *Flash Art*, March/April 1991

6. Ibid

7. Maaretta Jaukkuri, 'Hulda Hákon and Memory of a Tale', in Exh. Cat. *Hulda Hákon*, Galleria Okra, Vantaa, 19.8-16.9.1989, p.10

8. Ibid, p.11

9. 'Fire, Fire, Burning Bright...' in *Siksi*, Nordic Art Review, 3/1990

10. See Jaukkuri, op cit

11. See Hákon, op cit

HULDA HÁKON *Dogs, Men and a Burning House (Detail)*, 1990
Courtesy the artist

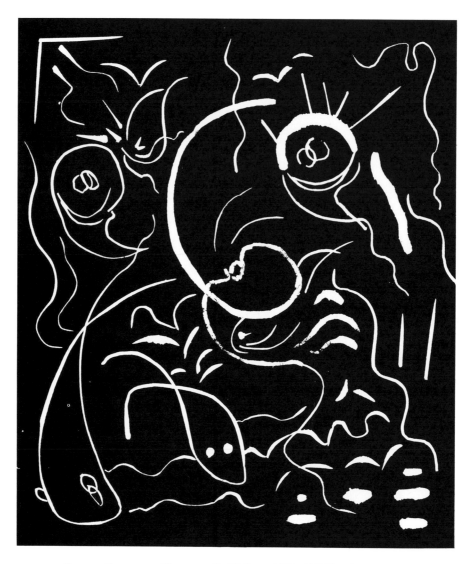

SVAVAR GUDNASON *Illustration for 'Helhesten' [The Hell Horse]* c1941-44

Two Masters from Iceland:
Kjarval and Svavar

Thor Vilhjálmsson

How gracious on the part of providence to grant a resurgent nation, after ages of alien yoke, a genius such as Jóhannes Kjarval; bestowed on the Icelanders stirring on the morn of a new era. It is only recently that art, in the sense we generally employ the term, came to be practiced in Iceland. Not so long ago the pioneers were still with us, the first to dedicate themselves to painting and sculpture.

The glorious past loomed in the trembling mirage and was never quite lost in the mind of the long starving people of Ultima Thule. The golden age of the Sagas and of the Eddas which rose into luminous universal importance in the Middle Ages was followed by significant achievements in other fields of culture in step with this literary eminence. Besides illuminated manuscripts there was also a richness in the plastic arts, with architecture of astonishing dimensions, such as the churches at both the bishoprics in-country, Hólar in the north and Skálholt in the south. Here there were also the largest wooden houses at that time in Europe, amply decorated and furnished with treasures.

But all this cultural richness that blossomed during the medieval ages, degenerates with the downfall of Catholicism in the middle of the sixteenth century and the advent of Protestantism, which was a catastrophe for the Icelandic nation. The Catholic Church was the last authority able to resist foreign regal power, and thereafter commenced a period of encroaching and enveloping darkness. In 1262 the Icelanders lost their independence; first accepting union with the royal house of Norway and later that of Denmark.

We shall not go down into that deep dark night, gently nor otherwise. Jóhannes Kjarval was born in 1885, and when his talents began to shine the word artist had barely come into use. At that time the whole idea of art would have sounded suspect. The people would have thought that the artist was either trying to wriggle out of the daily toil, from laziness, or that he had been struck by a meteoric fragment or an ice splinter from the shattered mirror of the dire witch-queen of a celestial ice castle in a Hans Christian Andersen's fable. In Iceland people always believed in the magic force of the word, the power of poets to conjure forth ghosts from their graves, sending them on errands and gaining power over them with a well-turned verse. But art, was there any such thing accepted in Iceland at that time? Any diversion from the merciless struggle for survival would be considered a misfortune, if not a damnation.

Kjarval was born in the south-eastern part of Iceland, under the shield of the largest glacier in Europe, Vatnajökull, in an isolated delta between two torrential rivers. His family was one of many in which food was scarce and where the only pastime besides fabulating was begetting superfluous children. So, at four years old Kjarval was put on top of the sacks on one of the postman's horses, firmly tied to the saddle and together they set out on a immense journey over sand and lava and rivers and mountains to arrive days later at his uncle's house where there was enough food for him as well. Now he would grow up strong and sturdy, in fit shape to face all the adversities that fortune offered an artist, a pioneer of art, a genius.

Here in the north-east of Iceland, Kjarval lived in one of the low turf-roofed farmhouses which barely emerged out of the landscape. This was the popular academy of story-telling, fables, yarns, the Sagas, poetry and folklore. Kjarval was disciplined early by hard work on his uncle's farm near the sea, and later on as a fisherman. As a young man he left his schooner and went to work in a bookshop in Reykjavik where he bought all forty Icelandic Sagas published; the handiest edition which still filled an entire shelf. He then packed his fisherman's suitcase with extra socks, ties, underwear and some stationary on which to report the marvels of the world; majestic palaces and heavenly churches, art and ideas; and set off to London to conquer the world from there.

Once in the great metropolis he soon discovered Turner

thus finding out about himself and the nature of his own gifts. After a year he set off again, this time for Copenhagen, by then also familiar with Marconi's invention of the wireless, and settled down to study at the Royal Academy of Art. Here Kjarval worked hard to acquire the technique that would enable him to freely express the richness of his mind, the tumult of his emotions and the urgency of his Icelandic message in the universal language of his craft, his art.

At times during those years Kjarval felt it an unnaturally heavy burden to carry on his shoulders the responsibility for all those lost ages, all the talent wasted, to speak for all those ages of Icelanders who never had the opportunity to express themselves; for all the dreams, sorrows, joy and yearnings of all the generations of his people silenced by outrageous fortune, one subdued generation after another crushed by natural calamities such as volcanic eruptions and epidemics. It seemed almost too much to bear while his creativity was growing, his wings stretched.

In Copenhagen he also found love, married a Danish writer, and soon there were two children. Two years later, in 1917, his studies at the Academy were concluded. He stayed for a spell in Copenhagen, intermittently travelling to other countries, hoping to sharpen and extend his artistic outlook and technique, whilst savouring new ideas and cultures. He spent a fertile period in Italy in 1920; in Rome, Florence and Naples; and painted in Iceland during summertime. Kjarval settled in Iceland in 1922, where he then lived for good, except for an extended stay in Paris 1928, and some brief journeys abroad.

It seems extravagant to use the term 'to settle down;' for after he and his wife separated in 1924, when she returned to her native Denmark with their children, his life resembled that of nomad, inflamed by his passion as a painter and secret vows of devotion. His country was not prepared for such a blessing of providence. Though conditions of life had improved fast with independence regained, economic conditions were far from satisfying for an artist. But the Icelanders can hardly be blamed for finding Kjarval difficult to understand. He was soon a living legend, due to his eccentric appearance, weird acts and outpourings that smacked of oracles.

Though he had fixed places to stay, he moved around Iceland according to his inspiration, setting up his tent in the wild and sacred places he discovered among the mountains of Iceland, and peopled this desert with his flaming visions. After his years abroad he trained himself to harmonise with the whims and caprices of Icelandic nature, surviving and retreating as need be before tempests and fury; with scant provisions in fickle weather. Sometimes he was blessed by mildness and splendour but was prepared for adversity. He discovered how to paint though it rained, and he continued painting when it was so cold that the lid on his paint froze and he had to explode the tube to get to the colour. He protected his hands by anointing them with codliver oil and availed himself of his physical strength to work under conditions impossible for lesser persons.

Kjarval was unpredictable, always fresh and unexpected on his canvases as well as in his personal appearance. The first painters had advocated beauty and far off vistas in Icelandic nature, the soothing serenity, the classical beauty. But Kjarval evoked nature's drama. Iceland is not mild, it is harsh, rough, wild, savage and awe-inspiring. He introduced the close-up and thereby changed the outlook, the vision of a whole nation. He painted stones and rock, lava; the terrifying wasteland of the Icelandic scenery. And he portrayed the rugged wrinkled faces of the Icelandic farmers and fishermen, unembellished, the obstinate survivors, lasting and enduring through all their tribulations of fortune. He pryed open the rocks to disclose fermenting dreams and fables, oracles. A painting by Kjarval offers layer upon layer upon layer of myths and tales, and discloses embedded figures, masks and faces in amongst cliffs, moss, rocks and lava.

His production was unbelievably prolific and varied. Nobody knows the limits of it. Many a humble abode was turned into a palace by a painting Kjarval left there. All his life was devoted to his art, to enrich those around him, stir their senses, make people alert to the adventure of existing. He possessed the power to enchant by his art, and in daily life his inventiveness with words and acts could turn dull moments into sparkling adventures, and a dreary day into a fountain of delight, greyness into bubbling wells of colour seeking form.

Kjarval died in 1972 at the age of 87. When he was a young man in Paris he looked out of the window in the morning and asked: 'Fait — il beau, petits oiseaux?' 'Is the

weather nice today, little birds?' They approached on their wings replying: 'Il fait beau', 'It is nice today', 'Il fait beau'. Then Kjarval asked: 'Est-ce-que je vivrais longtemps?' 'Shall I live long?' And the birds answered: 'Oui oui oui' – 'yes yes yes'.

Of all those who later emerged, Svavar Gudnason is closest to Kjarval, although their respective careers followed a very different path. Svavar is as steeped in nature as Kjarval, but has chosen an entirely different means of expression, for he avails himself of Icelandic scenery, nature, its weather, its light and play of shadows, its dramatic power within the realm of abstract painting. He is virile and obstinate and irrepressible as well.

He grew up in Hornafjördur in the south-east, not far from Kjarval's place of birth on the land between the two torrents, a stone's throw from the afore mentioned glacier shield Vatnajökull. Svavar also takes off for Copenhagen to devote himself entirely to his art as Kjarval had done some decades before. He was born almost a quarter of a century later than Kjarval, in 1909, when conditions had changed entirely; but now he had to face the great depression between the two World Wars.

Svavar's approach at the outset of his career has been widely contrasted with that of Kjarval, for like him, he felt that everything at the Danish Academy was dusty, crumpy, degenerated and outdated. By some marvellous intuition, and led by providence, he understood what was needed for his skills to blossom, and became sure in his approach, wasting no time in detours. He was entirely devoted to his calling as an artist in a manner reminiscent of Kjarval before him. He did not hesitate to brave hunger, and he soon found kindred spirits among Danish artists and others who introduced revolutionary methods in their art. Together these comrades in arms launched an entirely new trend, bringing about some of the most interesting pictorial inventions in modern painting at that time. They grouped under the name 'CoBrA', coined as a result of taking the first letters of their respective cities: Copenhagen, Brussels, Amsterdam. Under this banner these pioneers, radicals and revisionists became world famous. Svavar is the most original and closest to nature of them all, imbued as he was by his heritage and upbringing upon the enchanted scene of Icelandic nature.

Shortly after the end of the Second World War Svavar returned to Iceland. By then he was considered one of the foremost pioneers of modern art in the Nordic countries, and his renown was growing into international stature. He gave in to the urge to obey the call of nature, the magic of his country with its constant provocation in colours and form, although inevitably this entailed a certain isolation from the international art market. The general public in Iceland was not ready for his greatness, but he was fiercely acclaimed by those who were eager for something new and unexpected. These supporters were fascinated by Svavar's powerful new means to express himself, which he merged with the ancient truths of his ancestors, the perennial messages of the land with its light, darkness and weather. But as an international artist he responded to the claims of his own times, being ancient and contemporary at the same time.

His art is full of contrasts; lyrical interludes in delicate hues of colours provide a respite from the torrential surge of sweeping movements in form. Svavar is well versed in the use of strong virile oils; his paintings reminiscent of compositions by Bartok in which rough and gentle elements are combined, especially in the poetic, almost oriental handling of his water colours and his joyous use of crayon.

Svavar was not an easy man to deal with if he was not approached in the right manner. He was proud and obstinate. His art was powerful and always dominated by an unfailing instinct, firm common sense and clear-sighted intelligence.

His health failed prematurely, and in 1987 Svavar died.

LAND OF SHADOWS

EDVARD WEIE AND PER KIRKEBY

DORTHE AAGESEN

'In the north there are a lot of shadows. There are far more shadows than people. In the south the shadows are sharper and clearer. It is easier to talk to them. In the north, they dance sad waltzes with a sigh of rapture... The Nordic shadows tear themselves loose. Fragments which become independent... Is a shadow something? Shadow is at any rate just as much something as light is light. But shadow is also more than just something atmospheric. Shadow is a shadow.'

Per Kirkeby, 1991[1]

Although separated by more than half a century and all that means in differences of artistic conditions, close bonds connect the work of the two Danish painters Edvard Weie (1879-1943) and Per Kirkeby (b.1938). They are both so obviously preoccupied by the purely painterly, the struggle with the material of paint itself. Both work in close dialogue with nature, where they find nourishment for artistic development. And both are driven by a longing for the absolute, the realisation of the great Romantic work.

Weie has been called 'a modern classicist'. His early work is allied to 19th century French Naturalism, and in the twenties and thirties he went on to develop an art based on a deeply subjective experience of colour. In this respect he was amongst the most significant standard-bearers of modernistic painting in Denmark. In spite of his modern anchorage, Weie found himself increasingly out of step with his contemporaries. Unlike them, his aims were moral, romantic and visionary at a time when Romantic idealism was *passé*. Indignantly, he took issue with the empty decadence and lack of artistic purpose he saw around him. Instead, Weie sought a spiritual dimension borne on emotion, 'The Return of Poetry'.[2]

Weie's colouristic sensitivity is evident in the landscapes he painted during his recurrent stays on the Baltic island of Christiansø. There he roamed on the rocks and soothed his frayed nerves in the untouched idyll of natural surroundings.

In a letter of 1913, Weie describes his impressions of the island:

'... today I am simply surrounded by a blaze of almost southern nature and the most sonorous colours, where the Baltic adorns itself in Mediterranean blue and the rocks absorb the light so that they resemble a huge collection of oriental fruit in the clearest yellows and saturated orange...'[3]

This description could also be true of the picture *Sunlight on the Sea, Christiansø* (ill.p.67), painted that same year. Here the subject is captured in broad, textural strokes. The rocks stand as if actually built on the picture's surface; a play of warm colours against the cool blue of the sea. A low incidence of light permeates the canvas, colouring the sky golden and sparkling on the water.

Lyrical depictions of nature alone could not satisfy Weie's artistic ambitions. His goal was to create a new romantic art which would elevate the vast drama of existence with a sublime monumentality. Based upon the thorough study of nature and guided by Romantic music, art was to be formed of sheer sonorities and thus free itself from the earth-bound state of the old naturalism, in a move towards the supernatural. A lost 'poetry' was to be recovered – Weie's ringing Neo-platonic term for a metaphysical, more *real* reality.

The so-called 'compositions', three of which are shown in *Border Crossings* (ill.p.70,71,73), preoccupied Weie and it is in these that he sought to realise his ideal vision. His subjects most often have their origin in literary or mythological themes and it was not unusual for Weie to draw inspiration from the great masters of art history. Pictures by Rubens, Böcklin, Correggio and Delacroix, underlie Weie's transformed versions.[4] The original works stimulated Weie's Romantic inclinations. However, Kirkeby writing about Weie's art has speculated that his subjects may be feigned, in his attempt to elicit an underlying passion or drama, the picture's 'true Motif'.[5] It is characteristic of Weie that in

these Romantic compositions he gradually relinquishes the naturalistic point of rest in a move towards a pictorial idiom where colour and texture carry expression in themselves.

A significant step along the way towards a non-figurative idiom is Weie's *Romantic Fantasy*, 1920. From the explicitly dramatic depiction of Poseidon, who rushes foaming over the sea, where its expressive force results from the subject as well as the execution, the drama in *Romantic Fantasy* is by contrast transposed into the gestures of painting itself. The picture's most conspicuous allusion to something, a remnant of the motif, is the figure resting in the foreground. It is in marked contrast to the chaos of its surroundings. Fragments of landscape and textural strokes are interwoven in a diffuse scenography: unstable and transitory, articulated in a dramatic interplay between light, shadow and colour – Weie's reinterpretation of the Baroque. Here, we are far from the light-filled and sharply defined representation of nature at Christianso. The shadow has made its dramatic entrance. It is pitted against a cold white light, a light radically different from the warm glow that permeates the early picture. It is the abstract light of the composition.

The drama of the painting does not only reveal itself in the colouristic struggle between light and dark, but is strengthened by a compositional turbulence. Kirkeby talks of the 'profoundly baroque centrifugal space',[6] of Weie's 'Romantic Fantasies'. And true enough, an explosive force in the heart of the picture seems to force its components towards the outer edge. Thus, paradoxically, the recumbent figure enters a dynamic vortex. Moreover, violent and at times desperately mixed and unarticulated brush-strokes are added to the colouristic and compositional dramatics. In a close and partially conflict-filled dialogue with his material, Weie searches for an understanding of his subject. His inner struggle is transposed into an external one played out on the canvas.

The spontaneous abstract dimension of Weie's art culminated in 1930-35 with a re-creation of Delacroix's painting *Dante and Virgil in the Underworld*. For almost fifteen years, Weie had been working on various versions of his copy and nurtured high hopes of the final result. In 1931, he wrote of the picture:

'In order to prevent any misunderstanding about the designation "Copy", then what I am doing is nothing

in this word's ordinary meaning, in the sense that I am copying Delacroix. My ambition goes much further and consists of linking up with the dramatic line in painting that was broken with Delacroix's Romanticism and has in fact not been to the fore in art since, and for this I have used Delacroix's subject, which in this connection is a completely trivial and secondary matter.'[7]

Trivial and secondary, because Weie's *Dante and Virgil* speaks its own abstract language. Brilliant colouration, strong contrasts and an expressive painterliness in which the paint trickles down the canvas, evokes the drama which is the essence of Delacroix's picture: Dante and Virgil on their boat-trip to Hell, a journey from light to the land of shadows. The drama of life and death.

Kirkeby observes that the forms in Weie's copy of the Delacroix appear to fight their way out of the shadowy space which characterises the original; a struggle with the shadows that in later paintings leads to a sort of minimalistic purification.[8]

Kirkeby's artistic background is linked with the commotion that arose in the sixties when currents from American Minimalism and Pop Art poured into Denmark. He allowed himself to be carried on that wave and, even though this can be difficult to recognise at once, has never freed himself from its influence. The special thing about Kirkeby's minimalism is that it acts in a tense dialogue with his urge towards the opposite, the expressive use of colour and texture. And it is this Romantic longing for intense authentic expression that links him with Weie.[9]

The 'iconoclastic storm' of the sixties, as Kirkeby described Minimalism's endeavours to purify artistic expression of all suggestive qualities and contextual references, obviously placed his painterly yearnings in a negative light. Most important at that time was a recognition of the underlying disintegration of existence, which made the idea of the absolute all the more doubtful. Just as in the first decades of the century, when Weie was at odds with the contemporary scene, so Kirkeby struggled with 'this fear of being left behind, simply retarded, clinging to an outmoded medium

like painting'[10] with 'the anxiety of becoming such a lyrical, sensitive painter'.[11]

One way out of the dilemma was to think of tactile surfaces and expressive brush-strokes structurally, to understand them as formal signs, where any layers of meaning were merely superficial 'impurities' without validity. Art became an analytical reworking of structure, an attempt to derive systems from the world's throng of materials, thereby legitimizing the use of the enchanting material of paint.

Kirkeby's background in the natural sciences was, and remains, a support for this investigatory approach to structure. As a geologist he is educated to understand nature in a way which involves carefully registering the qualities of matter. In the late seventies he combined this understanding with a romantic enjoyment of texture resulting in a shift away from his earlier more analytical systematism. Transparent layers of colour and texture are now integrated in monumental compositions, such as in *Untitled*, 1978 (ill.p.103), in which cascades of atmospheric light stream from the picture. An architectonic zigzag structure the only remaining remnant of motif – a veiled trace of memory.

Kirkeby understands the painting process itself as a parallel to nature's alternation between sedimentation and erosion, a metaphor for the interplay between remembrance and oblivion. As a consequence, his paintings create a world in constant movement towards a new and changed state.

Relativism as the basic condition of modernity separates Weie's Romantic aspirations and those of Kirkeby. As a child of the 19th century, Weie had not yet lost the belief that he could compensate for the loss of context that marked his existence with pictorial art. Painting was to elevate the drama of life but also to point beyond it to the true and the eternal. It was this perfect and transcendent work that Weie was so laboriously struggling towards. Kirkeby, on the other hand, in the spirit of the sixties, has to take account of a disintegration. His great romantic endeavour is real enough, but only as an existential drive towards insight and clarification. It is this impetus that drives an endless process of enquiry that links one painting to the next. However, there is no resolution to this search of his. The individual work is just an interim stage, a provisional message, of which Kirkeby is painfully conscious.

Although the absolute requirements of the Romantic ambition have today lost their credibility, Kirkeby attempts, in spite of everything, to establish a foothold in his otherwise fluctuating reality. The shadow is one means toward this end. His *Untitled*, 1980 (ill.p.105) parallels Weie's *Romantic Fantasy*, in the struggle of light and dark, out of which a diffuse baroque space arises, and where mysterious depths loom behind abundant painterly super-impositions. In a painting from 1986 (ill.p.109) however, the shadow takes on a stronger independent character. A shadow being fleeting, transitory – a void – paradoxically appears as a firmly anchored monumental presence in Kirkeby's painting.

In contrast to Minimalism's pure, rationally conceptualised ideal of form, the shadow is for Kirkeby an 'impure' fragment. It is all that 'the iconoclasm' forbad; mobile, ambiguous, associative, emotional. It is of sensory life, and above and beyond all else represents death. Weie fought against the destructive forces of the darker side. He attempted to drive death away from both his life and art, whereas Kirkeby incorporates the shadow as an artistic and existential necessity. Ultimately death is the only thing of which he can be certain.

Translated by Peter Shield

1. Per Kirkeby, *Håndbog*, Copenhagen, Borgen, 1991, p.120

2. In the twenties and thirties, Weie expressed his views in a number of critical articles, some of which remain unpublished. His most weighty text, 'Poetry and Culture', composed in the last year of his life, was only published after his death. Here he turns sharply upon his contemporaneous artist-colleagues, criticising the 'mental lethargy and artistic impotence' of the Danish people and attempting to explain his own visionary ambitions.

3. Letter to his friend Ellen Rostrup, 18 May 1913. Quoted in Exh. Cat. *Edvard Weie*, Statens Museum for Kunst, Copenhagen, and Aarhus Kunstmuseum 1987, p.121

4. Lennart Gottlieb elucidates the thematic meanings attached to the models. 'Mennesket, dramaet og maleriet' (Man, drama and painting) in exhibition catalogue *Edvard Weie*, op cit (note 3)

5. Per Kirkeby, *Edvard Weie*, Copenhagen, Edition Bløndal, 1988, p.9

6. Ibid p.29

7. Letter to Leo Swane, 21 September 1931. Quoted in Exh. Cat. *Edvard Weie*, 1987, op cit, p.158

8. Per Kirkeby, op cit (note 5), p.17

9. Kirkeby's views on art can be traced from his comprehensive literary output.

10. Per Kirkeby, *Selected Essays from Bravura*, Van Abbemuseum, Eindhoven, 1982, p.21

11. Per Kirkeby, *Brauvura*, Copenhagen, Borgen, 1981, p.20

MAPPING THE INFINITE

HALLDÓR BJÖRN RUNÓLFSSON

We can pick any generation of modern Nordic artists and find that each have inherited a number of unaccountable contradictions, of an intrinsic and extrinsic nature, that sets them apart from the rest of their Western colleagues. Without mystifying this state of affairs, one can say that due to specific conditions, mainly geographical and cultural, Nordic art has evolved differently from the rest of European art. Since every European nation has its specific character when it comes to cultural expression, it would be wrong to exaggerate the Nordic difference, but omitting it altogether would be equally erroneous.

The Nordic countries, a vast, natural wilderness — the largest unexploited land mass in Western Europe — has a powerful influence on the culture of its inhabitants. Except for Denmark, which is quite densely populated, the rest of the Nordic countries are only partially and sporadically inhabited. A large proportion of Nordic people, therefore, live in remote regions and are to a degree isolated. This is the main reason for the solitude that is often attributed to the Nordic character. Far from being a feeling of loneliness, this solitude is rather a way of life, where nature — a silent substitute for direct social contact — plays an important role as partner, interlocutor and model of inspiration.

It is difficult to overestimate the influence of nature on Nordic art. It's dual effect — on the artist's subject and on the subject matter of his art — makes Nordic art less intellectual and less philosophical; hence less cultural than its European counterpart. Often it serves as a means of expression for the inarticulate who dread discussions and distrust verbal powers. Such an art is bound to be mystical, poetic and subjective, which is true of modern Nordic art in general. Yet, since it lacks the awe of the sublime and a contempt for classical values it is not romantic in the true sense of the word. Presumably, nature is still too much a part of the Nordic environment to be regarded as a reality forever lost. Instead

of yearning for the return of unbroken natural harmony, which is the essence of the romantic, melancholic mood, a good number of Nordic artists seem to be able to address nature as if it was not only surrounding them, but also a part of their inner selves. They identify with it spiritually, and instead of trembling in the face of its sublimity they rather take its infinity to be a token of their unlimited imagination.

This is a pagan attitude since, to a certain degree, it refutes the idea of cultural hegemony, above all its advance on nature in the name of artificial sophistication. An aversion to cultural mannerisms is undoubtedly the main reason why Nordic art has so often deviated from other European tendencies. For too long this explicit position has been interpreted as a psychological persistence favouring Expressionism, as if that particular stylistic trait suited the Nordic mentality above other types. Out of pure folklore a number of Nordic art historians have supported this idea, believing Expressionism to be a modern version of the old 'Viking' spirit. This theory cannot explain why so much of Nordic Expressionism looks calm, respectful of classical sobriety. It forgets that paganism does not necessarily entail abrupt rudeness; that classicism and stoicism — the peaks of natural sophistication — are among its creations, while Expressionism, as it has come to us, has its origin in the Dark Ages of barbaric Christianity.

It seems obvious therefore that Per Kirkeby's classical investigation into proportion, unity and detail, which he summed up in his gigantic hommage to classicism from 1966, *Das Urteil dae Paris*, is as suggestive of Nordic art as Munch's violent and ethical existentialism. Taking into account their differing periods and social circumstances, the spiritual difference of Munch and Kirkeby can hardly be narrowed down. To use the word Expressionism of both artists shows to what extent our terminology needs revision. Despite Kirkeby's fiery colour and aggressive execution, there are no traces of Munch's psychological crises, or spiritual anxiety in his works. Instead, they are full of the serene, atmospheric

splendour and a balance between calculation and spontaneity one finds in bucolic landscapes from Pompeii to the present.

In that sense Kirkeby is not only on the move geographically, he also crosses historical borders. His works are full of direct and indirect references, especially to the technical history of art. In *Look Back II* (ill.p.108) from 1986, whose nostalgic title and abstract classicism might well refer to the myth of Orpheus, Kirkeby casts a new light on the old pictorial problem of figures in landscape. Could this be the distinctive Danish seaside; it's steep cliffs and bright, sandy beaches which Kirkeby has infused with an amazing atmospheric brilliance? And it even suggests the Classical colouristic allusion to the paleness of the female figure and the suntanned male. Rather than referring to such a work as Expressionistic, or narrowing its possible content down to simple geological references – the white form would be the Geyser, the orange form and red lines would be the volcanic eruption and the title would refer to the artist's former profession of Geologist – one is tempted to invoke the term Impressionism, or even Fauvism, whose pastoral subjects seem spiritually quite close to Kirkeby's erased, or hidden motifs.

Marika Mäkelä also erases figurative elements by integrating them as symbols into the pattern of her decorative landscapes. Nothing of Kirkeby's lucid, Apollonian attitude can be detected in her works. The primitive, poetic aspect with references to animism is as opaque as Mäkelä's technique, a piling up of thick layers of dark colour and a pigment on large canvases. The result is a relief-like surface chiselled by brushstrokes forming a pattern akin to the regular structures of fibres in a tapestry. To a certain extent these paintings are related to the popular traditions of Northern Finland, but by crossing the border between localised folk art and international modern abstraction, Mäkelä has been able to bring a fresh impetus to both fields. The transavantgarde breakthrough in the late seventies and early eighties made such dialogue between local characteristics and international currents easier in Finland and other Nordic countries and thus created the possibility of a certain traditional revival.

Mäkelä's shamanic means of expression; the vision of the dark woods with the golden symbols shining like mysterious charms, could be classified as Romantic if they were not such

an integral part of her whole being. She does not observe her imagery from the outside as a nostalgic folklorist would do, but from within as a Dionysian Expressionist; a Norn* trying to withhold and strengthen the power of the symbol, which is vital to her personal vision and to the integrity of the tradition she comes from. If it perished so would everything her shamanism stands for and art would ultimately fall prey to a harsh, indistinct rationalism. That would confirm the fragmentation of our vision and put an end to any quest for re-unified meaning, which is the prime objective of the animistic ritual. In this sense Mäkelä is not far from Baudelaire, except for the fact that she seems to understand the esoteric whispering of the natural pillars. Her problem is not the reconstruction of the symbolic network, but how to keep its whispering alive in today's careless world.

It has been said that Olav Christopher Jenssen is spiritually closer to Kirkeby than to any other artist though their style and methods differ greatly. It is true that Jenssen, like Kirkeby and Mäkelä, is a natural painter. Yet, out of the simple fact that a good deal of his subject matter and technique in the eighties can be traced back to the Nordic tradition of nineteenth-century landscapes, his spirit is nearer Romanticism than theirs. Instead of Kirkeby's intensive use of opaque colours, Jenssen bases his paintings on more transparent layering, meticulous working of colours and dramatic contrast in light. The luminous quality of his painting comes from the centre and diffuses with a curious lustre towards the edges. This not only enhances the Romantic mysticism, which is as theatrical as the most dramatic of Friedrich's landscapes, it also turns Jenssen's best works into precious objects, highly wrought exquisite talismans.

As a draughtsman Jenssen is wide-ranging and imaginative. The spontaneity, which is often denied him in his paintings, gets a free play on paper. Towards the end of the last decade he integrated this free drawing into his paintings, shifting his attention to the biological side of nature. In the curiously shaped objects he draws, it is as if Jenssen, a fervent advocate of non-verbal expression, has conjured up an unreal folk-tale world of strange happenings and monsters. No less Romantic than his haunting landscapes, these beautiful works reinstate humour into Jenssen's painting, a dimension found in his earliest works. The eccentricities which fill his drawings

*In Nordic mythology, a female soothsayer.

are probably a Norwegian coastal trait that Jenssen has taken with him to the Continent.

If people find it hard to understand Romanticism mixed with humour they must think of Sigurdur Gudmundsson as an extremely difficult artist. Even if one concentrates solely on his photographic pieces from the seventies – the so called 'Situations', of which he only made one copy – one soon finds that their range and variety is enormous. Some are definitely more serious than others, although the humour is there most of the time. It is as if the artist, like Chaplin, or Keaton before him, had suddenly discovered how much seriousness it takes to be truly funny. What adds to their complexity is the fact that the humour cannot be located once and for all. It runs around from one place to another, either hiding beneath the conceptual content, the perceptual situation, or the title of the work.

Event, from 1975, shows a man on his knees hiding his head ostrich-like under the pavement. In a letter to Marlene Dumas, Gudmundsson describes the work as being one of his few nostalgic pieces dealing with the feeling of homesickness. Still, the spectator is bound to laugh aloud at this awkward situation.

Molecule, also from 1979, would not be humorous at all if it were not for its title. It helps alleviate the melancholy invested in the poetic situation, which tenderly describes profound loneliness. By locating himself at the centre of each situation, which can be interpreted as sheer narcissicm, or as an urge to self ridicule, Gudmundsson disturbs the often highly Romantic message, which might otherwise easily become too sentimental. No wonder Olav Christopher Jenssen should pay homage to Gudmundsson by calling a painting of his *The Great Icelandic Poet* (ill.p.128).

In many ways Hulda Hákon's wooden reliefs are reminiscent of Gudmundsson's photographic 'Situations'. However, in her intriguing works she relies less on her own presence than on a theatrical setting of anonymous figures. Where Gudmundsson is philosophical, Hákon indulges in modern story-telling, even epic myth-making based on an Icelandic narrative tradition where rhythm and movement are better understood than static representation in space. In this sense she crosses the borders of past and present, showing that what is actual is only that which was always there. But Hákon

also crosses geographical borders by working in a similar way to visual story-tellers from the Continent and North America. Situations are created in order to illuminate what is typical, or specific to modern times. In her reliefs she can be both poetic and sarcastic, critical of social attitude, or open to the caprices of Romanticism.

It may be far fetched to say that Hulda Hákon is Joycean, but her modern folk tales are realised through humour in a comparable way. Some of this humour is often difficult to follow because of the twists and turns it takes. Her *Self-portrait with Seven Ghosts* from 1988 (ill.p.134-5), shows her in the company of nine ghosts, not seven, as could be expected from the title, which is also written on the piece. The artist is reluctant to explain why the title does not correspond with what we see in the relief, except by pointing out the fact that after the work was ready and the title done, two more ghosts managed to slip into the picture. We are forever left in doubt about Hákon's true intention, but by leaving the question open she is able to multiply the possibilities of interpretation and still refer indirectly to a very original and old eccentricity in Nordic rhapsodic tradition.

Selected biographical details and
information on the works
exhibited are listed by artist in
alphabetical order.

Dimensions are in centimetres,
height preceding width.

SIGURDUR GUDMUNDSSON

1942
Born 20 September in Reykjavik,
Iceland. Son of a frame-maker and
art-dealer he grows up in the
company of artists, poets and
musicians. At an early age is
familiar with the work of
Icelandic artists, Jóhannes Kjarval
and Svavar Gudnason, among
others. Early interest in Cobra
and Asger Jorn.

1960
Studies at the Icelandic College of
Arts and Crafts in Reykjavik.
Leaves in protest at the sacking of
a teacher. His literary interests
include Hamsun, Ibsen, Laxness
and Maugham. Drawn to the
philosophy of Kierkegaard and
Nietzsche.

1963
Leaves Iceland and continues
studies at the recently founded
Academie '63 in Haarlem, The
Netherlands, until 1964.

1964
Moves to Zandeweer, a village in
Groningen. Makes objects and
three-dimensional paintings. Also
writes a number of romantic
philosophical texts. Stays until
1966.

1966
Returns to Iceland with his
family. Joins the Súm group,
which is strongly influenced by
Marcel Duchamp, Dieter Roth,
Joseph Beuys and the ideas of
Fluxus. The group also includes
his brother, Kristján.

1969
Co-founder of Gallery Súm,
Reykjavik. First solo exhibition
there showing objects and
paintings.

1970
Settles in Amsterdam and studies
at the Ateliers '63 in Haarlem,
The Netherlands. Remains in
close contact with Iceland, partly
thanks to his brother Kristján.

1971
Using photography, starts
recording 'situations' in which he
himself appears. Shows ice
installation, *Untitled (Ice-philosophy)*
at his first solo exhibition in
Amsterdam.

1972
Co-founder of the alternative
In-Out Center, Amsterdam.

1973
Participates in the Huitième
Bienale de Paris.

1978
Teaches at the Academie voor
Kunst en Industrie in Enschede,
The Netherlands, until 1986.
Co-founder of The Living Art
Museum, Reykjavik. Represents
Iceland at the Venice Biennale.

1980
Works at PS-1 in New York until
1981. Exhibits photoworks at the
Stedelijk Museum, Amsterdam.
Participates in the exhibition *Pier
+ Ocean* at the Hayward Gallery,
London. Stops making photographic
works and begins making sculpture.

1982
Participates in the exhibition
Sleeping Beauty, Guggenheim
Museum, New York.

1989
Work shown in the exhibition
Landscapes from a High Latitude,
Polytechnic Gallery, Brighton.

1992
Retrospective at Malmö Kunsthall,
Sweden. Lives and works in
Amsterdam.

CATALOGUE

1

Hommage à Grieg, 1971
(ill.p.116)
Black and white photograph with
text
110 x 80 cm
National Gallery of Iceland

2

Event, 1975 (ill.p.10)
Black and white photograph
54 x 57 cm
Thora K. Johansen & Kees
van Gelder

3

Composition, 1978 (ill.p.115)
Colour photograph with text
81 x 82 cm
Thora K. Johansen & Kees
van Gelder

4

Un mobile, 1979 (ill.p.117)
Black and white photograph with
text
83 x 90 cm
Thora K. Johansen & Kees
van Gelder

5

Collage, 1979 (ill.p.119)
Colour photograph with text
115 x 128 cm
Thora K. Johansen & Kees
van Gelder

6

Mathematics, 1979 (ill.p.112)
Colour photograph with text
115 x 128 cm
Rijksmuseum Kröller-Müller,
Otterlo

7

Molecule, 1979 (ill.p.121 and
cover)
Colour photograph with text
130 x 150 cm
Rijksmuseum Kröller-Müller,
Otterlo

8

Homage to Henri Rousseau,
1980 (ill.p.118)
Colour photograph with text
88.5 x 109 cm
Galerie Paul Andriesse,
Amsterdam

SVAVAR GUDNASON

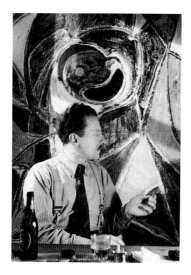

1909
Born 18 November in the village
of Höfn in the isolated south-
eastern part of Iceland. Largely
self-taught as a painter. In his
youth influenced by Jóhannes
Kjarval who regularly stays at the
Inn run by Gudnason's parents.

1933
Attends the Co-operative College,
Reykjavik.

1935
Moves to Copenhagen to attend
courses at the Royal Danish
Academy, where he stays until
1938. Financial problems bring
great hardship during these years
and Gudnason is eventually
hospitalised suffering from
malnutrition.

1938
Inspired by radical movements in
contemporary Danish art. Leaves
the Academy to join Fernand
Léger's School of Art in Paris,
which had attracted other young
Scandinavian artists, amongst them
Asger Jorn. Returns to Copenhagen
because of World War II.

1939
Marries Asta Eiríksdóttir.

1941-44
A leading figure among group of
young Danish artists centred
around the influential art journal
Helhesten [The Hell Horse], to which
he contributes poems and graphic
art. Paints *Storm Clouds* (cat.9).

1945
Returns to Iceland after 11 years
abroad. Takes part in a crucial
exhibition held in the
Listamannaskálinn Gallery,
Reykjavik, introducing modern
abstract art to the Icelandic
public. Is met with only limited
understanding although supported
by a small group led by the writer
Halldór Laxness.

1946
Paints *Mountains of Gold* (cat.10)
whilst still staying in Iceland.

1947
Returns to Copenhagen. Becomes
member of the Cobra movement,
1948-51.

1951
Settles in Iceland. Arranges a
Cobra exhibition in Reykjavik.
Starts spending the summers near
Hornafjördur where he re-cultivates
an intimate relationship with
nature.

1958
Illustrates poems by Halldór
Laxness.

1959
President of the Federation of
Icelandic Artists until 1961.

1960
Celebrated in Svavar Gudnason
festival including a large
retrospective at the
Kunstforeningen, Copenhagen,
which is shown in Iceland the
following year.

1960s
Is represented in numerous
international Cobra exhibitions
and at the Venice Biennale in
1972.

1988
Dies 25 June in Reykjavik.

CATALOGUE

9

Storm Clouds, 1944 (ill.p.80)
Oil on canvas
112 x 88 cm
Storstrøms Kunstmuseum, Maribo

10

Mountains of Gold, 1946
(ill.p.83)
Oil on canvas
122.5 x 150.5 cm
National Gallery of Iceland

HULDA HÁKON

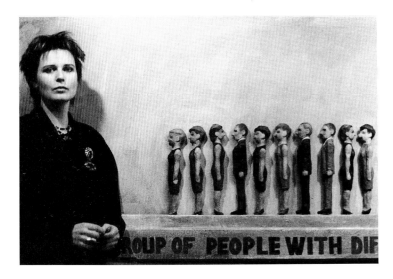

1956
Born 4 July in Iceland.
1977-81
Studies at The Icelandic College
of Arts and Crafts, Reykjavik.
1981
Lives in New York until 1985.
1983
Studies at the School of Visual
Arts, New York.
1984
Exhibits with Jon Oskar at
Kaplakriki, Harnarfjördur, Iceland.
From 1985, a series of solo
exhibitions include: 13th Hour
Gallery, New York (85); Galleri
Svartá á Hvitu, Reykjavik (87);
Galleria Okra, Vantaa (89);
Gallery Lång, Malmö (89);
Gallery II, Reykjavik (91);
Gallery Fahl, Stockholm (92);
Gallery Pieri Agora, Helsinki (92);
and O ZWEI, Berlin (92). Also
participates in group exhibitions in
Finland, Iceland, Russia, Sweden
and the USA.
1990
Participates in *The Ready Made
Boomerang*, 8th Sydney Biennale
Australia.
1991
Participates in *Figura, Figura*, Art

Museum of Gothenburg; The
Fruitmarket Gallery, Edinburgh.
1992
Lives and works in Reykjavik.

CATALOGUE
11
**Self-portrait with Seven
Ghosts**, 1988 (ill.p.134-5)
Mixed media
70 x 230 cm
National Gallery of Iceland

CARL FREDRIK HILL

1849
Born 31 May in Lund, Sweden.
1868
Already determined to become an
artist. His diary reads: 'The
undersigned is mad enough to
want to become an artist'
followed a year later by 'even a
small talent can reach far through
practice.'
1871
Despite Hill's intentions, his
father, a rather eccentric
Professor of Mathematics, forces
him to study Aesthetics at the
University of Lund.
1872
Leaves university to join the
Academy of Art in Stockholm.
Finds drawing after plaster models
dull, preferring to paint
landscapes. Hill's father regularly
tries to convince his son to return
to university.
1873
Shows the first signs of instability
and anxiety. Disappointed with
the Academy, decides to leave
Stockholm to continue his studies
in France where he lives until
1878, staying in Paris and painting
near the Fontainebleau village of
Barbizon, where his hero, Corot
had painted before him.
1875
Hill's beloved sister Anna dies,
followed by the death of his
father several months later,
strongly effecting Hill's already
weakened mental state. Begins to
lead a lonely and isolated life,
often complaining about his failing
health. Painting of a forest scene
is accepted at the Paris Salon.
1876
Travels to Luc-sur-Mer, a small
fishing and bathing village in
Normandy for the summer, where

he paints *The Beach, Luc-sur-Mer*
(cat.12). Travels to Montigny in
September and much to his
vexation misses Strindberg who
arrives in Paris where he had
hoped to meet him.
1877
In Stockholm, Strindberg writes
an article describing Hill's
painting at the Academy as an
example of a picture 'executed by
a fanatic pupil of Corot's.'
1878
After years of mental instability,
now hospitalised with a severe
form of schizophrenia. Tormented
by obsessions and hallucinations
he continues to draw and paint,
including *The Lone Tree* (cat.13).
1880
Hill's sister Marie Louise travels
to Paris to see her brother. He is
taken to the psychiatric hospital
near Roskille, Denmark.
1882
Transferred to the hospital in
Lund where he spends all his time
drawing. Case sheets describe
these as 'very odd'.
1883-1911
Discharged from hospital although
he never recovers from his mental

CARL FREDRIK HILL *Self-portrait*
(undated) Malmö Konstmuseum

illness. Lives in isolation with his
mother and sister Hedda. Suffers
from visual and auditive
hallucinations. Constructs his own
language mixing elements of
French, Latin and Greek. Hill's
sister supplies materials but
censors his work, destroying what
she finds too obscene. Hill draws
continuously until his death on
22 February 1911.

CATALOGUE

12
The Beach, Luc-sur-Mer, 1876
(ill.p.18)
Oil on canvas
53.8 x 65 cm
Malmö Konstmuseum

13
The Lone Tree, 1878 (ill.p.19)
Oil on canvas
59 x 72 cm
Malmö Konstmuseum

14
Untitled, from the *Flood Suite*,
(undated) (ill.p.21)
Black chalk on paper
30.8 x 20 cm
Nationalmuseum, Stockholm

15
Untitled, from the *Flood Suite*,
(undated) (ill.p.20)
Black chalk on paper
31 x 19.7 cm
Nationalmuseum, Stockholm

16
Untitled, from the *Flood Suite*,
(undated) (ill.p.20)
Black chalk on paper
30.5 x 19.7 cm
Lund Kulturen

17
Untitled, from the *Flood Suite*,
(undated) (ill.p.21)
Black chalk on paper
31 x 20.3 cm
Malmö Konstmuseum

18
Untitled, (undated) (ill.p.24)
Black chalk on paper
17.4 x 21.3 cm
Nationalmuseum, Stockholm

19
Untitled, (undated) (ill.p.24)
Black chalk on paper
18.4 x 25.3 cm
Nationalmuseum, Stockholm

20
Untitled, (undated) (ill.p.1)
Coloured chalks on paper
18 x 22.6 cm
Nationalmuseum, Stockholm

21
Untitled, (undated)
Coloured chalks on paper
17.2 x 21.4 cm
Nationalmuseum, Stockholm

22
Untitled, (undated)
Watercolour and gold paint
on paper
34 x 42 cm
Malmö Konstmuseum

23
Untitled, (undated)
Crayon on paper
17 x 21 cm
Malmö Konstmuseum

24
Untitled, (undated)
Watercolour and gold paint
on paper
34 x 42 cm
Malmö Konstmuseum

25
Untitled, (undated)
Chalk on paper
17.5 x 21.5 cm
Malmö Konstmuseum

26
Untitled, (undated) (ill.p.8)
Charcoal on paper
35 x 45.5 cm
Malmö Konstmuseum

27
Untitled, (undated)
Pastel on paper
21.1 x 17 cm
Malmö Konstmuseum

28
Untitled, (undated)
Chalk on paper
17.5 x 21.5 cm
Malmö Konstmuseum

29
Untitled, (undated) (ill.p.22)
Charcoal, pastel on paper
34 x 21 cm
Malmö Konstmuseum

30
Untitled, (undated) (ill.p.26)
Crayon, charcoal on paper
24 x 32 cm
Malmö Konstmuseum

31
Untitled, (undated) (ill.p.27)
Coloured chalks on paper
53.7 x 69.1 cm
Malmö Konstmuseum

32
Untitled, (undated) (ill.p.17)
Charcoal on paper
32.2 x 19.7 cm
Malmö Konstmuseum

33
Untitled, (undated) (ill.p.16)
Crayon on paper
21 x 34 cm
Malmö Konstmuseum

34
Untitled, (undated) (ill.p.22)
Crayon on paper
22.9 x 18.1 cm
Malmö Konstmuseum

35
Untitled, (undated) (ill.p.23)
Crayon on paper
36 x 22 cm
Malmö Konstmuseum

36
Untitled, (undated) (ill.p.23)
Crayon on paper
36.5 x 22.5 cm
Malmö Konstmuseum

OLAV CHRISTOPHER JENSSEN

1954
Born 2 April in Sortland, Vesterålen, Norway.

1973-76
Studies at The State Arts and Crafts School, Oslo.

1979
First solo exhibition at Galleriet, Oslo.

1980-81
Studies at The State Academy of Art, Oslo.

1981-82
Lives and works in New York.

1982
Moves to Berlin, where he settles. During the '80s has a series of solo exhibitions including: Galerie Artek, Helsinki(88); Galleri Lars Bohman, Stockholm (86-87); Galerie Dörrie & Priess, Hamburg (88); and Galleri Riis, Oslo (85, 87, 89, 90, 92). Also participates in group exhibitions, including *Borealis 3*, Malmö Konsthall (87), *5 Nordic Temperaments*, Rooseum, Malmö (88), and *Blue Transparency*, Moderna Museet, Stockholm (91), and South American tour.

1990
Illustrates new edition of Knut Hamsun's novel *Hunger* with a series of drawings which are also shown in a solo exhibition at the Henie-Onstad Kunstsenter, Hovikodden. Participates in *Northlands, New Art from Scandinavia* exhibition, Museum of Modern Art, Oxford; Trinity College, Dublin.

1992
Participates in *Documenta IX*, Kassel. Solo exhibition, Kunstnernes Hus, Oslo.

CATALOGUE

37
The Great Icelandic Poet, 1986 (ill.p.128)
Oil on canvas
200 x 188 cm
Private collection

38
My Father's Land, 1987 (ill.p.131)
Oil on canvas
200 x 188 cm
Galleri Lars Bohman, Stockholm

39
Nine drawings for Knut Hamsun's *Hunger*, 1990 (ill.pp.127, 130)
Wax and mixed media on paper each 12.5 x 8 cm
Courtesy Galleri Riis, Oslo and private collections

40
Berlin, January 1990
Wax crayons, wax
13.7 x 20 cm
Collection of the artist

41
Berlin, February 1990 (ill.p.6)
Wax crayons, wax
13.5 x 20 cm
Collection of the artist

ASGER JORN

1914
Born 3 March in the village of Vejrum, Denmark. After the death of his father in 1929 the family settles in Silkeborg which Jorn comes to consider his home.

1930
Begins to paint whilst training to be teacher. Later teaches briefly in local schools.

1933
First exhibition held in Silkeborg.

1936
Travels to Paris and studies under Fernand Léger until 1937.

1941-44
Co-founder and leading contributor to the art journal *Helhesten [The Hell Horse]* to which Svavar Gudnason also contributes.

1946
Travels to Sweden and later the same year to Paris and Holland. Meets the painter Constant.

1948
First solo show in Paris. Joins the activities of *Surréalisme Révolutionaire* in Paris, but breaks with the group to form Cobra together with Appel, Constant, Corneille, Dotremont and Noiret. Cobra exists until 1951.

1951-52
Hospitalised in Silkeborg Sanatorium with a severe form of tuberculosis aggravated by under-nourishment. There he completes manuscripts of his books *Held og Hasard [Risk and Chance]* (see pp.90 & 93) and *Lykkehjulet [The Wheel of Fortune]*. Continues painting.

1953
Pre-occupied with pottery and ceramics. Decides to leave Denmark in order to become a 'Danish European'. Travels to Switzerland.

1954
Moves to Albisola in Italy to continue working with ceramics. Joins an international group of artists including Appel, Baj, Cornelle and Matta.

1956
Settles in Paris.

1957
Joins the International Situationist Movement and is a leading member until 1961. Now recognised internationally, he holds several solo shows.

1958
Participates in the Brussels Expo.

1959
Begins work on a series of 'Modifications' a term used to describe his way of overpainting old canvases bought in junk shops. *Out of this World – after Ensor [Ainsi on s'ensor]* (cat.44), painted in 1962 belongs to a later group of 'Disfigurations'. Donates the first large collection of his own and other artist's works to Silkeborg Konstmuseum.

1961
Works on a series entitled 'Luxury Paintings' where he employs an experimental dribble technique. Travels widely in search of material to illustrate a large picture-book illustrating the history of Scandinavian folk art over 10,000 years. The book is never completed.

1962
Founds the 'Scandinavian Institute for Comparative Vandalism', a one-man organisation publishing books by Jorn focusing on historical subjects.

1964
Buys a farm on the island of Læso and builds a studio there. This later becomes one of his favourite residences and working places, together with those in Albisola and Paris.

1968
Participates in a cultural congress, Havanna, Cuba. Decorates the interior of a national bank.

1970
Makes a journey round the world.

1973
Dies 1 May in Aarhus, Denmark.

CATALOGUE

42
Wiedersehen am Todesufer
[Re-encounter on the Shores of Death], 1958 (ill.p.86)
Oil on canvas
100 x 80 cm
Galerie van de Loo, Munich

43
They Never Come Back, 1958 (ill.p.87)
Oil on canvas
146 x 114 cm
Städtische Galerie im Lenbachhaus, Munich

44
Ainsi on s'ensor [Out of this World – After Ensor], 1962 (ill.p.91)
Oil on canvas
60 x 43 cm
The Asger Jorn Donation, Silkeborg Konstmuseum

45
Commes si les Cygnes Chantent [As if the Swans Sing], 1963 (ill.p.94)
Oil on canvas
146 x 114 cm
Galerie van de Loo, Munich

46
La Luxure lucide de l'hyperesthésie [The Lucid Luxury of Hyper Aestheticism], 1970 (ill.p.95)
Oil on canvas
162 x 130 cm
Inger & Andreas L. Riis Collection, Oslo

PER KIRKEBY

1938
Born 1 September in Copenhagen, Denmark.

1957
Enters University of Copenhagen to study Biology.

1958
Participates in expedition to Narssak, Greenland. Returns to Greenland several times during the '60s on geological expeditions and in 1972 and 1980 to film. Makes further expeditions in the '70s to Middle America and the Arctic.

1962
Joins the Experimental Art School in Copenhagen.

1963
Takes part in a group exhibition organised by the Experimental Art School.

1964
Graduates with a thesis on Polar Quaternary Geology. First exhibition of drawings and collages.

1965
First solo show, Copenhagen. Publishes his first volume of poetry and the booklet *Blue 5, Blue Square*. Writing continues to

be an important part of his work, with numerous publications being produced through his career to date.

1966
Exhibits part of a 30 meter image of a blue fence. Performances with Joseph Beuys, Bengt af Klintberg, Henning Christiansen, Bjørn Nørgaard. Travels to New York.

1967
Performances in New York with Nam June Paik, Charlotte Moorman; and in Aachen with Jörg Immendorff, Bjørn Nørgaard, among others. Publishes his first novel *2.15*.

1970
Works on a film with film maker and poet Jørgen Leth.

1971
Travels in Central America where he studies Mayan art and architecture. Later visits the Soviet Union. Produces a film on the Danish surrealist painter Wilhelm Freddie.

1973
Finishes his first brick sculpture in the form of a small house, Ikast, Jutland.

1974
First exhibition at Galerie Michael Werner, Cologne.

1975
Works with Paul Gernes on the film, *The Normans*. Retrospective of works on paper, Statens Museum for Kunst, Copenhagen; and exhibition of drawings, Henie-Onstad Kunstsenter, Norway.

1976-77
Makes a film on Asger Jorn commissioned by the Asger Jorn Foundation. Represented at the Venice Biennale. Solo exhibition

at Folkwang Museum, Essen.

1978
Begins teaching at the Academy of Art, Karlsruhe.

1979
Solo exhibition Kunsthalle Bern and Konstmuseum, Aarhus.

1979
Buys a house on the island of Læsø where Asger Jorn had also worked. Represents Denmark at the Venice Biennale.

1981
Participates in the exhibition *A New Spirit in Painting* at the Royal Academy, London and Venice Biennale. Publishes collected essays *Bravura*.

1982
Solo exhibition Stedelijk Van Abbemuseum, Eindhoven and participates in the exhibitions: *Documenta VII*, Kassel; *Sleeping Beauty* at the Guggenheim Museum, New York; *Zeitgeist* in Berlin; as well as an extensive number of other museums and galleries.

1983
Starts working with plaster sculpture at Læsø.

1984
Participates in the exhibition *Munch-Jorn-Kirkeby* at the Stedelijk van Abbemuseum, Eindhoven; *Von Hier aus*, Düsseldorf.

1985
Solo exhibition at the Whitechapel Art Gallery, London, and retrospective of bronze sculptures, Copenhagen.

1986
Travels to Australia.

1987
Retrospective, Museum Ludwig, Cologne.

1988
His book on Edvard Weie published.

1989
Becomes Professor at the Städelschule in Frankfurt.

1990
Art Prize of the NORD / LB, endowed for outstanding efforts in contemporary art; solo exhibition at the Städelsches Kunstinstitut, Frankfurt, and at Louisiana Museum of Art, Humlebaek.

1991/92
Solo exhibition Kestner Gesellschaft, Hannover; opening of major touring exhibition to USA.

1992
Solo exhibition, Centre National d'Art Contemporain de Grenoble. Participates in *Documenta IX*, Kassel.
Lives and works in Copenhagen, Frankfurt and Læsø.

CATALOGUE

47
Untitled, 1978 (ill.p.103)
Oil on canvas
210 x 163 cm
Private collection

48
Untitled, 1980 (ill.p.105)
Oil on canvas
200 x 150 cm
Private collection

49
Look Back II, 1986 (ill.p.108)
Oil on canvas
200 x 200 cm
Private collection, Winterthur

50
Shadow, 1986 (ill.p.109)
Oil on canvas
200 x 160 cm
Private collection, Cologne

JÓHANNES KJARVAL

1885
Born 15 October and grows up in the rural district of Geitavik on the eastern coast of Iceland. Throughout his childhood is in close contact with nature.

1901
Moves to Reykjavik and receives his first formal schooling. Becomes familiar with the painting of the pioneer Icelandic artists, Thórarinn B. Thorláksson and Asgrímur Jónsson, and is briefly a pupil of the latter. During the summer months he works as a deckhand on fishing boats.

1908
First exhibition in Reykjavik.

1911
Travels to London and unsuccessfully applies for admission to the Royal Academy. Becomes familiar with London galleries and museums and is especially impressed by Turner.

1912
Moves to Copenhagen and receives drawing lessons at the Technical School.

1914
Admitted to the Royal Danish Academy of Art where he studies until 1918. Draws on numerous sources of inspiration; especially influenced by French symbolism, the Nabis and Paul Gauguin.

1915
Marries Tove Merrild.

1919
Travels to Denmark, Norway and Sweden, and in 1920 to Italy.

1922
Returns to Iceland with his family to settle, where they live in virtual poverty.

1924
Commissioned to paint a mural at the National Bank of Iceland.

1925
To his great regret, Kjarval's wife, Tove, asks for divorce. Despite their subsequent separation they remain closely attached to one another.

1927
Finds renewed strength whilst staying in eastern Iceland where he embarks upon a series of drawings of local characters in a realistic style. These are among his most important and widely appreciated works.

1928
Travels to Paris. Paints forest scenes in Fontainebleau, where Hill and Strindberg had sought inspiration before him.

1929
For the first time paints landscapes at the historic location of Thingvellir, the site of the original National Assembly.

1935
The hitherto largest exhibition of Kjarval's art in Reykjavik establishes his position as one of Iceland's most celebrated national painters.

1972
Dies in Reykjavik.

EVERT LUNDQUIST

1904
Born 17 July in Stockholm, Sweden. Grows up in a prosperous middle-class milieu in Tegnérgatan 9, the street where Strindberg also lived in his last years. Recalls the impression of the old playwright on his walks in the streets of Stockholm.

1918
Begins to paint but also shows interest in literature, philosophy and music. Reads Strindberg's *The Red Room* and later comes to admire his painting.

1921
Sent to a public school outside Dresden where he is strongly influenced by German romantic literature and philosophy.

1922
Visits London and Paris. Is especially impressed by the Parthenon Frieze and the Greek sculpture of Demeter in the British Museum.

1923
Lundquist begins studying music but comes to loathe the piano lessons and decides to become a painter instead.

1924
Begins art studies at Wilhelmson's Art School in Stockholm. Travels to Paris and continues studies at the Académie Julian. Admires paintings by Chardin and Ingres in the Louvre.

1925
Returns to Sweden and is admitted to the Academy of Art in Stockholm where he feels ill at ease with his contemporaries.

1931
Leaves the Academy and travels to France, Italy and England until 1933.

1933
Spends some time in Paris where he paints his 'first completely independent painting', *Jardin du Luxembourg*. Inspired by Munch, this painting points to his mature style.

1934
First exhibition held at the Konstnärshuset, Stockholm.

1936-37
Suffers a depression caused by an unhappy love-affair.

1941
Increasingly acclaimed as a result of an exhibition at the Konstnärshuset in May.

1943
Marries Ebba Reutercrona.

1944
Retrospective exhibition at the Academy of Art, Stockholm.

1948
Journeys through post-war Europe. Moves to Sicily with his family, visits the Temple Valley and comes into contact with classical culture which, he writes, 'has followed me throughout life and formed my art'. The experience inspires his later *Columns, Sicily*, 1957-58 (cat.53).

1950
Exhibition at 'Färg & Form' confirms his position as an established artist.

1951
Writes a series of articles in *Svenska Dagbladet* as part of a current debate on Concretism and non-representational art.

1953
Moves to Kanton in Drottningholm where he still lives. Converts a disused transformer station into a studio.

1960
Appointed Professor at Konsthögskolan, Stockholm. Soon becomes a popular and respected teacher.

1960s
Participates in numerous international exhibitions.

1961
Exhibits in New York and travels in the USA, returning in 1964 in connection with his participation in an exhibition at the Guggenheim Museum.

1970
Retires from teaching.

1974
Retrospective exhibition at the Moderna Museet, Stockholm.

1984
Publishes his autobiography *From a Painters Life.*
1992
Lives quietly in Kanton, Drottningholm, Sweden. His studio there is due to be opened as a museum in May 1993.

CATALOGUE
53
Columns, Sicily, 1957-58
(ill.p.97)
Oil on canvas
145 x 76 cm
Stiftelfen Rooseum, Malmö

54
Leg I, 1968 (ill.p.99)
Oil on canvas
116 x 73 cm
Collection the artist

55
The Man on the Hill, 1975
(ill.p.101)
Oil on canvas
116 x 105 cm
Private Collection, Paris

MARIKA MÄKELÄ

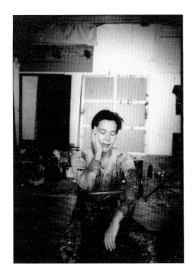

1947
Born in Oulu, Finland.
1969-73
Studies at The School of the Fine Arts Academy of Finland, Helsinki.
1974
First solo exhibition at Künstlergalerie, Helsinki. Followed by numerous solo shows throughout the '70s and '80s, including at Galleria Katariina, Helsinki (76,78,80,83); Galleri Paloma, Stockholm (77); Galeri Bronda, Helsinki (78,80); Galleria Krista Mikkola, Helsinki (84,85,86) and Galleri Lars Bohman, Stockholm (90).
1977-78
Participates in European tour, *Contemporary Finnish Art*
1981
Participates in the exhibition: *Art Today*, The Sapporo Triennial, Japan.
1982
Participates in the American tour, *Contemporaries – New Art from Finland.*
1987
Participates in *Borealis 3*, Nordic Biennale, Konsthall, Malmö.

1988
Exhibits in Kunsthalle Basel, Switzerland
1990
Participates in the exhibition: *Northlands, New Art from Scandinavia*, Museum of Modern Art, Oxford; Trinity College, Dublin.
1992
Lives and works in Helsinki.

CATALOGUE
56
Small Sacriledges, 1990
(ill.p.125)
Oil on canvas (2 panels)
230 x 300 cm
Folksam Insurance Group, Stockholm

57
Signed Place II, 1990
(ill.p.124)
Oil on wood
51 x 50 cm
Folkhem, Stockholm

58
Signed Place III, 1990
(ill.p.124)
Oil on wood
39 x 30 cm
Folkhem, Stockholm

EDVARD MUNCH

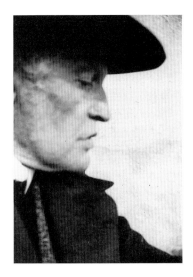

EDVARD MUNCH *Self-portrait*, Ekely, 1930. Courtesy of The Munch Museum, Oslo

1863
Born 12 December in Løten, Norway. The following year the family moves to Kristiania (Oslo) where Munch grows up.
1868
His mother dies of tuberculosis.
1877
His sister, Sophie, also dies of tuberculosis aged 15.
1879
Munch enters technical college in Oslo to train as an engineer. Leaves after a year to become a painter.
1881
Enters the Oslo School of Design and attends classes in freehand and life drawing.
1885
Visits Paris where he admires work by Delacroix in the Louvre.
1887
Buys a small fisherman's cottage in the village of Åsgårdstrand on the Oslo fjord. The village becomes his home base during the 1880s. The long curving shoreline

frequently appears in his paintings from 1889 onwards.

1889

First solo exhibition in Oslo. Travels to Paris to join the school of Leon Bonnat. Begins a ten year period of travelling that embraces Norway, Germany and France. Also includes visits to Italy, Switzerland, Austria and Czechoslovakia. Munch's father dies.

1892

Invited to exhibit in Berlin by the Verein Berliner Künstler. The exhibition, which opens on 5 November 1892 provokes outrage amongst the establishment and is closed after only a week 'in the name of decency and proper art'. Meets the 41-year-old Strindberg who supports him in the controversy surrounding the exhibition. They have a brief but fruitful friendship, which ends dramatically in 1896 when the deluded Strindberg, in the depths of his 'Inferno crisis', believes Munch, among many others, is set against him.

1893

Lives and works in Berlin. Frequents a circle of artists and writers, the so-called Ferkel Group, including August Strindberg, the Danish poet Holger Drachmann, the German poet Richard Dehmel, the Polish writer Stanislaw Przybyszewski, and the Norwegian music student Dagny Juel, to whom Munch, like Strindberg, is strongly attracted. Exhibits in Dresden, Munich and at the alternative Freie Verein Berliner Künstler alongside paintings by Strindberg. Breaks with naturalism and begins his famous 'Frieze of Life' series.

1894

Produces his first lithographs and etchings.

1895

The artist's brother Andreas dies.

1896

Travels to Paris where he stays until the following year. Works on illustrations for Baudelaire's *Les Fleurs du Mal*. Joins a circle of friends including Frederick Delius, William Molard, Julius Meier-Graefe, Stéphane Mallarmé and others. Finally falls out with Strindberg, and makes lithographic portrait of him entitled *Stindberg*. Starts making woodcuts.

1898

Commissioned to illustrate an article on Strindberg's work for the January 1899 edition of the journal *Quickborn*. Later makes woodcut variant, *Blossom of Pain* (cat.62).

1900

Travels to Florence, Rome and, later, to Como, Italy. On his return to Norway paints *Train Smoke* (cat.66).

1902

His engagement to Tulla Larsen ends dramatically when, during an argument, Munch is shot in the hand.

1908

Suffers a breakdown after years of nervousness and alcoholic problems. Admitted to Dr. Jacobsen's clinic in Copenhagen for treatment and remains there for eight months before returning to Norway.

1910

Spends part of the year at Kragerø and purchases a property by the Oslo Fjord. Paints *The Murderer* (cat.67).

1916

Buys a large house at Ekely on the outskirts of Oslo where he lives as a recluse until his death in 1944. It is a spartan existence with only his housekeeper and many dogs for company.

1930

Suffers from an eye disease which persists sporadically over a number of years restricting his capacity to work.

1940

Munch begins one of his last works *Self-portrait between the Clock and the Bed* (cat.73).

1944

Dies at Ekely on 23 January.

CATALOGUE

59

Vision, 1892 (ill.p.44)
Oil on canvas
72 x 45 cm
The Munch Museum, Oslo

60

The Scream, 1895 (ill.p.46)
Hand coloured lithograph
35.4 x 25.3 cm
The Munch Museum, Oslo

61

Inheritance I, 1897-99 (ill.p.49)
Oil on canvas
140 x 120 cm
Munch Museum, Oslo

62

Blossom of Pain, 1898 (ill.p.47)
Woodcut
46.5 x 33 cm
The Munch Museum, Oslo

63

Two Women on the Shore,
1898 (ill.p.2)
Woodcut
103 x 75 cm
The Munch Museum, Oslo

64

Encounter in Space, 1899
(ill.p.51)
Woodcut
18.1 x 25.1 cm
The Munch Museum, Oslo

65

Mystery on the Shore/The Stump, 1899 (ill.p.50)
Woodcut
103 x 75 cm
The Munch Museum, Oslo

66

Train Smoke, 1900 (ill.p.52)
Oil on canvas
84.5 x 109 cm
The Munch Museum, Oslo

67

The Murderer, 1910 (ill.p.57)
Oil on canvas
94 x 154 cm
The Munch Museum, Oslo

68

A Mysterious Stare, c1912-15
(ill.p.56) Page from *The Tree of Knowledge of Good and Evil*
Coloured crayon on paper
149.5 x 120.5 cm
The Munch Museum, Oslo

69

By the Deathbed (Death Struggle), c1915 (ill.p.55)
Oil on canvas
174 x 230 cm
The Munch Museum, Oslo

70

Abstract, Optical Illusions from the Eye Disease, 1930
(ill.p.58)
Watercolour on paper
49.7 x 47.1 cm
The Munch Museum, Oslo

71

The Artist's Eye and Threatening Figure of a Bird's Head, 1930
(ill.p.58)
Pastel on paper
50.2 x 31.5 cm
The Munch Museum, Oslo

72
Winter Night, Ekely, 1931
(ill.p.53)
Oil on canvas
100 x 80 cm
The Munch Museum, Oslo

73
**Self-portrait between the
Clock and the Bed**, 1940-43
(ill.p.60)
Oil on canvas
149.5 x 120.5 cm
The Munch Museum, Oslo

74
Self-portrait at 2.15am,
1940-44 (ill.p.61)
Gouache on paper
51.5 x 64.5 cm
The Munch Museum, Oslo

TYKO SALLINEN

TYKO SALLINEN *Self-portrait*, 1914
Ateneum, Helsinki
Photograph courtesy of The
Central Art Archives

1879
Born in Nurmes in eastern
Finland. Moves with his parents to
Haparanda in the north in 1883.

1893
Runs away from his strict pietist
home to become a roaming
tailor's apprentice, working in
both Finland and Sweden.

1897
Returns home to Tampere in
autumn and works for his father.

1902
Moves to Helsinki to study at the
art school of The Finnish Arts
Society, whilst still working in the
evenings as a tailor to finance his
training in art.

1904-05
Travels to Copenhagen. Works as
a tailor in Helsingør, Denmark.

1906
Participates in joint exhibition,
Helsinki.

1909
Visits Munch exhibition in
Helsinki in January. Spends nine
months in Paris with his young
wife Mirri where he comes into
contact with Fauvism which
strongly influences his painting.

1910
Paints in Karelia, at the home of
his wife's parents.

1912
Shows a number of recent works
in conjunction with the annual
exhibition of The Finnish Art
Society, which mark the
breakthrough of Finnish
expressionism. The works cause a
great uproar known as 'The First
War over Sallinen' bringing him
into conflict with the public and
critics as well as other artists.
Subsequently flees Finland and
works for a year as a cartoonist in
the USA.

1913
Returns to Finland. Obtains a
permanent agreement with the
leading dealer and authority on
modern art in Finland, Gösta
Stenman, who promises a steady
income in return for sole rights
on his paintings.

1914
Works at the home of his wife's
parents in Sortavala on the island
of Riekkala. Here paints *Early
Spring* (cat.76). Breaks up with
Mirri. Spends the summer in Paris
and en route visits the Baltic
Exhibition in Malmö where his
works are being shown.

1915
'The Second War over Sallinen'
caused by a painting entitled *The
Dwarf* in which critics accuse him
of 'brutality, humbug and
dishonesty.' His work is,
however, increasingly recognised.

1916
Leaves Helsinki for Hyvinkää with
his friend Jalmari Ruokokoski.
Abandons bright colours and
comes under the influence of
Cubism. Gösta Stenman organised
the first group exhibition of the
artists who became the November
Group the following year. Sallinen
is the undisputed leader.

1917
Assists in the organisation of
exhibitions on Finnish art in
Petrograd.

1920
Mirri dies.

1922
Holds well received retrospective
exhibition at Stenman's 'art
palace' in Helsinki.

1930s
Paintings change to a more
austere and understated style.

1955
Sallinen dies.

CATALOGUE
75
Mirri in Green, 1911 (ill.p.63)
Oil on canvas
47 x 45 cm
Private Collection

76
Early Spring, 1914
Oil on canvas
49 x 46.5 cm
Ateneum, Helsinki

77
Rainbow, 1914 (ill.p.64)
Oil on cardboard
53 x 47 cm
Ateneum, Helsinki

AUGUST STRINDBERG

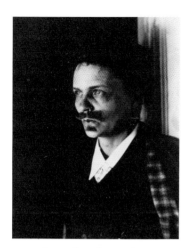

August Strindberg, 1891
Photograph by Professor
John Lundgren courtesy of
Strindbergsmuseet, Stockholm

1849
Born 22 January in Stockholm,
Sweden, to middle class parents.

1862
His mother dies two month's after
his 13th birthday.

1868
Begins studies at the University in
Uppsala. Breaks off to work as a
teacher, resuming higher
education from 1968-70. Finally
leaves without qualifications to
work as a playwright and
freelance journalist.

1872
First major drama *Master Olof* is
staged, but is not well received.

1873
Stays at Kymmendö and Sandhamn
on the Stockholm Archipelago,
where he makes his first tentative
paintings. The landscape of the
archipelago, which he loved,
continues to be an inspiration for
his playwriting and painting.

1874
Becomes a permanent staff writer
for the newspaper, *Dagens Nyheter*,
and soon becomes one of
Sweden's leading art critics. Takes
up post at Stockholm's Royal
Library as Secretary.

1876
Travels to Paris and sees the first
Impressionist paintings. Discusses
them in *Dagens Nyheter*.

1877
Marries his first wife, the actress
Siri von Essen.

1879
His novel *The Red Room*, based
largely on his experiences as a
journalist, is published and is an
instant success.

1883
Travels to France with his family
and alternately lives in France and
Switzerland until 1887. In France
lives in a Scandinavian artist colony
in Grez, outside Paris where he
becomes friends with the Swedish
artists, Carl Larsson and Karl
Nordström. Other artist company
includes Munch's teacher, the
Norwegian, Christian Krohg and
the German, Max Klinger. Writes
many influental socio-critical articles,
as well as writing novels and plays,
including *The Father* and *Miss Julie*.

1886
Takes a series of remarkable self-
portrait photographs in Gersau,
Switzerland, which he hopes will
be published as complement to his
autobiography, *The Son of a
Servant*, published the same year.

1887
Moves to Denmark before
returning to Sweden in 1889.

1890
After more than three years of
bitter arguments and accusation,
Strindberg and his wife finally
divorce. Finishes the novel *By the
Open Sea*. For the next six
years he hardly writes and instead
devotes himself to studying the
natural sciences.

1892
Fatigued by separation
proceedings, Strindberg isolates
himself in Dalarö where he paints
more than 30 pictures, among
them *Burn-Beaten Land, Dalarö*
(cat.78) and *Vita Märrn II, Dalarö*
(cat.79). Holds his first exhibition
in Stockholm which is met with
only limited understanding.
Experiments in colour
photography. Lack of interest and
comprehension in his plays and
novels prompts Strindberg to
leave for Berlin. There becomes
the leading figure of a wide circle
of artists, writers and intellectuals
that meet in the café (named by
Strindberg) *Zum Schwarzen Ferkel*
(The Black Pig). Among others,
the group includes the Norwegian
painters, Edvard Munch and
Christian Krogh, the Danish poet,
Holger Drachmann, and the Polish
musician and occult writer,
Stanislaw Przybyszewski.

1893
Participates in the alternative Freie
Verein Berliner Künstler exhibition
together with Edvard Munch.
Meets the 21-year-old Austrian,
Frida Uhl, whom he marries.
Their stormy and complicated
relationship inspires the painting
Night of Jealousy (cat.80), presented
to Frida as an engagement gift.
Also has a brief affair with the
Norwegian, Dagny Juel, with
whom Munch is also involved.
She later marries Przybyszewski.
Strindberg visits London with his
new wife, sees pictures by
Constable and is particularly
impressed by Turner. Writes his
first scientific work *Antibarbarus*.

1894
Travels on to Austria and settles
in Dornach where he lives in a
small cottage by the Danube near
the estate of Frida's prosperous
grandparents. Here Strindberg
paints *Golgotha* (cat.81). Later
parts from Frida and his newly
born daughter (his fourth child),
and moves to Paris in the hope of
literary and scientific acclaim.
Paints *The Shore* (cat.83) as well as
one of his most radical pictures,
High Sea (cat.82) along with
another eight paintings, before
becoming preoccupied with
chemical experiments. Meets Paul
Gauguin whom he sees regularly
up until Gauguin's final departure
for Tahiti in June 1895.

1896
Writes an introduction to
Munch's exhibition at Bing's
Galleri L'Art Nouveau, Paris. His
chemical experiments become
increasingly directed toward
alchemy and the occult. Starts
writing his Occult Diary and makes
experimental photographs. Climax
of his so-called 'Inferno crisis'
results in a spiritual conversion.

1897
Travels to Lund in Sweden.
Finishes *Inferno*, a loose account of
his Paris years in which Munch
appears as the Danish painter
'handsome Henrik'.

1899
Returns to live in Stockholm after
fifteen years of travel.

1901
Marries his third wife, the
22-year-old Norwegian actress
Harriet Bosse. Shortly after the
wedding she temporarily walks
out on him and he is thrown into
a new crisis which prompts him
to take up painting again. Writes
his expressionist masterpieces,
A Dream Play, as well as the
Chamber Plays, *The Ghost Sonata*,
Storm, *The House that Burned* and
The Pelican.

1903
Finally parts from Harriet.

1907

Sets up the Intimate Theatre, Stockholm, which opens with two of the Chamber Plays and goes on to show a further 24 of his works over the next three years. Publishes the satirical novel *Black Banners*, which divides public opinion – Strindberg is supported by the Left and the worker's movement.

1912

Strindberg dies in Stockholm.

CATALOGUE

78

Burn-Beaten Land, 1892 (ill.p.31)
Oil on zinc
35.7 x 27.2 cm
Private collection

79

White Mare II, 1892 (ill.p.30)
Oil on board
60 x 47 cm
Private Collection

80

Night of Jealousy, 1893 (ill.p.34)
Oil on cardboard
41 x 32 cm
Strindbergsmuseet, Stockholm

81

Golgotha, 1894 (ill.p.35)
Oil on canvas
91 x 65 cm
Albert Bonniers Forlag, Stockholm

82

High Sea, 1894 (ill.p.41)
Oil on board
96 x 68 cm
Private collection

83

The Shore, 1894 (ill.p.39)
Oil on cardboard
26 x 39 cm
Strindbergsmuseet, Stockholm

EDVARD WEIE

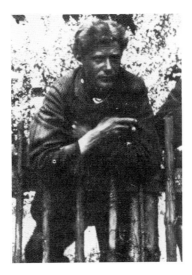

1879

Born 18 November in Copenhagen, Denmark. His father abandons the family when he is a young child and he is brought up by his dominant and authoritarian mother.

1893

Apprenticed as a house painter. Continues his apprenticeship while attending technical school which he concludes in 1899.

1899

Application to study rejected by the Royal Danish Academy, Copenhagen.

1904

First exhibits at the Charlottenborg Spring Exhibition.

1905

Accepted at Kristian Zahrtmann's School of Painting, a popular alternative to the Academy amongst young progressive painters.

1907

Travels to Italy with his teacher Kristian Zahrtmann who has set up a small community for Scandinavian artists in the small village of Città D'Antino where he stays for three months.

1908

Begins his first large composition in the grand style of 'Arcadian Landscape' but, frustrated by criticism, cuts it to pieces.

1911

From this time makes regular visits to the island of Christianso, which for years was to be a favourite resort of his and is where he met the painter, Karl Isakson. Later in the year he travels to Paris, but manic-depression – a problem throughout his life – forces him to return to Denmark where he is hospitalised.

1913

Although not entirely recovered from his mental disorder, leaves hospital for Christianso. Here he paints the lyrical seascape *Sunlight on the Sea* (cat.84).

1915

Begins a series of paintings based on a classical theme which he continues over the next six years, among them, *Poseidon Rushing over the Sea, surrounded by Nereids and Tritons*, 1917 (cat.85).

1920

Between 1920 and 1922 Weie paints four pictures entitled *Romantic Fantasy*, including cat.86.

1924

Having spent some months in Florence from the autumn of 1923, Weie travels to Paris where he makes studies after Delacroix's *Dante and Vergil* 1822, in the Louvre, which inspires a series of works made up to *c*.1935 including cat.87. Publishes his first critical essay on concepts of modern art.

1930

Marries Agnes Jensen.

1936-37

Long periods of illness, spent partly in hospital. The summers of 1937 and 1938 are spent on the island of Glæno.

1939

Travels to Southern France and temporarily takes up residence in Cannes.

1941

Paints various versions of *Faun and Nymph* inspired by Cézanne's *Abduction* (1867).

1943

Writes the book *Poetry and Culture* (published posthumously). Dies 9 April.

CATALOGUE

84

Sunlight on the Sea, Christianso, 1913 (ill.p.67)
Oil on canvas
59.6 x 77.9 cm
Aarhus Kunstmuseum

85

Poseidon Rushing over the Sea surrounded Nereids and Tritons, 1917 (ill.p.70)
Oil on canvas
56 x 78.5 cm
Statens Museum for Kunst, Copenhagen

86

Romantic Fantasy, Sketch, 1920 (ill.p.71)
Oil on canvas
152.5 x 151 cm
Statens Museum for Kunst, Copenhagen

87

Dante and Virgil in the Underworld Study after the Painting by Delacroix in the Louvre, 1930-35 (ill.p.73)
Oil on canvas
101 x 100 cm
Statens Museum for Kunst, Copenhagen

BIBLIOGRAPHY

Texts in other languages follow those in English.

GENERAL LITERATURE

BLONDAL, Torsten. (Ed.) *Northern Poles, Break-aways and Breakthroughs in Nordic Painting and Sculpture of the 1970s and 1980s*, Blöndal 1986

GRANATH, Olle *Another Light. Swedish Art since 1945*, The Swedish Institute

KENT, Neil *The Triumph of Light and Nature. Nordic Art 1740-1940*, London 1987

ROSENBLUM, Robert *Modern Painting and the Northern Romantic Tradition*, Thames and Hudson, London 1975

EXH.CAT., *Borealis 3*, Malmö Konsthall 1987

EXH.CAT., *Melancholy – Northern Romantic Painting*, Aarhus Kunstmuseum 1991

EXH.CAT., *5 Nordic Temperaments*, Rooseum, Malmö 1988

EXH.CAT., *Norsk Kunst* [Norwegian Art], Göteborgs Konstmuseum, Norsk Forum, Oslo 1987

EXH.CAT., *Scandinavian Art: 19 Artists from Denmark, Finland, Iceland, Norway, Sweden*, The Seibu Museum of Art, Tokyo 1987

EXH.CAT., *Scandinavian Modernism. Painting in Denmark, Finland, Iceland, Norway and Sweden 1910-1920*, Touring Exh. (Nordic Council of Ministers) 1989-1990

EXH.CAT., *Sleeping Beauty – Art Now. Scandinavia Today*, Solomon R. Guggenheim Museum, New York 1982

EXH.CAT., *The Nordic '60s*, Listasafn Islands, Reykjavik; and tour, 1990

EXH.CAT., *Uit het Noorden. Edvard Munch, Asger Jorn, Per Kirkeby*, Van Abbemuseum, Eindhoven 1984

SIGURDUR GUDMUNDSSON

EXH.CAT., Eyck, Zsa-Zsa (Ed.) *Sigurdur Gudmundsson*, Mál og menning, Reykjavík and Uitgeverij Van Spijk, Venlo, The Netherlands 1991

EXH.CAT., *La biennale di Venezia, Sigurdur Gudmundssen – Iceland*, Nordic Pavilion, Venice 1978

EXH.CAT., *Pier + Ocean. Construction in the Art of the Seventies*, Hayward Gallery, London; Rijksmuseum Kröller-Müller, Otterlo 1980

EXH.CAT., *Súm, 1965-1972*, The Reykjavik Municipal Art Museum, Reykjavik 1989

EXH.CAT., *The Frozen Image, Scandinavian Photography*, Walker Art Center, Minneapolis, New York 1982

EXH. CAT., *Sigurdur Gudmundsson: Situations*, Stedelijk Museum, Amsterdam 1980

SVAVAR GUDNASON

INGÓLFSSON, Adalsteinn, 'Svavar Gudnason. The Last Great Modernist in Icelandic Art', in: *Iceland Review*, 1, 1986, pp. 26-30

OLSEN, Robert Dahlmann *Danish Abstract Art*, Copenhagen 1964

RUNÓLFSSON, Halldór Björn 'Reflections on Icelandic Art', in: Julian Freeman (Ed.) *Landscapes from a High Latitude. Icelandic Art 1909-1989*, London 1989, pp. 21-48

VILHJÁLMSSON, Thor *Svavar Gudnason. The Man and the Artist*, Format, Edition Bløndal, Hellerup 1992

EXH.CAT., Nordal, Bera (Ed.) *Svavar Gudnason 1909-1988*, Listasafn Islands, 22.9.-4.11.1990

HULDA HÁKON

RUNÓLFSSON, Halldór Björn 'Fire, Fire', Burning Bright', in: *SIKSI. Nordic Art Review*, no. 3, 1990

EXH.CAT., *End of the Century*, Muzé Dekorativnogo I Prikladnogo Isskustva, Moscow 1990

EXH.CAT., *Five young Artists*, National Gallery of Iceland 1988

EXH.CAT., *Figura Figura*, Göteborg Konstmuseum; The Fruitmarket Gallery, Edinburgh 1991

EXH.CAT., *Hulda Hákon*, Galleria Okra, Vanta, Finland 1989

EXH.CAT., *New Scandinavian Painting*, ASF Galley, New York 1990

EXH.CAT., *The Readymade Boomerang*, 8th Biennale of Sydney 1990

CARL FREDRIK HILL

BLOMBERG, Erik *Carl Fredrik Hill*, Stockholm 1950

EXH.CAT., Lindhagen, Niels *Carl Fredrik Hill*, Malmö Kunsthall 1976

EXH.CAT., *Carl Fredrik Hill*, Eggum, Arne, Nils Lindhagen, Sten Åke Nilsson, Gunnar Sörensen, Göran Christenson, Munch-museet, Oslo 1979

EXH.CAT., *C.F. Hill "Det sannas hjärta. E. Munch "Kunsten er ens hjerteblod"* [C.F. Hill "The Heart of Truth". E. Munch "Art is Heart's Blood"], Liljevalchs Konsthall, Malmö Museer 1987

OLAV CHRISTOPHER JENSSEN

PRIESS, Holger and Ulrich Dörrie (Eds.) *Olav Christopher Jenssen. Episodes*, Münster 1991

VALJAKKA, Timo 'Olav Christopher Jenssen', interview, in: *SIKSI. Nordic Art Review*, no. 2 1992

EXH.CAT., *Borealis. 10 Künstler aus Norwegen* [Borealis. 10 Artists from Norway], daadgalerie, Berlin 1986

EXH.CAT., *Det grønne mørke* [Green Darkness], Nordiskt Konstcentrum, Helsinki 1988

EXH.CAT., *Olav Christopher Jenssen. Malerier/Paintings*, Galerie Riis, Oslo 1990

EXH.CAT., *Northlands. New Art from Scandinavia*, The Museum of Modern Art, Oxford; The Nordic Arts Centre, Helsinki 1990

Olav Christopher Jenssen. Ventetid [Olav Christopher Jenssen. The Waiting], Galleri Riis, Oslo 1988 (Partly translated into English)

ASGER JORN

Asger Jorn. 1914-1973, Silkeborg Kunstmuseum 1974

Asger Jorn. Malerier [Asger Jorn. Paintings], Silkeborg Museum 1964

ATKINS, Guy *Asger Jorn. The Crucial Years: 1954-1964*, Lund Humphries, London 1977

ATKINS, Guy *Asger Jorn. The Final Years: 1965-1976*, Lund Humphries, London 1980

BIRTWISTLE, Graham *Living Art. Asger Jorn's comprehensive theory of art between Helhesten and Cobra (1946-1949)*, Reflex, Utrecht 1986

HANSEN, Per Hofman *Bibliografi over Asger Jorns skrifter/A bibliography of Asger Jorn's writings*, Silkeborg Kunstmuseum 1988

JORN, Asger *Banalities* (Originally published as 'Initime Banaliteter' in: *Helhesten*, 1941), 1964
LAMBERT, Jean-Clarence *COBRA*, London and New Jersey 1983

SCHADE, Virtus *Asger Jorn*, Copenhagen 1965

JORN, Asger *Guldhorn og lykkehjul* [Goldhorns and Wheel of Fortune], Copenhagen 1957. (With French version)

JORN, Asger *Held og hasard. Dolk og guitar* [Risk and Chance. Dagger and Guitar], Silkeborg 1952. (Translated into German, Dutch and French)

PER KIRKEBY

GRANATH, Olle *Per Kirkeby*, Format, Edition Blondal, Hellerup 1990

KIRKEBY, Per *Selected Essays from Bravura*, Van Abbemuseum, Eindhoven 1982

KIRKEBY, Per *Natural History and Evolution* (Originally published as *Naturhistorie*, 1984 and *Udviklingen*, 1985), Haags Gemeentemuseum 1991

EXH.CAT., Nilsson, Bo and Lidman, Evalena (Eds.) *Per Kirkeby. Måleri/Paintings, Skulptur/Sculptures, Teckningar/Drawings, Böcker/Books, Films/Films 1864-1990*, Moderna Museet, Stockholm 1990

EXH.CAT., *Per Kirkeby* The Fruitmarket Gallery Edinburgh, 9.3.-13.4.1985, Douglas Hyde Gallery Dublin, 6.5.-8.6.1985

EXH.CAT., *Per Kirkeby* Galerie Michael Werner, Cologne 17.10-15.11.1990

EXH.CAT., *Per Kirkeby: Pinturas, esculturas, grabados y escritos* [Per Kirkeby: Paintings, Sculptures, Engravings and Writings], Ivam Centre del Carme, Valencia 12.12 1989-18.2.1990 (with an English version)

EXH.CAT., Serota, Nicholas and Rachel Kirby (Ed.) *Per Kirkeby: Recent Painting & Sculpture*, Whitechapel Art Gallery, London 1985

JOHANNES KJARVAL

INGÓLFSSON, Adalsteinn and Matthías Johannessen *Kjarval: Málari lands og vætta – Kjarval: A Painter of Iceland*, Reykjavik 1981

THORODDSEN, Emil *Art in Iceland, 20 Artists*, Reykjavik 1943, pp. 13-14, 64-70

LAXNESS, Halldór *Myndir eftir Jóhannes Sveinsson Kjarval*, Reykjavík 1938

LAXNESS, Halldór *Kjarval*, Reykjavík 1950

VILHJÁLMSSON, Thor *Kjarval*, Reykjavík 1964, 1978

EXH.CAT., *Kjarval, Aldarminning – Centenary Exhibition* Kjarvalsstadir, Reykjavik 15.10.-15.12.1985

EVERT LUNDQUIST

BLOMBERG, Erik *Svenska målarpionjärer* (Swedish Painting Pioneers), 1959

GRANATH, Olle *Another Light. Swedish Art since 1945*, The Swedish Institute

HOLDEN, Cliff 'Evert Lundquist', in: *Art News and Review*, 1959

SPENDER, Stephen: 'Round the London Art Galleries', in: *The Listener*, 3.11.1960

WRETHOLM, Eugen *Evert Lundquist*, General Art Society of Sweden, Stockholm 1977

EXH.CAT., Linde, Ulf *Evert Lundquist*, Moderna Museet, Stockholm 1974

MARIKA MÄKELÄ

EXH.CAT., *Art Today*, Sapporo Triennale 1981

EXH.CAT., *Borealis*, Malmö Konsthall 1987

EXH.CAT., *Marika Mäkelä*, Galleria Mikkola & Rislakki, Helsinki 1990

EXH.CAT., *Northlands. New Art from Scandinavia*, The Museum of Modern Art, Oxford; The Nordic Arts Centre, Helsinki 1990

EDVARD MUNCH

EGGUM, Arne *Edvard Munch. Paintings, Sketches, and Studies*, Oslo 1984

EGGUM, Arne *Munch and Photography*, Yale University Press 1989

ELDERFIELD, John and Arne Eggum *The Masterworks of Edvard Munch*, Museum of Modern Art, New York 1979

HELLER, Reinhold *Munch. His Life and his Work*, London 1984

HELLER, Reinhold 'Edvard Munch's "Vision" and the Symbolist Swan', in: *Art Quartely*, Detroit 1973

HODIN, J.P. *Edvard Munch*, Thames and Hudson, New York 1985

JAWORSKA, W 'Edvard Munch & Stanislav Przybyszewki', in: *Apollo*, Feb. 1965

LANGGAARD, Ingrid *Edvard Munch: Modningsår* [Ripening Years], Oslo 1960

LIPPINCOTT, Louise *Edvard Munch. Starry Night*, J. Paul Getty Museum, California 1988

STANG, Ragna *Edvard Munch. The Man and his Art*, Gordon Fraser 1979 (Oslo 1977)

EXH.CAT., *Edvard Munch. Symbols and Images*, National Gallery of Art, Washington 1978-1979

TYKO SALLINEN

LEVANTO, Marjatta *Ateneum Guide,* The Fine Arts Academy of Finland, The Art Museum of the Ateneum, Otava Publishing Co., 1987

AUGUST STRINDBERG

DITTMANN, Reidar *Eros and Psyche: Strindberg and Munch in the 1890s*, UMI Research Press, Michigan 1976

FEUK, Douglas *August Strindberg. Inferno Painting. Pictures of Paradise*, Format, Edition Bløndal, Hellerup 1991

HEMMINGSSON, Per *Strindberg som fotograf/August Strindberg – the Photograher*, Malmö 1989 (1963)

LAGERCRANTZ, Olof *August Strindberg*, New York 1984

RENNER, Eric *August Strindberg's Photographic Transformations*, In: *Pinhole Journal*, Vol 4 #1, April 1988, pp. 12-18

ROBINSON, Michael *Strindberg and Autobiography*, Norvik Press, Norwich 1986

ROBINSON, Michael (Ed.) *Strindberg and Genre*, Norvik Press, Norwich 1991

ROBINSON, Michael (Ed.) *Strindberg's Letters*, The Athlone Press 1992

EDVARD WEIE

KIRKEBY, Per *Edvard Weie*, Format, Edition Blondal, Hellerup 1988

ZIBRANDTSEN, Jan *Moderne dansk maleri* (Modern Danish Painting), Copenhagen 1967 (On Weie pp. 109-125, 301-303. With an English version; on Weie pp. 344-345)

ACKNOWLEDGEMENTS

BRITAIN
Cecile Latham-Koenig
Magnús Pálsson
Michael Robinson
Peter Shield
Mara-Helen Wood

DENMARK
Troels Andersen
Helle Behrndt
Torsten Blondal
Else Marie Bukdahl
Elisabeth Dilen Hansen
Carl Tomas Edam (d.1991)
Björn Fredlund
Lennart Gottlieb
Anders Kold
Ane Hejlskov Larsen
Jens Sandberg
Birgitta Schreiber
Erik Wallin

FINLAND
Leena Ahtola-Moorhouse
Tuula Arkio
Bengt von Bonsdorff
Staffan Carlén
Michael Garner
Maaretta Jaukkuri
Jan Olof Mallander
Vesa-Matti Velhonoja

GERMANY
Anne Blümel
Michael Werner
Rudolf Zwirner

ICELAND
Ingólfur Arnarsson
Asta Eiríksdóttir
Thorunn J. Hafstein
Jóhannes S. Kjarval
Bera Nordal
Halldór Björn Runólfsson
Hrafnhildur Schram

THE NETHERLANDS
Marente Bloemheuvel

NORWAY
Alf Bøe
Arne Eggum
Svein Engebrektsen
Steinar Gjessing
Liv Mörch Finborud
Per Hovdenakk
Iris Müller-Westermann
Espen Ryvarden
Olga Schmedling
Tone Skedsmo
Mette Spendrup
Øivind Storm Bjerke
Åsmund Thorkildsen
Gerd Woll

SWEDEN
Mikael Adsenius
Britta Birnbaum
Lena Boëthius
Lars Bohman
Margareta Brundin
Ulf Cederlöf
Göran Christenson
Hans Dyhlen
Douglas Feuk
Jan Gottfarb
Torsten Gunnarsson
Agneta Lalander
Ulf Linde
Elisabeth Lindén
Monica Nieckels
Lars Nittve
Bo Nilsson
Per Österlind
Fredrik Posse
Göran Söderström
Mia Sundberg

UNITED STATES OF AMERICA
Melanie Franko

LENDERS TO THE EXHIBITION

Barbican Art Gallery would like to thank the following lenders, and those who preferred to remain anonymous, for their support of *Border Crossings*.

DENMARK
Aarhus Kunstmuseum (cat.84)
The Asger Jorn Donation, Silkeborg Kunstmuseum (cat.44)
Statens Museum for Kunst, Copenhagen (cat.85-87)
Storstrøms Kunstmuseum, Maribo (cat.9)

FINLAND
Ateneum, Helsinki (cat.76 & 77)

GERMANY
Olav Christopher Jenssen (cat.40 & 41)
Galerie van de Loo, Munich (cat.42 & 45)
Städtische Galerie im Lenbachhaus, Munich (cat.43)

ICELAND
National Gallery of Iceland, Reykjavik (cat.1,10,11,51 & 52)

THE NETHERLANDS
Galerie Paul Andriesse, Amsterdam (cat.8)
Thora K. Johansen & Kees van Gelder (cat.2-5)
Rijksmuseum Kröller-Müller, Otterlo (cat.6-7)

NORWAY
Inger & Andreas L. Riis Collection, Oslo/Henie Onstad Kunstsenter, Høveikodden (cat.46)
The Munch Museum, Oslo (cat.59-74)
Galleri Riis, Oslo (cat.39)

SWEDEN
Galleri Lars Bohman, Stockholm (cat.38)
Albert Bonniers Forlag, Stockholm (cat.81)
Folkhem, Stockholm (cat.57 & 58)
Folksam Insurance Group, Stockholm (cat.56)
Kulturen Lund (cat.16)
Evert Lundquist (cat.54)
Malmö Konstmuseum (cat.12,13,17,22-36)
Nationalmuseum, Stockholm (cat.14,15,18-21)
Stiftelfen Rooseum, Malmö (cat.53)
Strindbergsmuseet, Stockholm (cat.80 & 83)

CORPORATE MEMBERS

Barbican Art Gallery gratefully acknowledges the support of its Corporate Members:

3i Group plc

Barings Group

British Gas North Thames

British Petroleum Company plc

British Telecommunications plc

Clifford Chance

MoMart plc

Robert Fleming Holdings Ltd

Save & Prosper

Sun Alliance Group plc

TSB Group plc

Unilever plc

S.G. Warburg Group plc

AUTHOR BIOGRAPHIES
ACKNOWLEDGEMENTS

DORTHE AAGESEN is a Danish art historian.

LEENA AHTOLA-MOORHOUSE is a curator at the Ateneum, Helsinki.

HALLDÓR BJÖRN RUNÓLFSSON is an Icelandic freelance writer and critic, and was previously Head of Exhibitions at the Nordic Arts Centre, Suomenlinna, Helsinki.

GERTRUD SANDQVIST is the Director of Galleri F15, Moss, Norway and has written extensively on Scandinavian art. From 1984-88 she worked at the Nordic Arts Centre, where she founded the Nordic art review, SIKSI.

THOR VILHJÁLMSSON is a poet and novelist. He was born in Edinburgh but lives in Iceland. His books include *The Grey Moss*, 1988 (Prize-winner of the Nordic Council Award of Literature) and *Svavar*, 1992 which was awarded the Swedish Academy Nordic Prize for Literature.

© 1992 Barbican Art Gallery, Corporation of London, and the artists whose texts are included, and translators of the same.

Published November 1992 in an edition of 2,000 copies on the occasion of Barbican Art Gallery's exhibition

BORDER CROSSINGS
Fourteen Scandinavian Artists
11 November 1992 – 7 February 1993

The exhibition is part of the Barbican Centre's Festival of Scandinavian Arts,
TENDER IS THE NORTH
10 November – 13 December 1992

Exhibition selected and organised by
Jane Alison and Carol Brown
with assistance from Dorthe Aagesen

Barbican Art Gallery gratefully acknowledges the support of the Nordic Council of Ministers

The exhibition is presented in association with Visiting Arts

The organisers are grateful to Her Majesty's Government for agreeing to indemnify the exhibition under the National Heritage Act 1980 and the Museums and Galleries Commission for their help in arranging this indemnity.

Catalogue edited by
Jane Alison and Carol Brown

Barbican Art Gallery would like to thank all
those lenders and public institutions who have
kindly supplied material for reproduction, and
the photographers listed below:

Paul Andriesse, portrait Sigurdur
Gudmundsson (page 149); Lars Bay, cat.44;
Daniel Blau, portrait Per Kirkeby (page 154);
Marente Bloemheuval (ill.p.122 & 123);
Central Art Archives, Ateneum, cat.77
(ill.p.64) and *Self-portrait* (ill.p.159); Alexis
Daflos, cat.80; Lars Flack, cat.54;
Ludek Holub, cat.36; Tord Lund, cat.82;
Per Maning, portrait Olav Christopher
Jensson (ill.p.153); Frank Oleski, cat.78;
Thomas and Paul Pedersen, cat.84;
Hans Petersen, cat.85,86,87;
Kristján Pétur, cat.10,52; Planet Foto, cat.81;
Magnus Reynir, (ill.p.133) (top);
Svala Sigurleifsdttin, portrait Hulda Hákon
(ill.p.151)

Designed by Tim Harvey
Printed by BAS Printers Limited,
Over Wallop, Stockbridge, Hampshire

ISBN 0 946372 28 4

cover: SIGURDUR GUDMUNDSSON *Molecule*, 1979
(cat.7)

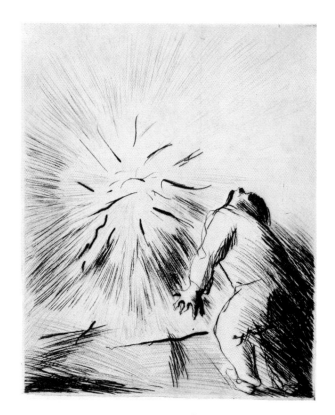

EVERT LUNDQUIST *Explosion*, 1959